CAPTURING THE LANDSCAPE WITH YOUR CAMERA

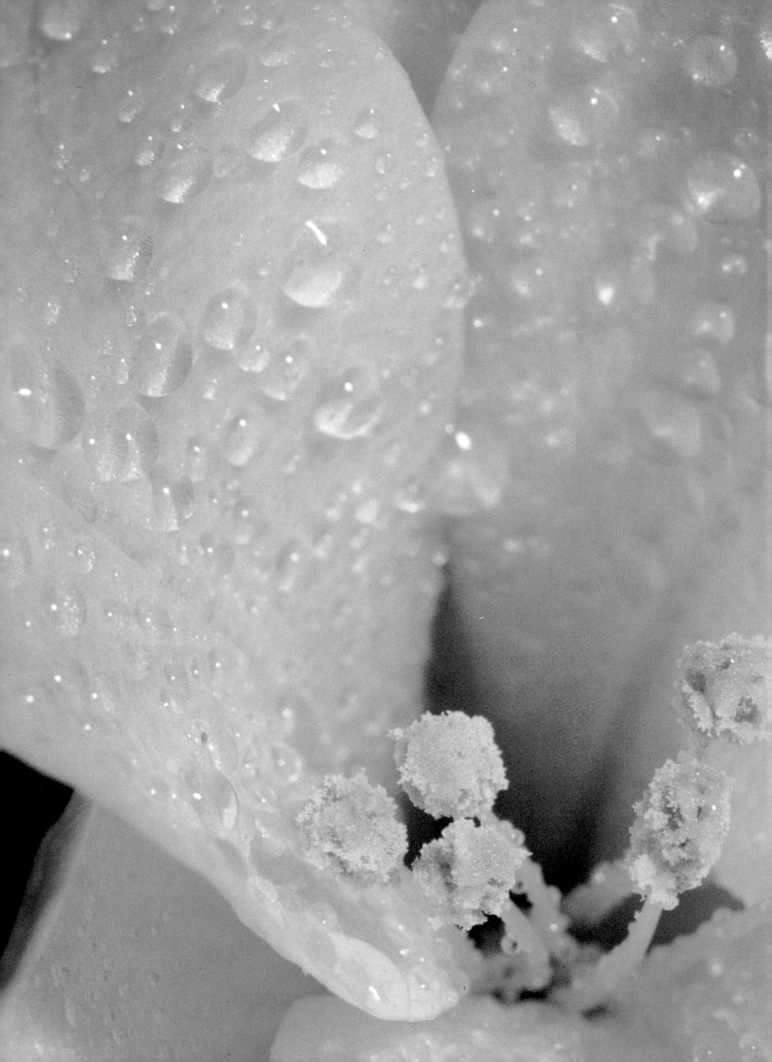

Patricia Caulfield

CAPTURING THE LANDSCAPE WITH YOUR CAMERA

Techniques for Photographing Vistas and Closeups in Nature

AMPHOTO
An Imprint of Watson-Guptill Publications, New York

Editorial Concept by Marisa Bulzone
Edited by Robin Simmen
Designed by Bob Fillie
Graphic Production by Ellen Greene

Copyright © 1987 by Patricia Caulfield

First published 1987 in New York by AMPHOTO,
an imprint of Watson-Guptill Publications,
a division of Billboard Publications, Inc.,
1515 Broadway, New York, NY 10036

Library of Congress Cataloging-in-Publication Data

Caulfield, Patricia.
 Capturing the landscape with your camera.
 Includes index.
 1. Photography—Landscapes—Handbooks, manuals, etc.
I. Title.
TR660.C37 1987 778.9′36 86-26516
ISBN 0-8174-3657-X
ISBN 0-8174-3658-8 (pbk.)

Manufactured in Japan

1 2 3 4 5 6 7 8 9/91 90 89 88 87

*For Mary Alacoque Caulfield
and Bernard Nicholas Schilling:
My Auntie and my Uncle Dave*

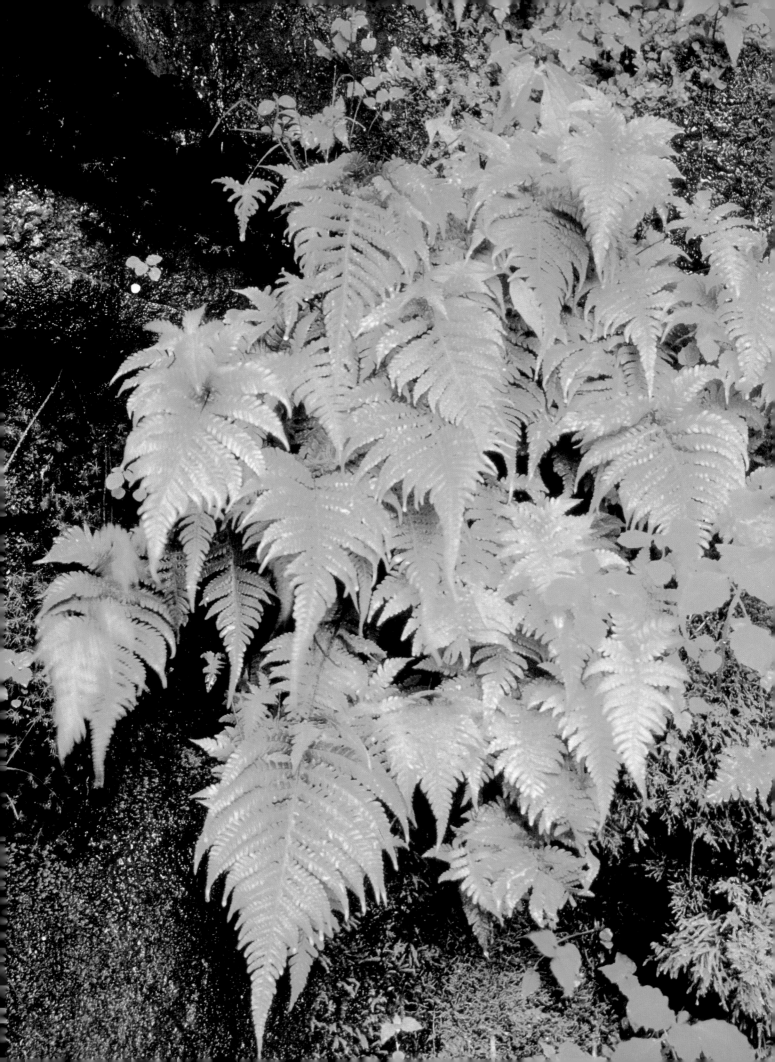

CONTENTS

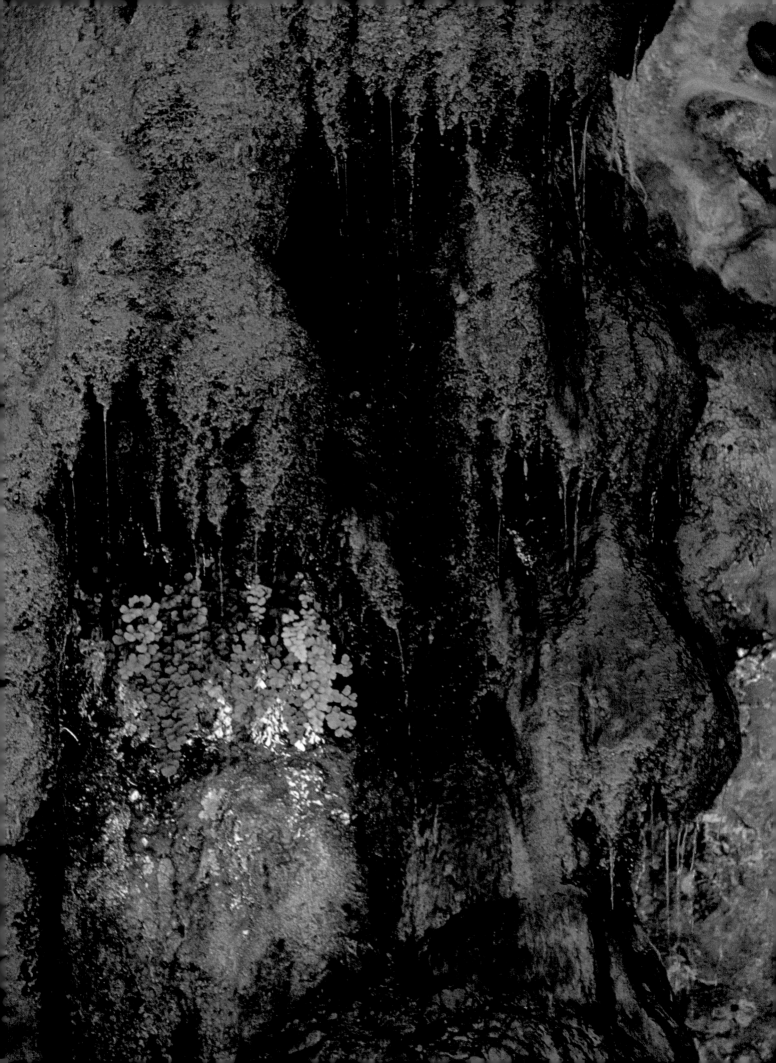

INTRODUCTION

Seeing pictures in shade is as simple as seeing them in sunlight, yet shade images are often overlooked by the amateur. The exposure and camera techniques for shooting shaded areas are easy: for overall middle-toned subjects, such as this waterfall in a travertine-coated canyon off the Grand Canyon, take an overall meter reading with the camera's through-the-lens meter, and shoot as recommended. The exposure here was 1 sec. at ƒ/5.6 on Kodachrome 64 with a 105mm lens on a 35mm camera. To keep the camera steady at this slow speed I used a tripod and a cable release.

Nature photographers are a diverse group. Our aims, attitudes, attributes, and approaches are as varied as our subject matter and how our pictures are used. Among us are landscape experts who respond most strongly to the way an overall scene is specially revealed by some miracle of natural light. We also include specialists who make personal images of smaller, more intimate views of inanimate subjects to grace museum, gallery, and collectors' walls. Other nature photographers are students, professional and amateur, of animal ways. Some of our skills are more often associated with the hunter and tracker than with the fine artist.

Our motivations and methods differ, but we have a strong common bond and usually an uncommon respect for one another. We are united in our regard for our subject matter. In the most real sense we are all amateurs—we are lovers of the lands and the life we portray. Without such concern, we wouldn't have the patience or the persistence consistently to produce good pictures.

There are many frustrations in the field that are quite foreign to studio and people photographers. For example, so very much is totally out of our control. We can't force the sun to shine, the rain to fall, or a plant to bloom. We can't direct our animal subjects, at least not very effectively, even in the most controlled of circumstances. At worst, we sometimes can't even find the subjects we're looking for no matter how thoroughly we've researched the plants or animals and how exhaustively we've searched their haunts.

Even so, there are extraordinary satisfactions when we do succeed. Once we become aware of and committed to the natural world, there is no turning back, as I learned many years ago on an ill-timed trip to the jungles of Guatemala.

It was a three-week vacation from my job as a magazine editor. The bad timing wasn't on our part—it was the rain, which failed to stop according to predictions. When the clouds broke briefly, a plane dropped us off at an airstrip especially hacked out of the jungle for us. The only way back to civilization was to canoe hundreds of miles down rivers that led to a permanent airstrip. A scheduled plane stopped there twice a week.

We had good tents, plenty of food, and very good Indian guides. We were in no danger even when the waters rose twenty feet, threatening to flood the jungle around us because we could have taken to the boats and bailed. We weren't in danger, but we were very uncomfortable. My socks and feet were never dry and my film developed a fungus infection. I was cold—there is no cold so penetrating as that of the rainy season in the tropics. And the biting insects were so voracious I kept my face wrapped in a scarf and my hands under my armpits. None of this was very stimulating for photography.

Late one afternoon, a little cold rivulet found its way into my poncho and all the way down me. I hunched into myself, chilled and peering out at the murky, ugly surroundings as we paddled through the drizzle. Just a week before I had been high and dry in my office in Manhattan's sky putting out a monthly magazine with my fellow editors. "What am I doing here?" I wondered. Then I thought, "Where do I want to be?" "Here. This is exactly where I want to be now." When I realized this, I felt at peace.

If you care very much about something—in this case photographing nature and its ways—the idea of choice no longer has much meaning. You may as well relax and enjoy it. To be enjoyed nature photography need not be a full-time pursuit nor practiced in such an exotic place as Guatemala. You can do it on weekends, on vacations, even during parts of an ordinary day if your location permits, or you can do it on evenings.

I had been a photographer for many years before I started taking nature pictures. I knew several of our greatest nature photographers—in fact, I had done stories on Ansel Adams and Eliot Porter. Even so, I felt extraordinarily ignorant of how to go about photographing nature, although I did understand the patience required for fine landscape work, and the importance of certain lighting conditions. I've learned a great deal over the years. And having learned as an adult, it's closer to me, easier to pass on to you than if I had been trained in the outdoors as a child. However, I did have a head start in picture taking, and I believe that's harder to learn than the outdoor lore one needs to cope with the wilds. This book is intended to impart both, to lend you my experience in all the aspects of nature work that I have practiced with the hope that it will shorten your route to consistently fine results in the field.

There are really three parts to nature photography. The first part is largely photographic. For good nature pictures you need the same personal sense of composition and technical skills that you do in any other photographic specialty. Every photographer has the same bag of tricks, and they are surprisingly few: camera angle, camera height, camera-to-subject distance, lens choice, variations in exposure, aperture choices, selection of shutter speeds, films, and printing. That just about sums it up, except for those very important subject attributes and elements that you arrange into a composition, the lighting in which you shoot, and the moment you choose to make your exposure. The choices we compile from this infinitely variable set of ideas and facts distinguish for each of us our own personal style. In this book I present the elements that go into making nature pictures, so that you can make your own choices and develop your own way of seeing and your own style, rather than mimic mine or anyone else's. I'll be talking about the "scenic," not the classic scenic picture synonymous with a landscape, but a bigger, broader category of scenic photography, as big as the whole outdoors and as small as a grain of sand. Here the term scenic includes all inanimate subjects and sometimes even extends to the animate. Sometimes a snail, a bird, a beast, or a

In this field of flowers the blossoms display a great difference in color, and the blurred pink flower toward the bottom of the frame attracts your attention like a magnet.

These flowers were in an old field rimmed with sidewalks, streets, telephone poles, power lines and backyard shacks. The contrast between the ugly artifacts of the town and the natural wildflowers was startling but not really photogenic; so I decided to focus solely on the flowers. I used a tripod because I wanted a slow shutter speed, and I finally settled on a 55mm lens after trying a wide-angle that failed to exclude the offensive surroundings.

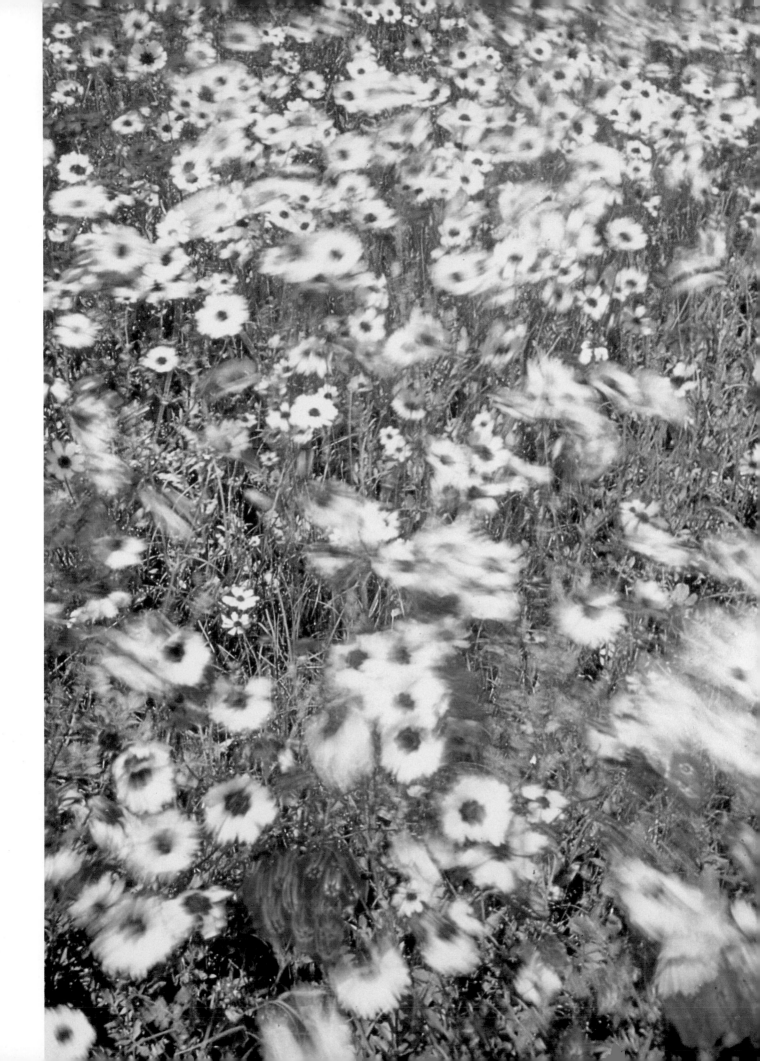

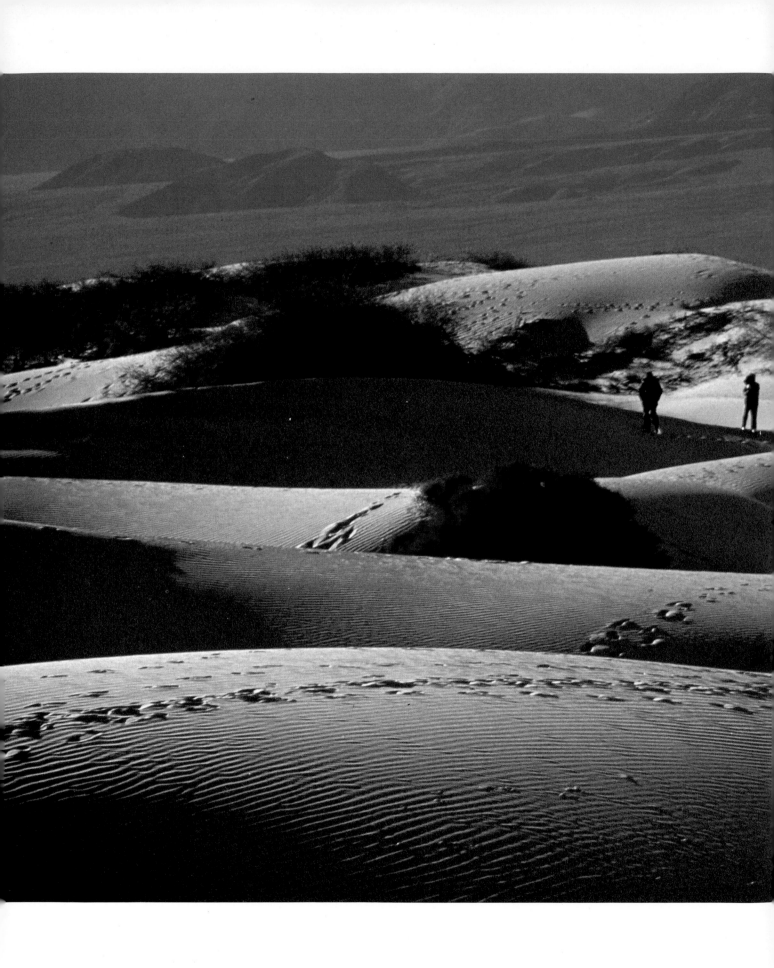

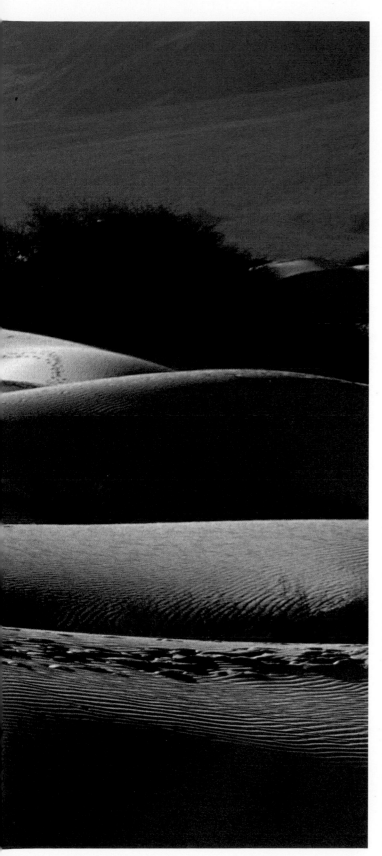

reptile is a part of the bigger picture; instead of being photographed close-up for itself alone, its role in the scenic is to be a part of its habitat, giving that landscape scale and significance. To make scenics, you need patience and a highly-developed awareness of natural light. This means patience to wait for the perfect illumination to light your subjects. This is generally considered the most artistic area of nature work, the most contemplative, and the one requiring the most exact seeing.

Secondly, you also need ingenuity, perseverance, and, strangely enough, you must cultivate the virtues of acceptance and flexibility. The most extraordinary endeavors frequently come to naught, and the most extraordinary pictures often result from no more than being there and being ready to shoot. Many situations I have diligently sweated and strived for have not worked out at all or have produced pictures that illustrate little more than technical skill. But in all fairness, many situations involving much preliminary labor have paid off, in pictures that wouldn't have been possible without it.

The third part is getting with it outdoors. Don't despair even if you are a city person. The quickest route to learning how to cope outdoors is to go on planned trips, and there are plenty of tours and organizations to help you get started. No one but the most expert outdoorsman spends much time wandering around solo in real wilderness—it's not safe. I know of too many broken ankles in canyon country and too many venomous snake bites in the swamps. These accidents are described by genuine outdoor experts only because they had a companion who carried them out or who went back to get help—otherwise no one would be left to tell the story. For those of you who are relatively inexperienced, organizations that sponsor outings are listed in the appendix on page 158. These should help you get started safely.

Bright sun on a brilliant subject, such as these sand dunes at Death Valley National Park, calls for less exposure than a normally bright subject, but still needs more exposure than would be indicated by an overall meter reading. Here I exposed for detail in the brightly lit areas of the dunes. The exposure was 1/125 sec. at f/16 on Kodachrome 64.

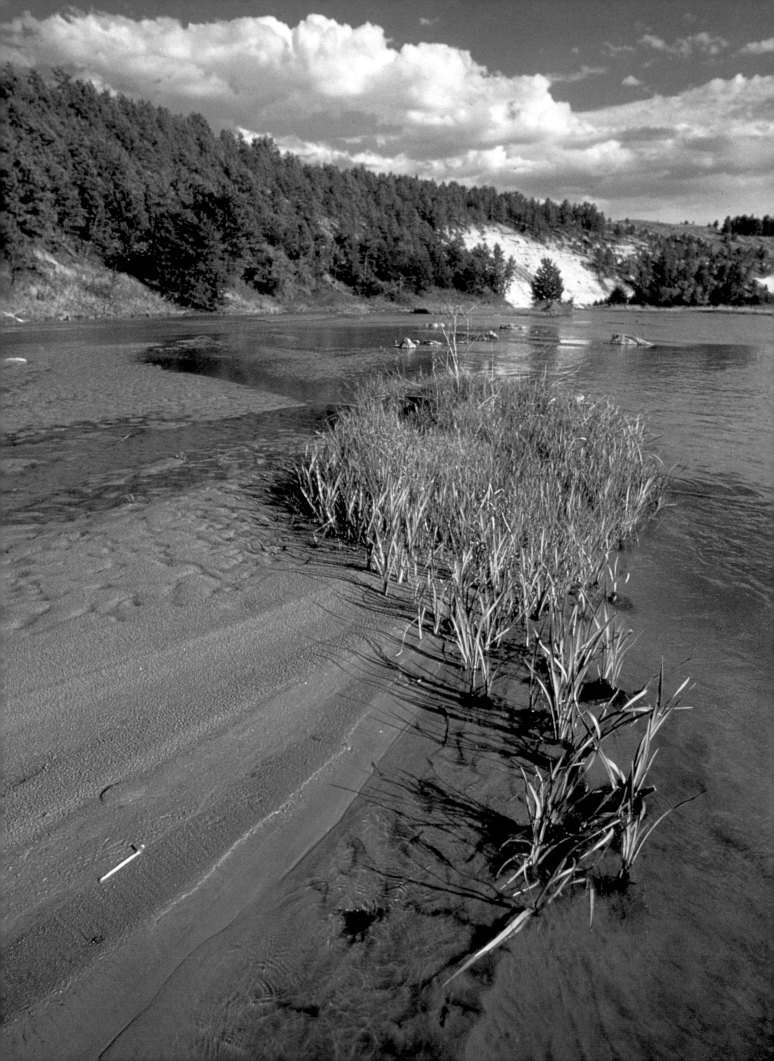

Chapter One

CAMERAS AND LENSES

This river scenic was shot from a sandbar in Nebraska's Niobrara River with a 20mm wide-angle lens. By stopping the lens down to $f/16$ I expanded the depth of field to include with great sharpness a foreground beginning just a few feet from the camera and a background hundreds of feet away. With a standard 50mm I couldn't have included so much of the sandbar or maybe not any of it, and I wouldn't have had a depth of field ranging from 2 feet to infinity at any aperture.

My first camera was a twin-lens reflex. My next camera was a 35mm rangefinder with a noninterchangeable lens. During my early years in photography I also did some work with 4×5 view cameras. Then long before I began to specialize in nature photography, a 35mm single-lens reflex (SLR) became my favorite format.

I discovered I was happiest with 35mm, not because the results were technically so superior or even more interesting in their composition but because I liked the 35mm SLR viewing mechanism better. I found I preferred to look directly at what I was photographing, rather than down into the $2\frac{1}{4}''$-square ground glass. I also liked to be able to work fairly fast and spontaneously, unlike the more studied fashion dictated by the view camera. Essentially, I was most comfortable with a 35mm SLR.

This feeling of "fitness" with a particular camera system must be experienced to be comprehended, and it is far more important than any practical recommendation for using one kind of camera or another. When you find the format you prefer, you will know it (after, of course, an initial breaking-in period). Over the years your preference in formats may change, just as your goals and purposes for what you have to say in your pictures may change. One example of how a master photographer finally found his perfect format gives me pause whenever it crosses my mind: Eliot Porter had been working for over twenty years with a variety of smaller formats, especially 35mm, before he took to shooting with 4×5 and 8×10 view cameras. Besides amazing me, this extraordinary fact gives me patience.

The View Camera

View cameras are the classic tools for classic scenic photographs. In several ways they are without peer in the camera world—their adjustments, swings, tilts, and rising and falling fronts allow you to rearrange nature and take pictures that would be impossible to make by any other means. Because the film they expose is so much bigger, the photographs they produce have a quality unobtainable with tiny 35mm film.

But how much quality do you need? You can get wonderful 16″ × 20″ color prints from 35mm film, and I have even made quality 4 × 6 ft. prints from it which sell to collectors. And when it comes to versatility, the 35mm format beats the view camera on many fronts. View cameras are not good for making close-ups in the field or anywhere else, except under special circumstances. You need too much extension to get even a 1:1 life-size image; so filling the picture with a small subject is a nightmare. Also, you can't move fast with a view camera. To use them you must be willing to sacrifice speed and spontaneity.

View cameras are not for everyone. I thought I wanted to start using a view camera many years ago, and I mentioned it to the editor of one of the most prestigious nature magazines. He said I should not, that it would cripple me, and that I would lose my ability to see in my own special way. The same advice may or may not apply to you, but I suggest you consider it well before switching formats.

The Versatile 35mm SLR

The most suitable cameras for shooting the greatest variety of nature pictures are certainly 35mm SLRs. When the first models with rapid-return mirrors were introduced in the 1950s, I took to these cameras with great enthusiasm before I was a very accomplished photographer. These cameras feature through-the-lens (TTL) viewing and focusing, which allow the photographer to see exactly what the film sees and are of great help to me in composing.

Since becoming a nature photographer I have rarely used any cameras other than 35mm SLRs. I take many different kinds of nature pictures. I may photograph an overall landscape in the foggy dawn and a few minutes later focus close-up on an insect slowed down by the dissipating chill of night. Shortly after that I may try, and try, and try again to capture a fast-flying, territorial bird bursting with song near his nest. Then before breakfast, I may go on to shoot five different pictures of the natural world, each calling for different ways of seeing and different techniques and lenses.

I need as much versatility as I can get from as little equipment as possible. I must have TTL focusing and viewing for close-up work and for the long lenses I so frequently employ for shooting birds and animals. I must also be able to shoot extremely rapidly, sometimes from moving vehicles such as airboats, boats, and trucks; therefore, I need motor drives. The only camera systems that fill all my needs are 35mm SLRs.

Am I satisfied with 35mm quality? I have had 35mm transparencies enlarged to 4 × 6 ft. dye-transfer prints. Examined from a distance of a few inches, they look sharp. That's quality enough for me, better quality than my book and magazine assignments require.

For many years I used Nikon Fs, now long discontinued. Recently I acquired several Minolta cameras. I chose them over other automatic cameras largely because at that time they were the only cameras on the market that offered the option of either shutter-speed or aperture priority in an automatic mode—and I genuinely didn't know which I would prefer using—as well as a manual mode. It turns out that I prefer aperture priority for inanimate subjects and shutter-speed priority for animals. Of course, it isn't necessary to own a camera with these options to shoot either type of subject.

Choosing a 35mm System

There are a number of excellent camera systems on the market in addition to Nikon's and Minolta's. If you aren't already outfitted, I suggest you choose your system by checking the technical write-ups in the photographic magazines that perform very thorough equipment tests. Also, go to your camera store and look over the equipment before purchasing a system. Find out for yourself which camera or cameras fit best in your hand, feel most comfortable, and have their controls placed so you can identify them by touch without looking at them. Naturally, you aren't going to be able to operate a new camera with the same ease it took you years to develop with an old one. Real familiarity takes time and experience. The length of this breaking-in period, when you are learning to get the most from your equipment with the least expenditure of effort, is a good argument against continuous switching around between cameras. So is the great cost of reinvesting in new equipment.

A good photographer can consistently make very good pictures with any of the 35mm SLRs on the market today. If you aren't satisfied with your results, you probably need more work on composition, tim-

These pictures of a sunset were taken at St. Joseph's State Park, and they give a general idea of the inclusive and exclusive capabilities of the wide-angle, standard, and telephoto lenses typically used to make scenics. Notice that the size of the sun increases as the focal length increases, from the wide angle on the left to the telephoto on the right. Being much closer to the camera, the tree grows proportionately much larger than the sun does. Most importantly, you can see how the shorter lenses encompass more of the nearby surroundings in this scene. In the telephoto shot, this larger perspective is completely missing.

ing, exposure, recognizing the photogenic aspects of a subject, or all of the above. A new camera outfit won't solve your problem, but spending more time taking pictures, experimenting, and analyzing the results will.

Lenses

I have many lenses ranging in focal length from 18mm to 640mm. Would I like more?—you bet, but I would add slowly to the selection I have, getting to know the lenses one at a time just as I have done in the past. Every focal length represents a different way of seeing and showing what I see in photographs. It takes me a long time to begin to exploit the potential of a new lens and to integrate it into my work. Here are a few general ideas to keep in mind when buying and using lenses.

"What does that lens take in?" is the question most often asked about a specific lens. How far you are from the subject affects the answer just as much as the focal length of the lens. Generally, wide-angle lenses include more of a scene and render it smaller than a camera's standard 50mm or 55mm lens. Telephoto lenses exclude much of a scene and render what you frame with them larger than your camera's standard focal length.

Focal length determines more than magnification. There are good reasons for using lenses of different focal lengths other than the obvious differences in the image size they produce. Changing the apparent size and space relationships between near and distant objects in a picture is one of the best and most frequent reasons for switching lenses. Wide-angle lenses can be used to stretch, or extend, space. Telephoto lenses can be used to collapse, or compress, space.

The difference between the camera's distance from the closest and farthest parts of a subject is the key to this spatial phenomena, not just the focal length of the lens. Wide-angle lenses are more useful for shooting inanimate subjects than for shooting animals, because often you can't get close enough to wildlife to use a wide-angle lens effectively. Even with a long lens, you must get much closer to animal subjects than most people realize.

For landscape photography my first accessory lens choice would be a 28mm or 35mm wide-angle. However, I do use long lenses—usually up to about 300mm—in basically three situations: when I can't approach and frame a small section of a subject any other way; when I want the flattened perspective that a long lens gives; and when I'm including an animal in the scene and can't get any closer.

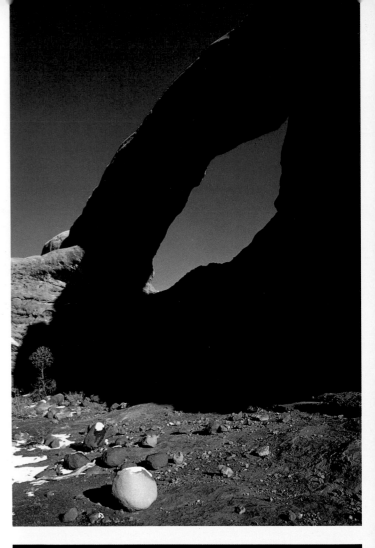

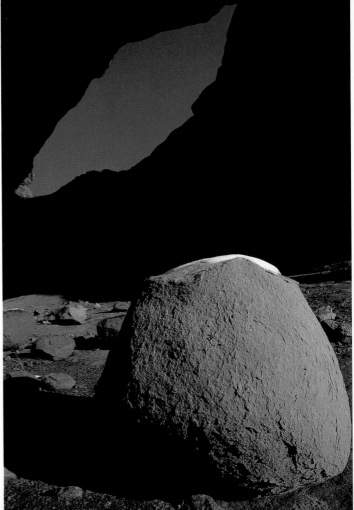

The top left picture of the rock and the arch was made with a standard 50mm lens from the vantage point where I first noticed the scene's photogenic potential. This was not a small boulder—it just looks small in relation to the giant arch. The minute I saw the scene, I wanted to make the boulder look bigger and more significant.

For the picture below it, I got much closer to the boulder and used a 20mm lens. Notice that the size of the hole in the rock hasn't changed appreciably; however, the boulder's size has multiplied many times. By itself the wide-angle lens didn't make the boulder bigger; getting up close and shooting it within a few feet did. With the standard lens I couldn't have approached the boulder this closely and still have included it along with the arch in the photograph. With my standard lens, I could have photographed part of the boulder's surface, or I could have framed the arch and found a vantage point that perhaps included a bit of the top of the boulder; however, I couldn't have rendered both the boulder and the arch in sharp focus. Such depth of field is not possible with any but the widest wide-angle lenses.

The window is about the same size in both pictures. The distance I lost coming in for the second picture correspondingly enlarged the rock window by about the same amount that using the wide-angle lens reduced it. The closer subject distance and the shorter focal length cancelled each other out.

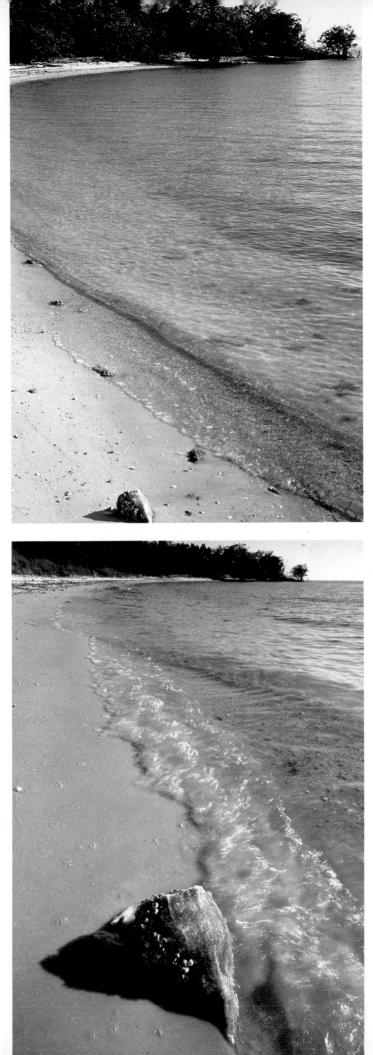

At first glance, these pictures to the right of a shell and the surf at a Florida beach seem similar, but in the shot made with a wide-angle lens, the background is greatly reduced. This shell is in fact much smaller than the boulder pictured to the left. To make the wide-angle picture of the shell, I didn't need to lose as much distance as I did photographing the wide-angled boulder.

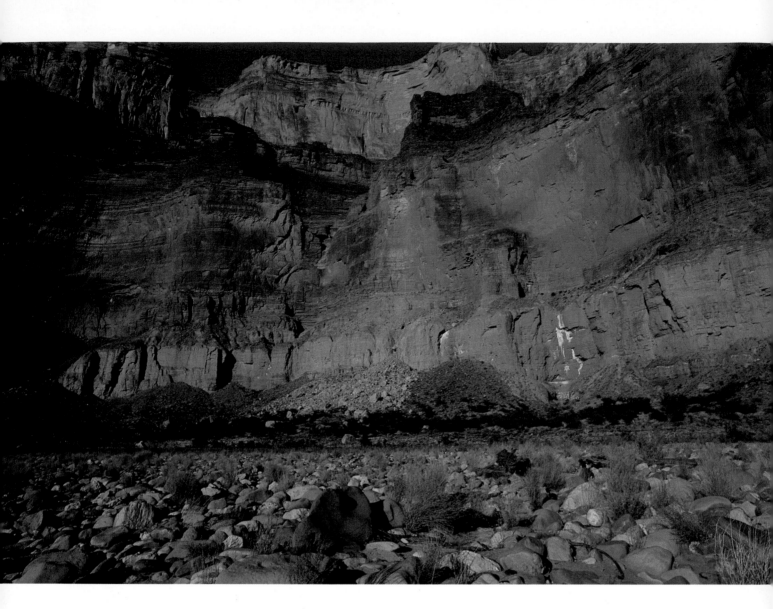

Extreme Wide-Angle: 15–21mm

I use extreme wide-angle lenses for a number of situations, especially when I want to include as much as possible of what is before me in a single picture. Often the background will dictate my lens choice.

I also use extreme wide-angle lenses a lot to exaggerate the size of foreground objects in relation to backgrounds, as you can see in the photographs of the boulder and the arch and in many other pictures throughout the book. I often use my 20mm lens to photograph flowers and other inanimate subjects, though if the opportunity presents itself, I'm perfectly happy to use it on wild animals, too. Such opportunities are quite rare.

Wide-Angle: 28–35mm

How to decide which focal-length lens to use isn't always as obvious as in the Hovenweep landscape, where my back was literally against the wall to get what I wanted in the picture while using an extreme wide-angle lens. Other than in such situations, where some aspect of the terrain limits your mobility, you'll find that compositional decisions largely dictate your choice of different lens focal lengths.

I might want a foreground object to loom large in comparison with something in the background, or I might want to create some extra distance between objects. Often I'll take pictures with lenses of various focal lengths and then decide which perspective I like best after the pictures are processed. A distinct preference for one photograph over another variation of a scene is not at all a foregone conclusion. Many times I like all the versions I take, rather than preferring one to all the others.

I wanted big flowers and a small sun in the sunrise picture to the right, and I wasn't especially limited in my choice of camera-to-subject distance. As usual when I have vantage-point flexibility, I also took some pictures with longer lenses. After processing, I liked the 35mm version best.

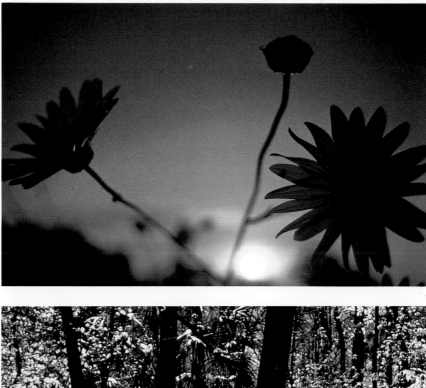

The widest wide-angle lens I had was perfect for making the picture to the left, a scenic of the cliff face behind the boulder field at Hovenweep along the Colorado River in the Grand Canyon. Here the background dictated my lens choice. To include the entire cliff top to bottom I had to use a 20mm- or-wider-angle lens from the farthest available vantage point on the giant boulder-strewn sandbar. Any lens that was longer excluded either the cliff top or the boulder field, and I definitely wanted both.

If you try alternately covering the top and then the bottom of the picture, you'll see why. The cliff alone is interesting, but it is not a complete scenic. And with the top covered, you can't see the convoluted edge or the contrasting blue sky.

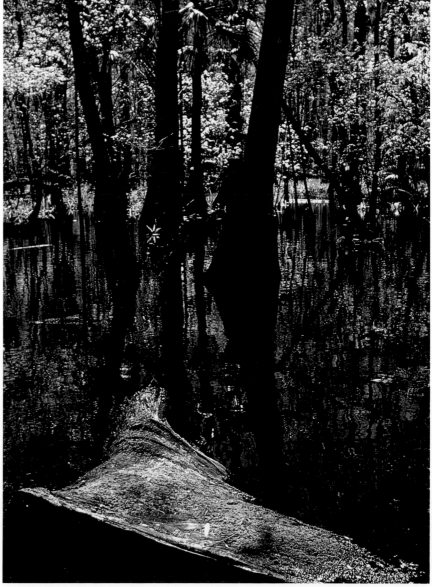

I chose a 35mm lens to make the lower right picture of the Oklawaha river swamp in Florida because it gave me the relationship I wanted between the background trees and the partly submerged fallen log in the foreground. I didn't have anything like unlimited mobility because I was wading in the swamp itself. I could have used a wider-angle lens to come closer, or I could have backed off and tried to get all the same elements in the picture with a standard lens. But I liked the picture the way I saw it, the way you see it here; so I didn't even attempt to make any variations of it.

Standard: 45–58mm

In the photography press much publicity has been given to the various virtues of all lenses with special focal lengths. There is undue emphasis on unusual images made by wide-angle and telephoto lenses, and on the many problem situations that can be solved by using them. If I depended on what I read for what I know, I would think I could dispense with my standard lens altogether and never miss it. Fortunately, what I know comes more from what I have done than from conventional photographic reading; therefore, I strongly believe my standard 55mm lens is the most useful I have. Because mine is a macro lens, it offers much closer focusing than most standard lenses. (I discuss macro lenses later in this chapter.)

The 55mm lens is probably one of the most versatile, and it is too often ignored in favor of more special optics. I deplore the general preoccupation with equipment, and I try to teach my students to work with a minimum of different lenses. Many amateurs believe that buying a special lens makes it possible to get all sorts of great pictures. In fact, it doesn't help a bit. Until they learn to take good pictures with the lens they have, they won't be able to make great pictures with a lens of a different focal length, either.

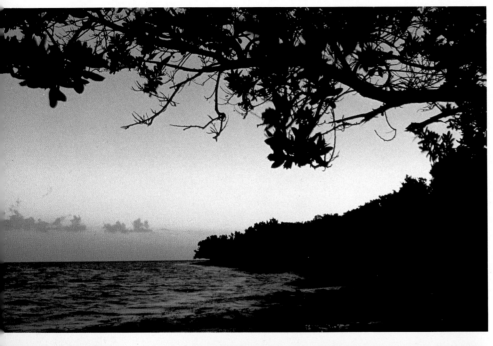

On Florida's Ligumvitae Key, my 55mm lens was the best choice for taking pictures of the island's one rocky shore at dawn. The terrain limited my movement: a few feet to the right, I was back in the dense jungle growth; a few feet to the left, I was in the water; a few feet forward, I didn't have the trees as a frame, and if I used a wide-angle, the background was too small; a few feet backward, I was stuck in the ooze of a mangrove swamp.

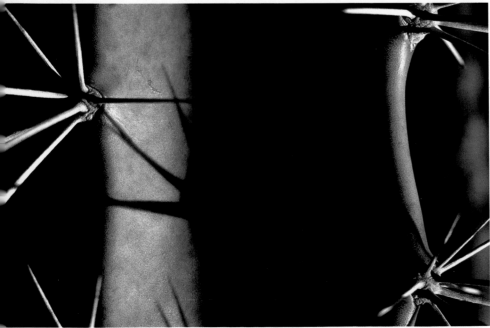

Lignumvitae Key is comprised of many plant communities, including a dry, sandy, inland stretch populated with prickly pear and night-blooming cereus, which are both spined, cactuslike plants. This dramatic close-up of plant spines was made with my 55mm macro lens.

Short Telephoto: 90–105mm

My lens in this range is a 105mm, and I use it a lot. For landscapes it is much more useful than my longer telephotos. With them I may seize a significant detail within the larger scene, but with the 105mm lens I can make a larger range of pictures including overviews that represent the whole scene.

The smaller telephoto lenses are still short enough to be very versatile and are regularly useful for many different subjects. I take a lot of flower photographs with mine, sometimes using an extension tube if I want to focus closer than the lens itself permits. Many short telephotos are available as macro lenses. My newest lens is a 105mm macro, and I am still exploring its potential.

I stood on the rim of Canyon de Chelly National Monument in Arizona to take this autumn picture. Including more than a sliver of sky confused the composition. Only the 105mm lens showed the dry river bed in good juxtaposition to the sweeping curves of the canyon walls, and to the textures in the foliage and shadow.

Short telephotos are wonderful for close-ups with such subjects as the flowers below. I focused them as closely as possible without adding any extension tube to my 105mm lens. The exposure was 1/250 sec. at f/4 on Kodachrome 64 film.

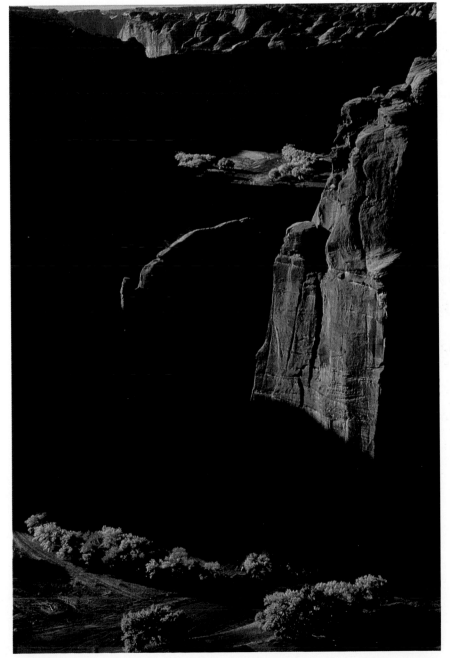

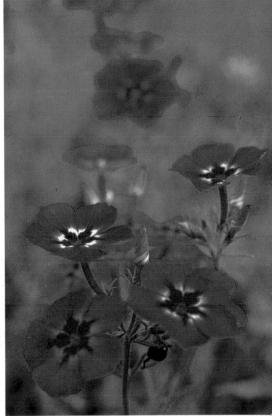

Medium Telephoto: 135–250mm

I use my medium telephoto lenses for details within a scene more than for overall landscapes, but there are photographers who use them almost exclusively to shoot "landscapes from a distance" and who rarely, if ever, shoot with the wider-angle lenses I prefer. Focal-length preference is a powerful tool in your stylistic arsenal, and just because any photographer usually employs a lens in a certain way doesn't mean you should.

Before I bought a 70–210mm zoom lens, the only medium-telephoto focal length I had was a 200mm lens. I relied heavily on my 105mm lens and my 300mm, so my 200mm saw relatively little action.

With the medium-telephoto lenses, depth of field becomes an important consideration. The limited depth of field can be a problem. For instance, the depth of field marked on my 200mm lens extends only from infinity to 80 feet when the lens is stopped down to its minimum aperture of f/22. In bright sunshine at this aperture Kodachrome 64 requires an exposure time of 1/30 sec., and generally this is too long to hand-hold a camera with such a long lens without exposing camera shake.

Whenever possible, I prefer to use a tripod for shooting inanimate subjects. I hand-hold a camera only when I can't get it mounted on a tripod in the exact position I need for the exact angle I want. For example, although my tripod goes down very low, it doesn't really go to ground level. For ground level pictures I often put the camera right on the ground, propping it to the angle I want with a solid object, maybe an extension tube. Or I turn my body into a solid support for the camera by lying flat on the ground on my stomach with my elbows extended. Any posture enabling me to hold the camera steadier is an improvement when I'm not able to use my tripod.

I choose lenses primarily for the perspective they bring to the subject. I won't switch lenses simply because a low-light level requires a longer exposure time. Because I choose to use a tripod at all times and even like the effects rendered by long exposures of such moving subjects as water and foliage, it doesn't usually occur to me to change lenses for a wider aperture.

Long Telephoto: 300–400mm

Although I use my 300mm and 400mm primarily to photograph animals and birds, I also use them for scenics. I use them to get pictures of distant subjects that I can't approach, such as this mountain shrouded with blowing snow. I also use them for a flattened perspective, as with this pattern of day lilies growing in a roadside ditch.

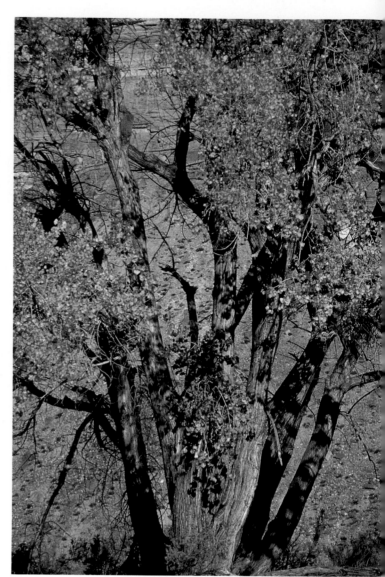

By the Green River in Utah I cropped in on the cottonwood tree with autumn foliage shown above, using a 200mm lens to emphasize the contrasting textures of its leaves and the wall of Desolation Canyon behind it.

The perspective in the top right picture of a furious mountain snowstorm was only available from a roadside scenic turnoff in southern Utah. The scene was not visible farther down the road or above this vantage point. A 300mm lens framed it perfectly, and the exposure was 1/125 sec. between f/11 and f/16 on Kodachrome 64.

To get the flattened look in the bottom right picture, I shot this roadside hill from the opposite side of the pavement using a 300mm lens. The flowers at the top of the picture were really about eight feet behind those at the bottom, yet they all appear to be on the same plane.

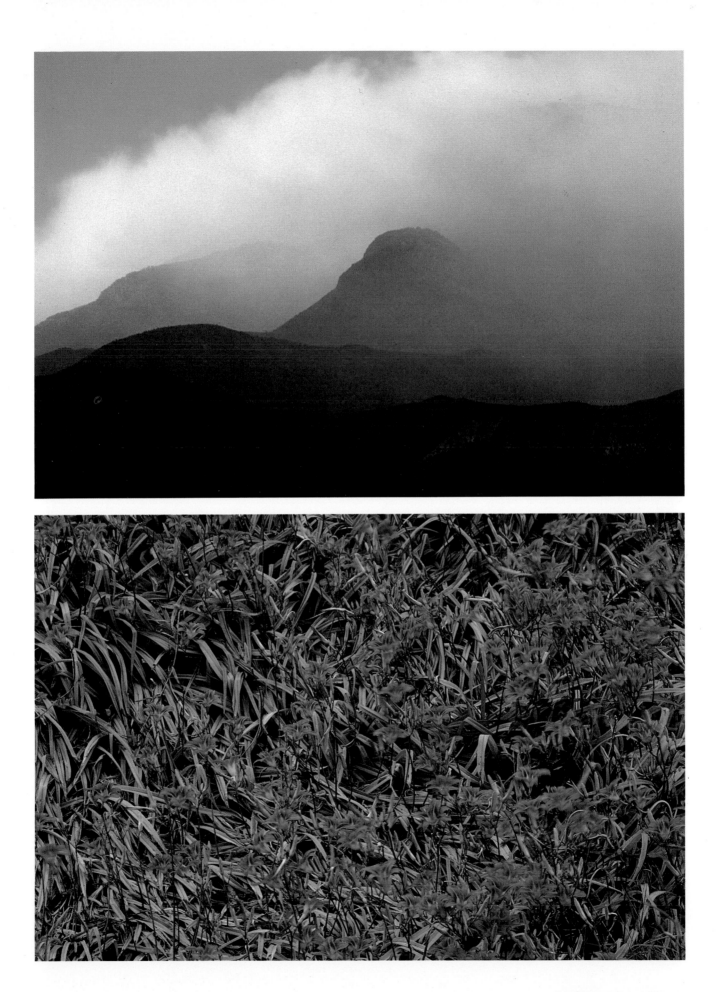

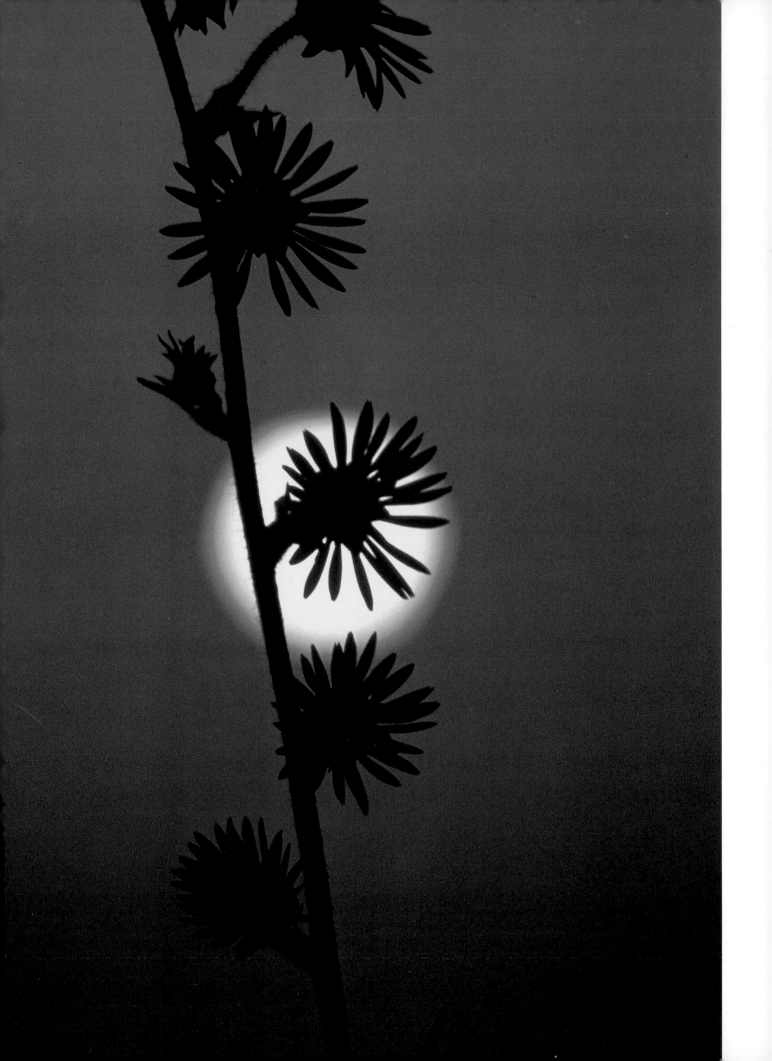

In the pictures above, the out-of-focus highlights are shaped like donuts, which is an optical effect characteristic of mirror, or catidioptric, lenses. The top picture is of a bladderwort growing in the Okefenokee swamp. Notice that the in-focus blossom looks very sharp, whereas the out-of-focus root structure to the right exhibits the donut-shaped, specular highlights. The bottom picture of flowers called shooting stars was taken at Hayden Prairie, a state prairie preserve in Iowa. Again, the foreground looks sharp, and the out-of-focus blossoms are abstracted by the mirror lens.

I like the effect that a long telephoto lens has on an out-of-focus sun image. In the picture on the left, this effect creates a dramatic impact in what would otherwise be a very dull composition.

I almost always use at least a 300mm lens for sunsets and sunrises just to get a good-sized image of the sun. The size of the sun in a picture depends to some extent on atmospheric conditions, but it also depends on how close the lens is focused. If the focus is on a foreground subject and you are using a wide aperture, as in the picture to the left, the out-of-focus sun gets much bigger than it would be if you were focused at infinity.

The longer the lens, the more important it is that it be firmly supported, but don't avoid making long-lens scenics because you don't have a tripod or other means of making your camera rock-steady. Just use the fastest shutter speed possible. Also, the closer your subject is, the higher the speed that you should use will be. The rule for hand holding is to use a shutter speed at least as fast as the reciprocal of the focal length. For a 300mm lens you should shoot at least at 1/250 sec., and better at 1/500 sec. Don't forget that at long focal lengths, camera shake is magnified along with the subject matter.

I cannot emphasize too strongly that long lenses are not miracle makers. Optical laws are clear and rigid, and there are no miracles working inside them. A subject's image size depends on camera-to-subject distance as well as lens focal length. Novice photographers tend to disregard the former when thinking about long lenses and, unfortunately, even when using them.

Super-Long Telephoto: 500mm and Longer
The very longest lens I normally use for scenics is my 500mm mirror lens. I use it because I like its odd optical effects, or I use it for large sun images. Sometimes I even attach a 2X teleconverter to get even bigger suns. I rarely use this lens or my 640mm Novoflex lens if I can get closer to the subject to use a shorter focal length.

With very long lenses your depth of field is so limited that you don't even have to think about it much. It never extends more than a few inches or feet beyond the point of sharp focus, so I tend to use my 640mm at an aperture of about $f/11$, even though it stops down to $f/45$. Getting the fastest shutter speed I can is important for minimizing camera shake, but at $f/11$ the shutter speed can't be very high, even in bright sun, with the Kodachrome 64 film I prefer.

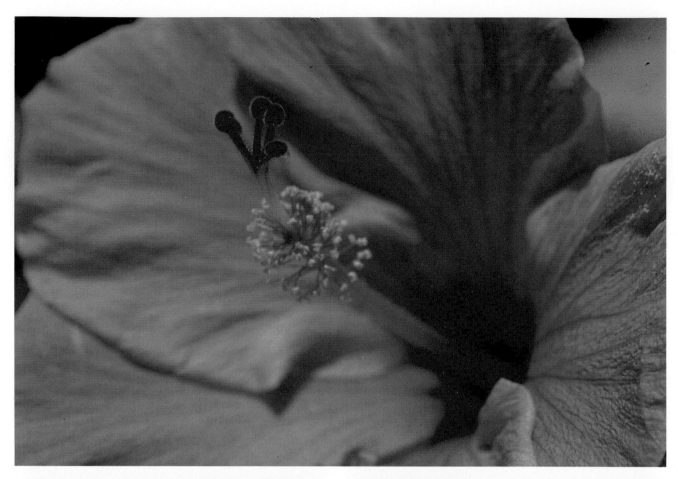

Depth of field is shallow when you work close-up. To shoot the top picture of this hibiscus, I stopped my lens all the way down to f/32. For the greater magnification in the bottom pictures I refrained from attempting to get any depth and shot at f/4. I used a 105mm macro lens for all of them, and the film was Kodachrome 64.

Many of the longest telephoto lenses are mirror, or catadioptric, lenses. These contain mirrors that bounce the image back and forth inside the lens barrel, thereby dramatically reducing the need for a physically long lens barrel to amplify the image. The physical length of these mirror lenses is much less than their long focal length would indicate, as you can see in pictures comparing the 400mm telephoto and the 500mm mirror lenses.

Mirror lenses have fixed apertures. For 500mm lenses the aperture is $f/8$. For 1000mm lenses it is usually $f/11$. Out-of-focus parts of the picture's foreground or background have an odd, fluttery look when shot with mirror lenses. However, when the subject matter is all on one plane, images made with mirror lenses are indistinguishable from pictures made with conventional optics.

Macro Lenses

A macro lens is a wonderful tool, permitting continuous focusing from infinity to one-half life-size or even to life-size. It provides excellent image quality focused at infinity and at close-up distances. However, compared to regular lenses, macro lenses are expensive; they also always have a smaller maximum aperture than a regular lens of comparable focal length. While a standard 50mm lens usually has a maximum aperture of at least $f/2$, most 50mm macro lenses have apertures of $f/3.5$. For a 50mm macro lens, $f/2.8$ is considered fast.

If you are starting out with a new camera system, I suggest you consider buying macro lenses rather than the regular standard and short telephoto lenses. In addition to the standard 50mm or 55mm macro lenses, camera makers and independent manufacturers make macro lenses in focal lengths of 90mm, 100mm, or 200mm. The initial cost of buying macro lenses will be substantially greater, but as far as I am concerned the long-term convenience is well worth it.

Zoom Lenses

From most photographers' point of view, probably the most important advances in optical design have been made in the area of the so-called macro-zoom lenses. These zooms allow you to focus close-up; thus, they not only replace a whole range of fixed-focal-length lenses, but take the place of special close-up lenses as well.

The maximum magnification that most macro zooms permit is 1:4, one-quarter life-size. Nevertheless, they can be useful in the field, especially when you can't carry a lot of gear or have to work fast.

In order to design these lenses to perform several jobs reasonably well and at a reasonable cost, their optical designers had to make numerous compromises in image quality. You'll find that each type of macro-zoom lens performs differently. For example, a wide-angle-to-telephoto zoom may exhibit noticeable distortion at the extreme wide-angle setting, but it may work very well at or near the telephoto setting. Similarly, different models of macro-zoom lenses will produce varying results at their close-up settings ranging from mediocre to very good.

Different macro zooms function differently at the close-up setting. For example, some lenses will only let you use the close-up setting when the lens is set to its shortest focal length. Others let you focus close-up at all focal lengths. With these you can set up your lens for the right magnification and subject distance, then focus by "zooming" until the image is sharp.

If your macro-zoom lens doesn't provide enough magnification, you can use extension tubes or even bellows for additional magnification. For extreme close-ups, though, remember that macro zooms aren't necessarily better than standard camera lenses.

True Macro Lenses

The type of lens that technically qualifies for the name "macro" is actually a short-focus lens. These lenses are designed specifically for macrophotography, which means images larger than life-size. Because they have no focusing helicoids, they must be used with a bellows. Also, they don't have automatic diaphragms. Many of these lenses have short focal lengths, such as 21mm, so that high magnifications are possible without a great deal of bellows extension. These short-focus macro lenses aren't designed to produce good results when focused at infinity; instead, they are designed for best results at shorter distances.

If you have a good enlarging lens and have a way to attach it to your bellows, you may find that it works very well for close-ups. After all, enlarging lenses are designed for flat-field work at magnifications typically encountered in macrophotography.

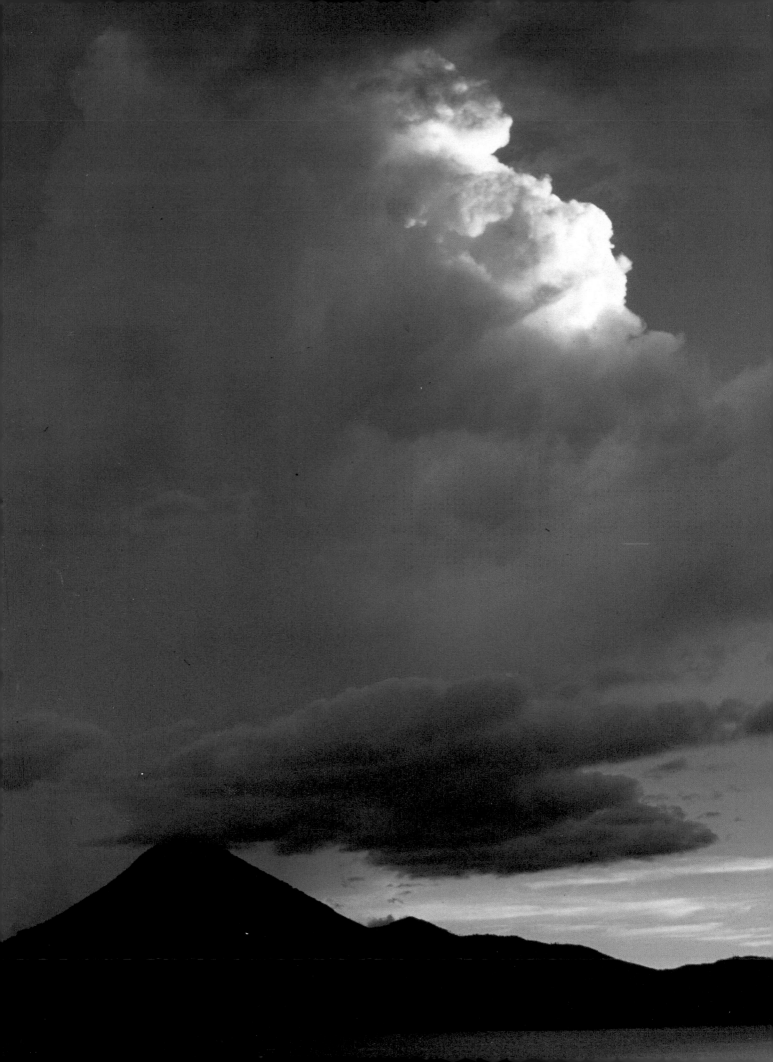

LIGHT BASICS AND EXPOSURE

Sunny, midday skies rarely make the best scenics, but storm light is great for shooting skies and dramatic landscapes. Here in Guatemala the storm was breaking up and showing patches of brilliant sky beyond. The exposure was 1/125 sec. at ƒ/8 on Kodachrome 64, using a 70–200mm zoom lens at 200mm.

To capture such a picture you have to be willing to hang outdoors through hours or sometimes days of unphotogenic weather. In remote locations you usually have no weather predictions to guide you. Even in the United States, predictions are not necessarily accurate.

In the field it is often the light as much as a picture's subject matter that interests me. Arrested by dramatic storm light, I will search the scene for possible subjects. In practice I don't usually think of light in terms of its scientific definitions. Sometimes I describe it in emotional terms—the day is *luminous* as a fog disperses and the sun breaks through it. Or the light is *ominous* when the sun shines through a break in heavy storm clouds. Illumination is *dramatic* when the sun rides low along the horizon in a clear sky, casting long shadows.

Even so, I do understand the facts of light, and I urge you to learn them also if you want to work effectively. A grounding in the basic characteristics of natural light and what to look for in it will be as important to your nature pictures as learning to understand and compose the visual components of your subject. A short study of light and a few field experiments will put the fundamentals you need into your unconscious photographic vocabulary, allowing you to respond to any outdoor lighting situation appropriately and automatically.

Because lighting is so important I mention it throughout the book whenever its contribution to a picture is significant. In chapter 5, I consider unusual types of light, including light commonly associated with different kinds of weather and at different times of day. In this chapter you'll find a definition of the terms used later to discuss light as well as some facts you should keep in mind about light, lighting, and getting the best exposure.

Light Is All Important

How every picture's subject appears is determined by the light in which you see and photograph it. There are two ways to think about light for photographic purposes. You should be able to analyze the light that falls on the subject, which is called *incident light*, and you should also be aware of the characteristics of the light reflected from the subject, which is called *reflected light*.

Light's *intensity* means the amount of light reaching a subject. This is the aspect of light most important to exposure, and this is what you measure with an incident-light meter. Light intensity and subject reflectivity (the latter is discussed later in this chapter) determine the shutter speed and aperture combinations that will produce the correct negative or transparency density for film of a given speed.

Even outdoors you can sometimes control the natural light falling on your subject. For example, to make a close-up picture of a flower you could use translucent cloth or plastic to diffuse direct sunlight before it hits the blossom. In some outdoor pictures you may want to use electronic flash rather than relying on existing daylight. You can also employ reflectors, which are usually used to direct light into shadow areas to give them stronger details.

Light Sources

In nature photography your most important light source is the sun. On cloudless days the sun itself provides most of the illumination in brightly lit areas, but it is not the immediate source of all light falling on a subject. Other phenomena reflect sunlight, too, and contribute significantly to lighting your subjects.

The sky is the second major light source outdoors. The particles of water vapor and dust in the atmosphere bounce light back and forth, sending skylight into sunlit areas and into shadows. Skylight is the main illuminator of shadow areas, but the environment also reflects light that contributes proportionally more to lighting shadows than it does to areas directly lit by the sun. Skylight and environmental light are ubiquitous and nondirectional. Together they constitute *ambient* outdoor light. Without this atmospheric and environmental reflection

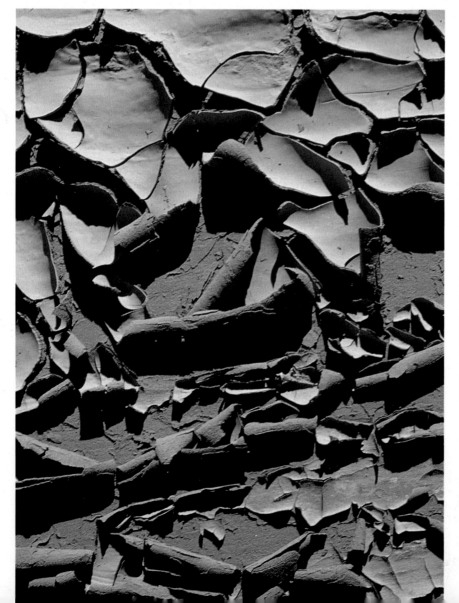

The dried mud pictured on the left was actually all the same tone. The contrast you see comes from hard, high, direct sunlight casting shadows made by the convoluted curls of mud. The exposure was 1/125 sec. between *f*/11 and *f*/16 on Kodachrome 64, using a 55mm macro lens.

Although this flower picture was also made in high, bright sun, subject contrast accounts for the tonal differences between the white water lily and the black water. The water was stained by tannin that had dissolved from trees, which is common in southern swamps. The exposure was 1/125 sec. at *f*/16 on Kodachrome 64, using a 55mm macro lens.

of light, shadows would be black and unilluminated, and photographs would have much more contrast than they do.

The sky is the main light source for subjects in open shade on sunny days and on overcast days, not direct sunlight. Blue sunny-day skies give the shadows in pictures taken in open shade a characteristic blue tint. On overcast days the great dome of the gray sky is the light source. The clouds act as a giant diffuser, diminishing both light intensity and contrast. There are different degrees of overcast and correlated degrees of diffusion.

The size of the light source also affects the quality of your pictures. Small sources, such as the sun on clear days, cast sharp-edged shadows. Light from small sources is called *hard, harsh*, or *specular*. Large sources, such as an overcast sky, cast shadows that are much less clearly defined or, if the overcast is heavy, no shadows at all. This kind of light is called *soft*. Clouds diffuse light, scattering it in every direction, and in addition they greatly increase the light source's size. (When you work close-up to a small subject with such a tiny source as a cigarette-sized flash unit, the light it provides in the picture will be soft and diffused because given the subject's size, the light is a relatively large source.)

Light Contrast

Light contrast varies with the weather, the time of day, and altitude. On overcast days clouds diminish contrast by reducing the amount of direct sunlight reaching the subject. At higher altitudes contrast is greater than at lower ones. There is less atmosphere higher up, and there are fewer dust particles and water molecules to scatter the short blue rays. In pictures taken at high altitudes, the shadows are much darker relative to the highlights.

Lighting contrast is a comparison or ratio of the intensities of light falling on the fully lit and on the shaded parts of the subject. To determine lighting contrast you must measure the light falling on the fully lit areas with an incident-light meter (or with a reflected-light meter using the substitute method described later in this chapter.) Then you measure the light falling on the shaded part of the subject. The difference you get will be in stops.

Light contrast is usually expressed as a ratio and is called a *light ratio*. Light ratios are important because color films can't record great differences in contrast. A one-stop difference is the same as 1:2, a two-stop difference is 1:4, a three-stop difference is 1:8, a four-stop difference is 1:16, and a five-stop difference is 1:32. A 1:32 light ratio means that the brightest element in the picture is thirty-two times

These two pictures of a wild flower called prairie smoke demonstrate clearly how dramatic the differences made by light quality and light direction can be. First I made an exposure with the sun at my back and the blue sky behind the flowers. Next I walked 180° around the flowers to photograph them backlit.

brighter than the darkest element. The clearer the day, the greater the contrast between the brightly lit and shaded parts of a subject. At times there may be a five-stop or even greater difference between those areas lit by direct sun and those in shade.

Light Direction

Light always has direction, whether it comes from specular or diffuse light sources. It is important to be aware of light direction because it reveals form and texture, and it also creates contrast.

The angle formed by the lens-to-subject axis and the light-source-to-subject axis is called the *angle of incidence*, which is used to describe light direction. If you work indoors in a studio, you can move the lights or the subject to change the angle of incidence. When you work outdoors in natural light, you can only change the angle of incidence by changing camera position or by photographing at a different time of day when the sun is in a different position in the sky.

The height of the sun in the sky creates an ever-changing vertical angle that is as important to light direction as the horizontally based angle of incidence. At noon, the sun is as close to being directly overhead as it ever will be on that day at that location. You will always have a greater angle of incidence at sunrise and sunset when the sun is low and close to the horizon, a time when you can nearly align your vantage point with the light's direction.

Front light on a subject creates a small angle of incidence and is flat, lacking contrast. It is probably the least effective kind of light for revealing form or showing texture. Side light can be either hard or soft and reveals the maximum degree of texture and form. Back light is very contrasty and is most effective with such translucent subject matter as leaves or flowers. Backlighting can be used to create a rimlight effect that outlines a subject's shape.

The Color of Light

Visible light is part of the electromagnetic spectrum, which also includes such familiar radiations as radio waves, microwaves, heat or infra-red waves,

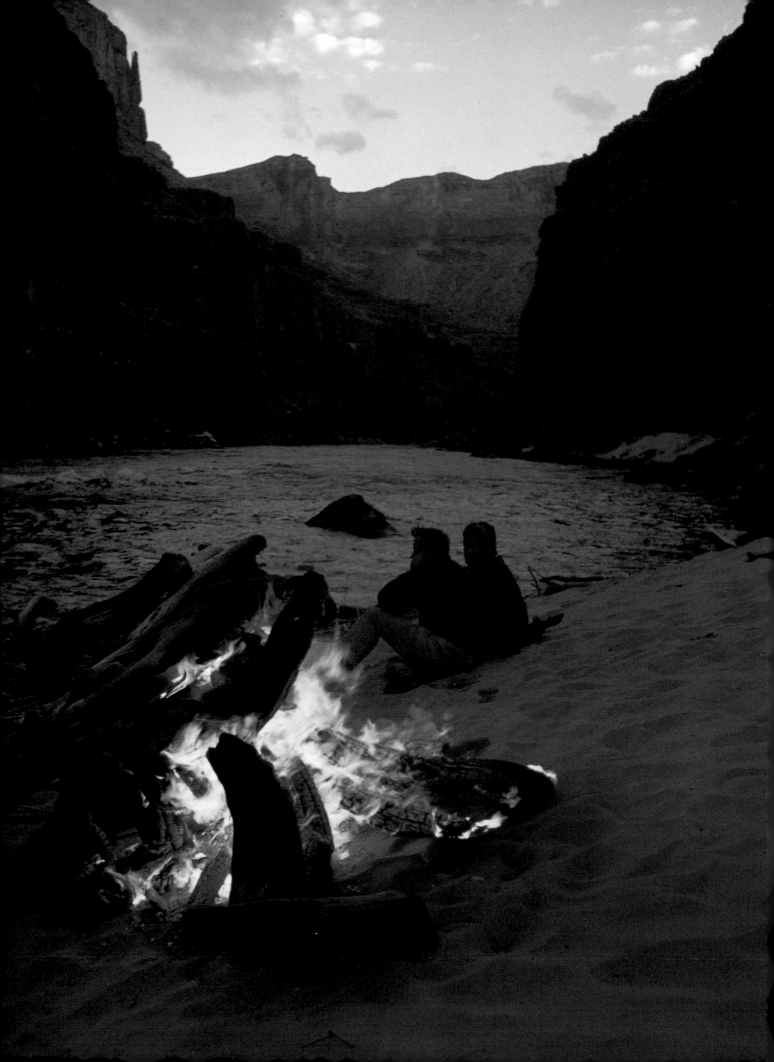

x-rays, and cosmic rays. Different kinds and colors of light waves are defined by their different wavelengths. We see midday light on a bright sunny day as being white light, and our daylight color films are balanced for this midday light. White light consists of practically equal amounts of red, green, and blue light. All the other colors in the light spectrum are made by mixing these three colors in various proportions.

The color of light is usually expressed in units of color temperature. Color temperature is measured in degrees Kelvin or K. The Kelvin scale starts at absolute zero, which is −273 C. Color temperature indicates different proportions of red and blue light and assumes a constant proportion of green in all light.

A high color temperature indicates cool, bluish illumination, or light with relatively more blue wavelengths than red and green. The color of daylight—direct sunlight plus skylight—midday on a sunny day is 5400K. The color temperature of skylight alone is extremely high, about 22,000K. A low color temperature indicates warm, reddish light, with relatively more red wavelengths than blue. The color temperature of tungsten light—photoflood bulbs—is about 3200K. Indoor color films are manufactured to produce normal-looking results when exposed by tungsten lights.

The color temperature of natural daylight varies with different times of day and different types of weather. For all practical purposes, midday's white light persists throughout the day, from a few hours after sunrise until a few hours before sunset as long as the sun is shining. When a cloud obscures the sun, scenes are illuminated by light from the blue sky, and that light is much bluer than midday light. Just after dawn and just before dusk the light is warmer or redder.

AVERAGE COLOR TEMPERATURES OF NATURAL LIGHT	
Midday sunlight alone	5000K
Midday sunlight plus light from a clear blue sky	5500K
Daylight (sunlight + skylight) before 9 AM and after 3 PM	4800K–5100K
Daylight, slight overcast or air pollution	5800K
Daylight, substantial haze or air pollution	6000K–6400K
Daylight, complete overcast	6500K
Skylight from blue sky	12,000K–27,000K

You can increase your sensitivity to the color of many different kinds of light by practicing your awareness to it in any location. Don't wait to practice until you are out picture taking—do it anytime, anyplace, indoors or out, on any day. Particularly noteworthy is the warm yellow look of tungsten light turned on in daytime in a room also lit by natural daylight. The color difference is startling if you compare the two different kinds of light in juxtaposition. Yet in a dark room at night, or in the interior of a building, tungsten illumination looks normal and white, not noticeably yellow or reddish.

The chart to the left gives some average color temperatures for different mixes of sun and skylight at different times of day, different times of year, and in different weather. I carry an approximation of this chart in my head and am reasonably good at recognizing the color illumination, having been aware for so long of how daylight's color changes under different conditions. I also know from experience that in some conditions what I see, or think I see, may not be what my color film will record, especially in very low light levels.

Subject Brightness and Reflectivity

The light reflected from your subject is, in fact, the same thing as your subject matter because it is what your camera records. The brightness of this reflected light is what you measure with reflected-light meters, whether they are built into your camera or are separate devices.

The characteristics of reflected light depend both on the incident light falling on the subject and on the nature of the subject's surface. Different types of surfaces reflect light differently: smooth shiny surfaces produce specular reflections; matte surfaces produce diffuse reflections. All surfaces absorb

The color temperature of light varies with the source. Here in one picture you can see the contrast between the low, reddish hues of the campfire and the cold, blue color of the skylight that illuminates the scene overall. This picture was taken after the sun had set behind a canyon wall. I took an overall light reading with a reflected-light meter, and this exposure was also perfect for the campfire—1/15 sec. at f/8 on Kodachrome 25. The lens was 35mm in focal length, and the camera was on a tripod.

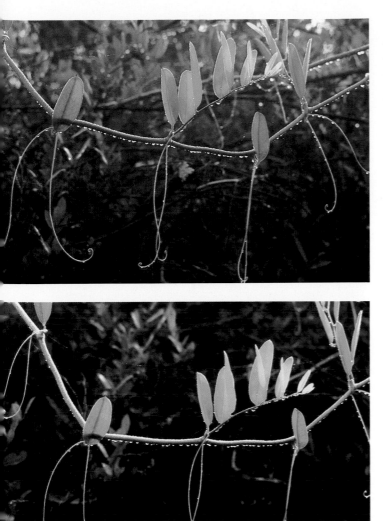

some light. Surfaces we call "pure white" reflect about 90 percent of the light striking them, still absorbing about 10 percent of it. A matte black surface reflects only a few percent of the light, absorbing most of it.

The subject-brightness range describes a subject's range of contrast under given lighting, and it has two variables: the light ratio or the contrast rendered by the incident light, and the subject reflectivity range or the reflectance of different parts of the subject. Most scenes have great brightness ranges, much greater than can be recorded on color film, even though you can see detail in both the brightest and darkest areas.

I took reflected light meter readings from a white sheet of paper in bright sun, in open shade, and in deep shade under a tree. For ISO 64 film, the exposures indicated were 1/125 sec. at $f/22$, at $f/5.6$, and at $f/2$, or a total of seven stops difference. Taking readings from a sheet of black paper in the same lightings, I got readings of 1/125 sec. at $f/5.6$, at $f/1.4$, and 1/8 sec. at $f/1.4$, another difference of seven stops. The difference between the exposures for the white paper in the sun and the black paper in the shade is eleven stops.

Subject Color

The reason objects appear colored is that they reflect some of the wavelengths in incident light and absorb others. Objects look white when they reflect all the wavelengths in white light equally. They look black when they absorb all the wavelengths equally. They look red when they reflect the short red wavelengths, absorbing blue and green. They look blue when they reflect blue wavelengths, absorbing red and green. They look green when they reflect green wavelengths, absorbing red and blue.

The other colors come from mixtures of various wavelengths. Yellow objects reflect equal amounts of red light and green light. Purple objects reflect equal amounts of red light and blue light. All the colors that you see illuminated by white light result from selective absorption of one or more of the light's wavelengths. Naturally, the colors reflected depend on what colors are present in the light source and on the absorption and reflectance characteristics of the subject. A red object, for instance, looks black in green light.

Film Facts

Films can record a limited number of subject-brightness ranges. A film's exposure range indicates this range of subject brightnesses or exposure levels. The exposure ranges of color films are set by the film's manufacturer. Standard processing produces

The difference between the two pictures above is solely the result of the way they were exposed. I exposed the top picture at $f/5.6$ for 1/60 sec., as indicated by a TTL reflected-light reading. I exposed the bottom picture according to the sunny $f/16$ rule (described on page 45), rendering detail in only the highlights, and reducing the cluttered shadow area to black. The lens was a 105mm, and the film was Kodachrome 64.

The color tinting the white flower on the left came from light reflected from red canyon walls in Colorado. The light source itself—skylight and direct sunlight—was considerably colder and more blue. This kind of reflected light is known as environmental light. The exposure was 1/60 sec. at $f/5.6$ on Kodachrome 64, using a 20mm lens.

a fixed density range in film when your subject has an average brightness range of about five-to-seven stops between the darkest shadows containing detail and the lightest detailed highlights. With color negative films the exposure range is about five stops. (Although it's not within the scope of this book to explain, you should be aware that you can increase or decrease the exposure range of black-and-white films by controlling their exposure and development.)

The limitations imposed by a film's exposure range make it essential for you to understand light contrast and subject reflectivity. Otherwise, you won't be able to make intelligent exposure choices, especially with transparency films. When your subject's lighting contrast is greater than a film can record (and this is often the case) you must decide if you prefer burned-out highlights and visible shadow detail or the reverse, or even if you prefer burned-out highlights and black shadows with a full coverage of the scene's middle tones.

A film's limited exposure range is not necessarily a disadvantage. If you understand the limitation as it pertains to different subjects, you can make it work for you, rather than being its victim. For example, I often compose effective pictures by isolating brightly-lit main subjects against black backgrounds, creating the black from the low lighting involved rather than by using a solid background. In these situations I purposely expose my film to render shadows black, thereby eliminating the obvious clutter that would otherwise be visually apparent in those shadows.

Although a subject with a greater-than-average brightness range presents one type of exposure problem, when a subject has a significantly less-than-average brightness range, another kind of problem exists. There are different ground rules for what constitutes correct exposure of negative film and of positive, or transparency, films. Negative films have more exposure latitude. One way they display this latitude is during the printing process, where highlights can still be recorded even though they are technically overexposed. With negative films you want an exposure that will record shadow detail even if this means overexposing the highlights in contrasty light situations. With positive films exposures should record highlight detail, even if that means some of the shadows record as solid black. (For further information on film, see the section on film in the appendix.)

Exposure Meters

The exposure meter built into your camera doesn't measure exposures—it measures light as do all

similar, separate devices available at any cost. All exposure meters give you light readings, and although these read out in exposures, these exposures must be interpreted—and sometimes altered—by you.

Shutter speeds and designated apertures progress in stops. Each stop admits half as much light as the one preceding it. Referring to shutter speeds, one stop less means the shutter is open for half as long. Referring to aperture, one stop less means the lens opening admitting the light is half as large. In the case of shutter speeds, 1/60 sec. is obviously half as long as 1/30 sec. and 1/125 sec. is approximately half as long as 1/60 sec., but the *f*-stop numbers used to designate aperture size are not so obvious in relation to each other, although they function in the same way.

For average- or middle-toned subjects, you can follow an exposure meter's suggested exposures to obtain standard results. For subjects that are lighter or darker than a middle tone, you may want to deviate from your meter's exposure recommendations—there are many creative reasons for making a different exposure.

What is a middle tone? Technically, it is a gray card with 18-percent reflectance. Gray cards manufactured by Eastman Kodak and others are available from your photographic dealer. In practice, a middle tone is green grass, and it is blue sky midday on a bright sunny day about 90° from the sun's position. Some gray or colored tree trunks are middle toned, as are some gray or colored rocks, some gray or colored gadget bags, and some denim washed until it has faded to the right tone. However, because there are a great variety of tree trunks, rocks, gadget bags, and jeans, it is best to stick to measuring middle tones with grass, the sky, or an 18-percent gray card.

There are two types of exposure meters: incident-light meters, which measure the light falling on the subject, and reflected-light meters, which measure the light reflected from the subject. Exposure meters built into cameras are reflected-light meters. You can get good exposures with either type of meter, as long as you remember that exposure readings should be interpreted, rather than followed slavishly.

How to Use Incident-Light Meters

In my opinion, it is easier for a beginner to use an incident-light meter correctly than to use a reflected-light meter. To use an incident light meter you generally stand at your subject's position and point the meter at your camera's position, and unless your subject is much lighter or darker than average, you expose your film as indicated by the meter for a

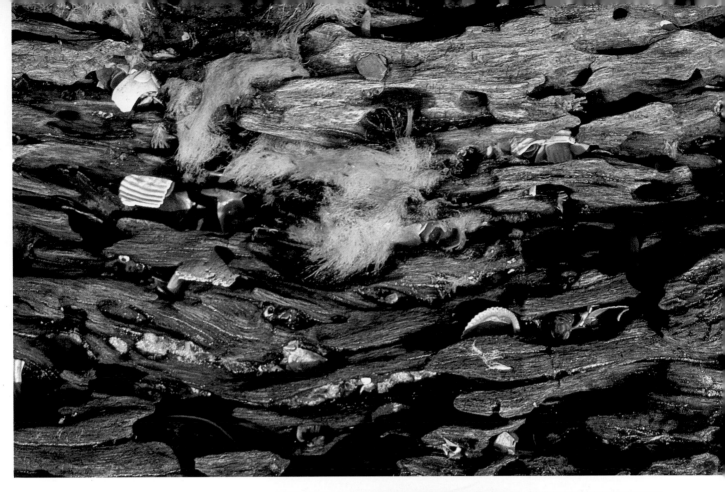

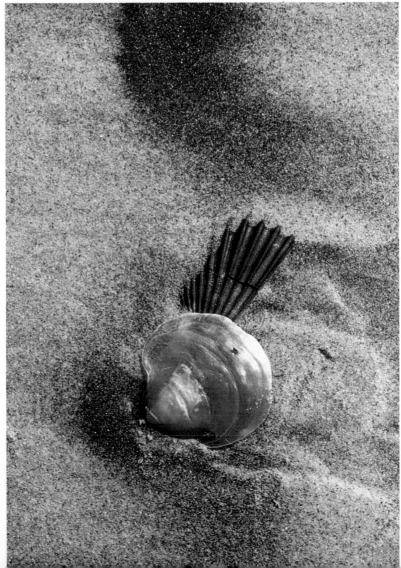

Here's an example of how and why I
deviated from my meters' recom-
mended exposures for two subjects,
one lighter than middle toned, and one
darker. I photographed both at a beach
illuminated by bright, midday sun. An
incident-light-meter reading indicated
an exposure of 1/125 sec. at ƒ/11 on
ISO 64 film for both shots. The re-
flected-light-meter readings indicated
exposures of 1/125 sec. at ƒ/16 for the
shells imbedded in the sand and 1/125
sec. at ƒ/8 for the driftwood. Wanting to
preserve the brilliance of the
shells in the sand, I shot them at 1/125
sec. at an aperture between ƒ/11 and
ƒ/16, which was less exposure than
recommended by the incident-light
meter but more than recommended by
the reflected-light meter. The exposure
for the driftwood was 1/125 sec. at an
aperture between ƒ/8 and ƒ/11, which
was more than indicated by the inci-
dent-light and less than indicated by
my reflected-light meter.

To shoot the top picture, I knew I couldn't rely on a reflected-light reading, so I used the sunny *f*/16 rule and shot at 1/30 sec. at *f*/22 on Kodachrome 64. The sun was very low, almost on the horizon, and the low sunlight hit only the tops of the flowers, leaving the cluttered grassy area surrounding them in deep shadow.

A TTL overall reflected-light-meter reading produced the perfect exposure for this spider web, the dawn, and the dew. The exposure was 1/15 sec. at *f*/8 on Kodachrome 64, using a 105mm lens.

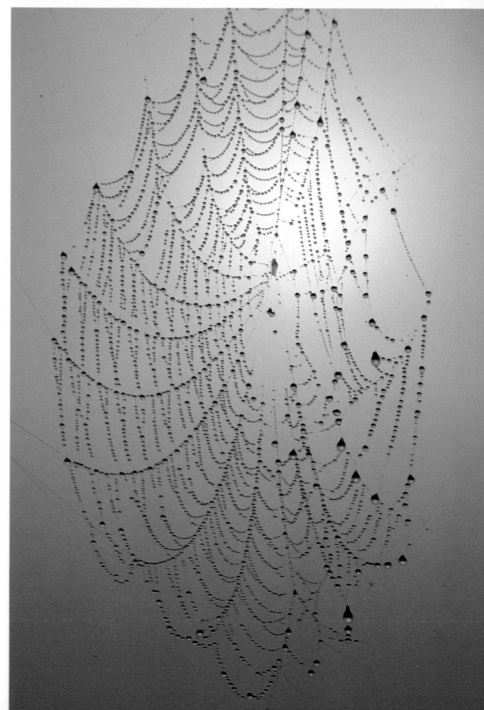

standard exposure. If your subject is much lighter than middle tone, you should give it between one-half and one-and-a-half stops less exposure than recommended. If your subject matter is much darker than middle tone, you will rarely want to give it more exposure than one-half stop beyond whatever is indicated.

Only unusual circumstances will prevent you from going up to an inanimate subject to take an incident-light reading. But if you can't approach the main subject—for example, if you are working with a long lens and a raging river separates you from your subject—and the subject is in different light from that prevailing at your camera's position, you can still take an incident-light reading in any light that is similar to that falling on the main subject. If the main subject is in open shade under a tree and you and your camera are in bright sun, take a light reading under a nearby tree. If that isn't possible, take a light reading in the shadow cast by your own body. Then be sure to bracket your exposures, since it may be darker under the tree than in the shadow you cast.

How to Use Reflected-Light Meters

In one very important way all reflected-light meters resemble one another. No matter what kind of a meter reading you take, in any scene the reflected light-meter assumes you are taking a reading from a middle-toned area. This works out fine if the average represents the scene's true middle tone as seen by the naked eye or if you have chosen to meter a middle tone close-up. But if you have taken your reading from an area lighter or darker than the middle tone you want accurately reproduced, the exposure recommendation will be misleading. A reflected-light reading will also be misleading with subjects that are darker or lighter overall than average scenes.

This difficulty is easily overcome by carrying your own standard tone with you—something you always do, although you probably aren't aware of it. It is the palm of your hand, which is about one stop greater than a middle tone in brightness. You can check your exposure meter's readings by metering your palm in exactly the same light that illuminates your subject, and figuring that your subject should get one stop more exposure than the meter's reading. For example, if exposure for a subject's middle tone is 1/125 sec. at $f/8$, a reading from your palm should indicate an exposure of 1/125 sec. at $f/11$. Take your palm's reading with your lens focused as it will be for the picture—don't focus close-up on your palm. And be careful not to let the exposure meter shadow your hand while you are taking a reading.

Metering Patterns

The reflected-light meters built into cameras have different metering patterns. The most common built-in meter is center-weighted, which means it measures light from the entire picture area but is more sensitive to light from the center of the scene than to light from the edges. Some meters average the brightnesses of different areas within the frame, which is called full-frame averaging. In this system, light from the corners or edges of the frame counts as much as light from the center of the picture; so backgrounds that are much lighter or darker than the main subject can cause exposure problems unless the subject covers most of the frame. A bright sky in a landscape picture can also sufficiently affect a full-frame averaging meter to cause underexposure of the picture's main subject in the darker foreground.

Spot or semi-spot metering systems are incorporated in some cameras. These systems measure the light from a small center area clearly marked in the viewfinder, and they ignore the light coming from other parts of the subject. Spot meters are also available as accessories for those camera systems lacking them in their TTL meters and are particularly useful in situations where you can't come up to your subject to take a close-up reading or readings. With spot meters you can stay in one position away from your subject and still measure its entire brightness range by taking readings from the darkest shadow area to the lightest area where you want to preserve detail. Then you'll know immediately if this brightness range exceeds your film's exposure range and you can accordingly make exposure decisions once you've had some experience.

Until you get that experience, my advice is to bracket your exposures widely and systematically if you are using transparency film, no matter what kind of metering system or technique you employ. In addition to what your meter indicates for each subject lighting situation, give at least one stop more exposure and one stop less exposure throughout many, many rolls of film. In this way you will learn more about lighting and exposure than if you memorize every word written on the subject.

It is important that you know what kind of metering system your camera has, and it should be described in your camera's instruction book. Without this knowledge it is absolutely impossible for you to use your meter intelligently, and if you slavishly follow a built-in meter's recommendations, especially without understanding its pattern, you are guaranteed bad exposures unless all your subjects are overall middle toned.

The Sunny f/16 Rule

You only have to worry about making exposure decisions when you're not in bright sun. In bright sun you don't need a meter—you can use the following sunny f/16 rule: for average-tone subjects, the correct exposure in bright sun is the reciprocal of the film speed at an aperture of f/16. Thus, the exposure for ISO 25 film in bright sun is 1/30 sec. at f/16. The exposure for ISO 64 film is 1/60 sec. at f/16. The exposure for ISO 100 film is 1/125 sec. at f/16.

For such very light subjects as white birds, white flowers, and snow scenes, the sunny f/16 rule becomes the sunny f/22 rule: the correct exposure is the reciprocal of the film speed at f/22. And there is another corollary. For such very dark subjects as driftwood, charred stumps, and black soil, use the sunny f/12.6 rule: the correct exposure is the reciprocal of the film speed at an aperture between f/16 and f/11, or f/12.6.

Memorize the sunny f/16 rule and its f/22 and f/12.6 corollaries. Always check the exposure indicated by your meter readings against it. If there is a conflict, if your meter reading in bright sun deviates from the sunny f/16 rule, make both the indicated exposures. Compare the pictures after processing and analyze the reasons for the difference between your meter's reading and the sunny f/16 estimate. If you are using a reflected-light meter, and if the difference does not come from photographing subjects that were darker or lighter than average, your meter may need adjustment. Neglecting to make this simple checkup produces more badly exposed pictures than any other reason I know.

You cannot always take an overall reflected-light reading and get the right exposure. However, two subjects you *can* meter from for the best results are green grass and blue skies because these are always middle-toned. So for this picture an overall reading would produce a correct exposure. Actually, I used the sunny f/16 rule. The exposure was made at 1/125 sec. at f/11 on Kodachrome 64, using a 55 mm macro lens.

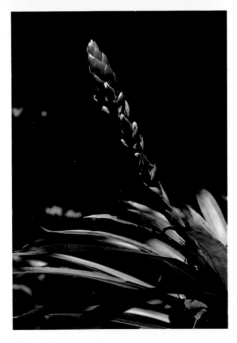

A cloud was covering the sun when I took the top left picture, exposed as recommended by an overall reflected-light reading. I used the same exposure for the next top right picture, taken after the cloud had passed and the sun was shining. The shaded subject areas are about the same as in the preceding frame, but the foliage lit by direct sun is burned out and without tone or detail. The third lower left picture represents a compromise made by exposing two stops more than indicated by the sunny 16 rule. In the last picture I exposed for the highlights.

Can you take good pictures in forests on bright sunny days? You bet. I took this picture of a bromiliad bloom on the bottom left shortly after I shot the sequence of the forest. I came in closer to the flower and chose an angle from which the background was nearly uninterrupted black without spotty, brightly lit patches. I disregarded my meter's readings and based my exposure on the sunny 16 rule.

High Contrast Lighting

As discussed earlier, both negative film and positive transparency film can handle the subject-brightness ranges produced by soft, diffused illumination, but greater lighting contrast introduces exposure problems, particularly with transparency films, and may make composition difficult. Yet many natural light situations involve extremes of light contrast. Locations where most of the sky is blocked usually have very high contrast lighting on overcast days as well as sunny ones. Forests and the deep canyons common in the southwestern United States are good examples of this.

In such high contrast light you must choose which areas of a scene you want to show in the picture. You can expose for the brightly illuminated areas or you can expose for the shadow areas and let the highlights burn out. Or you can arrive at a compromise exposure in which the bright areas are overexposed but still show some detail, and the shaded areas are very dark but also detailed.

High and Low Key

The intensity of illumination does not determine our impressions of subject brightness—the overall tonal balance of the subject does. Subjects that consist primarily of light tones, regardless of how they are illuminated, are suitable for what is called "high key" treatment, or exposure that renders the subject in the lightest, brightest tones possible. Subjects consisting primarily of dark tones seem more suitably rendered in "low key," or the darkest, richest tones possible.

The light intensities prevailing when I took the pictures on this page were the reverse of what you would imagine looking at them. The intensity of the light was much greater in the black picture of the grass than in the picture of the bird, which is a coot, in the fog. Yet my impression of these subjects, which led to my decision about how best to expose for them, was that the grass and black water should be low key, and that coot and mangrove roots in the fog should be high key. My decision was based completely on the preponderant tonality of the subject, which was light in the case of the coot and mangrove and dark for the grass and water.

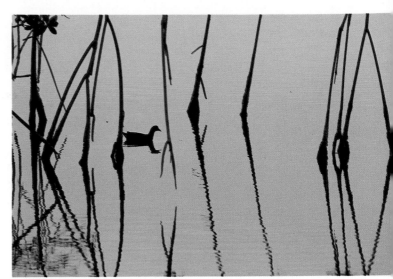

I photographed the top picture of the coot swimming through the mangrove roots early one foggy morning. Although the light intensity was low, my impression of this subject was that the water and the fog should be rendered white. If I had followed my meter the fog and the water would have turned middle gray in the picture; so I gave it it one-and-a-half stops more exposure than indicated.

The bottom subject and its lighting presented an opposite situation from that above. This picture of thin grass blades isolated against dark water was made shortly after dawn on a bright and clear day. The overall tone of the subject matter was very dark. Following my meter reading would have produced burned-out grass against a muddy, middle-brown cluttered background with underwater vegetation; so I gave the shot less exposure than indicated.

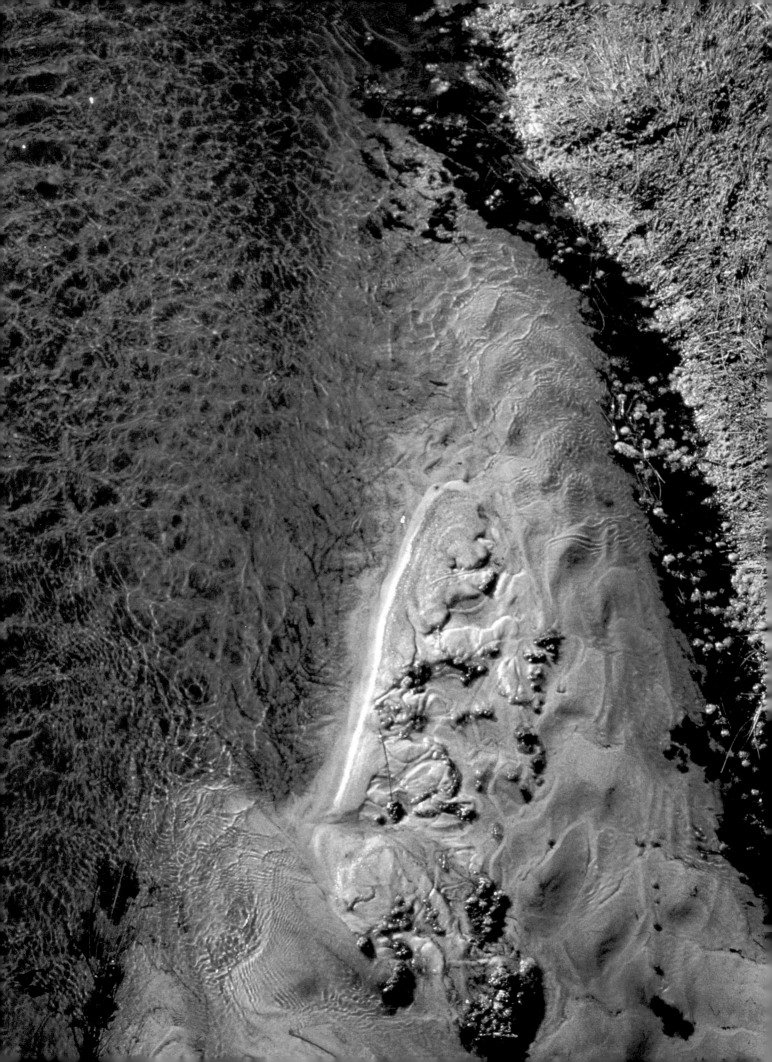

Chapter Three

ANALYZING THE LANDSCAPE

I stood on a bridge and surveyed a creek feeding into Florida's Suwannee river. Before me lay a perfectly standard landscape: cypress trees draped in Spanish moss and sun—dappled water weaving through them. Directly beneath me was a far more unusual and captivating scene showing different depths of tannin-stained water washing over rippled sand. The exposure was 1/125 sec. at ƒ/8 on Kodachrome 64, using a 105mm lens.

Imagine three accomplished nature photographers in the same place, at the same time, with the same assignment. Here is a possible scenario of what they would do.

The first photographer examines the scene, then walks around seemingly at random for a few minutes. Next he begins intently taking pictures. The second photographer also looks around, then hikes away, pausing to scan the horizon or examine some small object nearby. After an hour he finds a worthwhile subject half a mile from where he started. The third photographer looks around briefly and departs. He doesn't like the light and will return at another time of day.

Does the above sound unlikely? Not at all. No two people see the same potential image in the same subject. It's possible, even probable, that our three photographers would be attracted by the same specific subject—for example, an overall landscape, a distant rock formation, or a small flower. Even so, they would probably take completely different pictures of it because they each have developed their own distinctive way of really looking at things.

Looking, and looking *hard*, must precede seeing, or photographic vision. Looking hard is hard work. A giant step in the right direction is learning to analyze the elements that constitute all photographic subjects. The pictures in this chapter are illustrations of different subject elements, not examples of final composition. Some show lines that lead the eye, and others illustrate strong, bold shapes that might capture it. And there are examples of texture and of patterns.

Rarely does a single subject-characteristic account for the strength of a good photograph—usually several interesting characteristics occur in combination. Often what really makes the picture is the kind of deliberate photographic decision about composition discussed in the following chapter. First you need to concentrate on learning to see as the camera sees and on learning what to look for in a subject.

Practice Composing with a Viewing Frame

Experienced photographers can size up a subject's photogenic potential with their unaided eye. For you to see so clearly, the best shortcut in photographic terms is to use a viewing frame. A viewing frame should be small enough to carry with you easily. You can use it anytime, anywhere, not only on your favorite nature subjects. You can use it in your office, on the way to the grocery store, and out the car window (as long as you aren't driving) to frame fleeting landscapes and cityscapes as you pass by them. When I was a beginner, I found a viewing frame easier to use than the camera's own viewfinder.

Viewing frames are simple to make. Cut a hole in a piece of cardboard in the same proportions as the format you use: 2:3 for 35mm, 1:1 for 2¼"-square, and 4:5 for 4 × 5 and 8 × 10 view cameras. The outside dimensions of the cardboard can be 5" × 7" or even smaller. I prefer to use a small frame size: 2" × 3" for 35mm, 2" × 2" for 2¼"-square, 2" × 2½" for 4 × 5 or 8 × 10. How large you make the opening is a matter of personal choice as long as you use the correct proportions.

To use a viewing frame you just sight through it with one eye closed. Hold the frame a few inches from your eye to simulate the effect of a wide-angle lens. Hold the frame at arm's length to see the scene as a long telephoto lens would. With practice you'll find the distance your eye should be from the frame to take in as much of the scene as lenses of different focal lengths would. If you like, you can even use a 35mm or 2¼"-square slide frame for viewing and composing. If you follow the suggestions in this chapter for finding photographs with a viewing frame, you should cut down greatly on the amount of film spent on unsatisfactory pictures.

What are we looking for when we examine subjects for photographic potential? What are we trying to frame as we sight landscapes and scenics through viewing frames? All subjects great and small can be analyzed and broken down into a few elements. At first you should keep these subject elements fresh in your mind as you search for pictures. With practice you'll start looking for them uncon-

sciously and then you'll be well on your way to commanding a powerful visual vocabulary.

The Importance of Shapes

At first, looking for subject shapes takes a lot of effort, but this concentration pays off very shortly in better pictures. Look for objects that strongly shape the horizon line. Examine the details in areas before you at different distances. Look carefully for objects close by. Look up. Look down. And be sure to stop when you do all this looking—don't walk and look. An amazing amount of your attention outdoors will be diverted into watching where you put your feet—or it should be.

If nothing attracts your eye from one vantage point, walk slowly on and stop again. How far should you walk before pausing? No one can tell you for sure. It might be as far as a hundred feet, but that's about the maximum. In some locations particularly rich in picture possibilities I've changed position in one-foot increments. Bend over, get down on your knees, and look from there. If you are attracted to something in the far distance, you don't necessarily have to gallop on up to it. Instead, stop and look carefully around you on the way.

One of the best ways I know to learn clear seeing is to consciously practice it over a period of time. Plan some picture-taking sessions in which you find, frame and photograph as many subject shapes as you can find. Such practice pays off—soon you'll be able to locate fascinating forms without thought, and your pictures should be greatly improved in at least one regard.

Visually, the shapes of the sky patch and the arch are as important to this picture as the shapes of the rocks. I took this photograph several hours after taking my other predawn and sunrise photographs at Arches National Park, and only several hundred yards away. These giant, angular hunks of fallen canyon wall were near the entrance to a side canyon, and I stayed back to photograph them while the group I was with hiked on. I worked for half an hour with different lenses, angles, and distances before I managed to distill the clearest relationship between these shapes and shadows. Relatively small changes in my position altered the picture in small but very important ways. My principle aim was finding a position that would enable me to enclose the smaller square beneath the shaded, giant overhang.

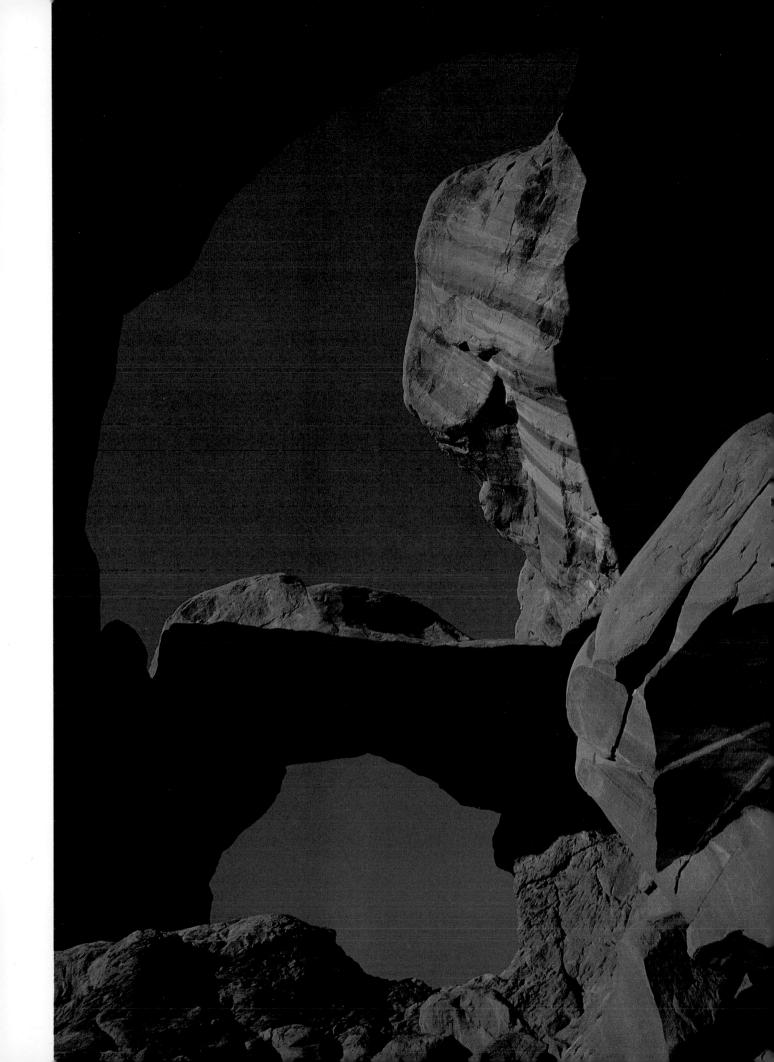

Looking for Lines

While casing scenes for eye-stopping shapes, scan them for eye-leading lines as well. Shapes hold the eye; lines lead it. Learning to see line in your subjects and to use it in composing is not much different from learning to see and use shapes.

Many compositions consist purely of lines. In some pictures the lines are real, such as when they are roads, paths, the ridges in a palmetto fan, or curved leaves of grass. Other lines are created by light, such as the shadows cast by tree trunks. And some lines are implied.

Converging lines make pictures look three dimensional. Parallel lines, and curving lines that don't converge, lead the eye around the picture plane and emphasize only two dimensions. When you search a scene for lines to use in your pictures, keep real and apparent convergence in mind.

The wide band of shadow in the picture below is a shaded hillside. This diagonal band is so thick it functions as a shape and as a line. It holds the eye, directing it on a diagonal from top right to bottom left.

In the top right photograph the subject is all lines, curving and straight blades of grass in the Everglades just after dawn. The composition is bold and simple, and arresting because the subject is being reflected.

The picture of the palmetto fan is an example of a two-dimensional subject looking three dimensional. The lines in this picture actually do converge—the convergence isn't the result of different camera-to-subject distances. I'm so accustomed to convergence indicating depth that in a flat subject it almost tricks me into thinking I'm looking at a three-dimensional object.

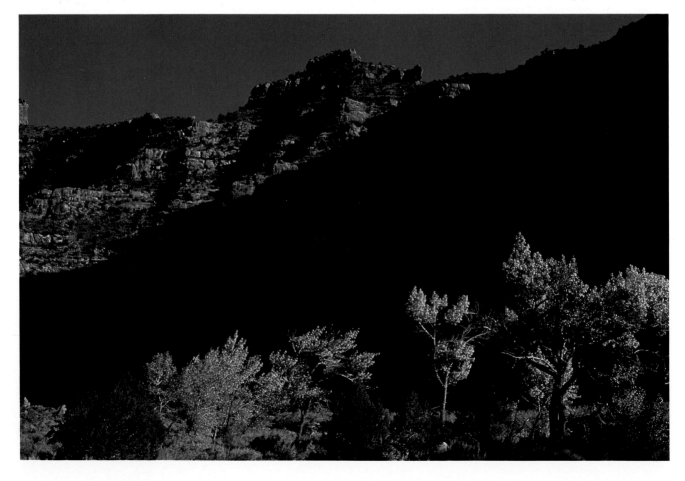

The Appeal of Texture

Texture is the third subject element to look for. Texture tells you about the nature of a surface. Sometimes the surface reveals a regular pattern, sometimes it is rough and irregular, sometimes it is smooth. Texture is tactile. It gives you an impression of how the object might feel, even if the object is too large or too small to touch.

Both the nature of a subject's surface and the quality and direction of the light falling on it contribute to apparent texture. I discussed light and lighting in detail in the last chapter. Here, I'll briefly mention that light quality and direction are important to revealing texture in black-and-white as well as color subjects.

Extremely contrasty lighting isn't always necessary to show texture. Sometimes tonal and color differences alone can do it. This detail of wild foxtail grass on the left is sharply etched, and its soft texture is clear even though the picture was made on an overcast day.

Imagine the picture on the right of the dry eroded mud under different illumination, for instance on a cloudy day or with the sun directly overhead instead of at a low angle. These weird rock shapes at Goblin Valley, a Utah State Park, are not at all photogenic in bright, midday sun or in overcast light. The dramatic forms of these geological oddities show up only in the earliest and latest direct sunlight.

A Sense of Scale

Any object of known size will impart a sense of scale, or relative size, to a photograph. If you know the approximate size of one object depicted, you know the size of the other objects and the scale of the whole scene.

The most common way to lend scale to a natural scene is to include a human being in it. I always try to find ways of *suggesting* human presence, rather than actually showing people. Recognizable artifacts are excellent indicators of scale and can add an element of mystery to photographs, too. If you need or want to photograph a human figure, try to have the person engaged in some appropriate activity rather than just standing and looking at the camera. Have him, or her, or them sit down, lie down, walk toward you, run from you, jump from rock to rock or over a stream, tie a shoelace, make a fire, or catch a fish. In most cases anything is better than photographing someone who is just standing and facing the camera. Sometimes the cliché of gazing out over the scene works splendidly, but because it has been so overused, do make the effort to try something else, too.

Ask yourself if you really want or need scale in a photograph. Frequently I don't. On assignments I must take some photos of the overall scene that immediately show the magazine or book audience what they are looking at and how big it is; so some of my pictures do definitely need scale. However, many of the pictures I take on the same jobs lack scale, and they are also used in these stories.

Usually it is the images lacking scale that I like best. I am most inclined to value them for their own sake—that is, independent of their usefulness in print. For example, if I am choosing a picture to hang on the wall, I often pick one with some ambiguity in which the viewer is not quite sure of size and subject at first glance.

But for picture stories or slide shows, pictures with a sense of scale are invaluable. After seeing a scene-setting picture, viewers are more fully appreciative of abstractions. So whenever good scene setters occur, I shoot them. They may not be my all-time favorite pictures, but they are indispensable to my complete coverage of the subjects at hand.

If I hadn't taken the above picture myself, I wouldn't know for certain what the subject is. It could be a photomicrograph of a molecular structure or a high-altitude aerial of a strange desert landform. In fact the area is about 4″ × 6″. The subject is a rock that has been sculpted by water, sand, and other rocks flowing across it during thousands of spring floods deep in the Grand Canyon.

On the right is a good example of the way an element of scale can enliven an image. I was busy taking pictures of a reflection in a puddle when I looked over my shoulder and saw the blaze well underway.

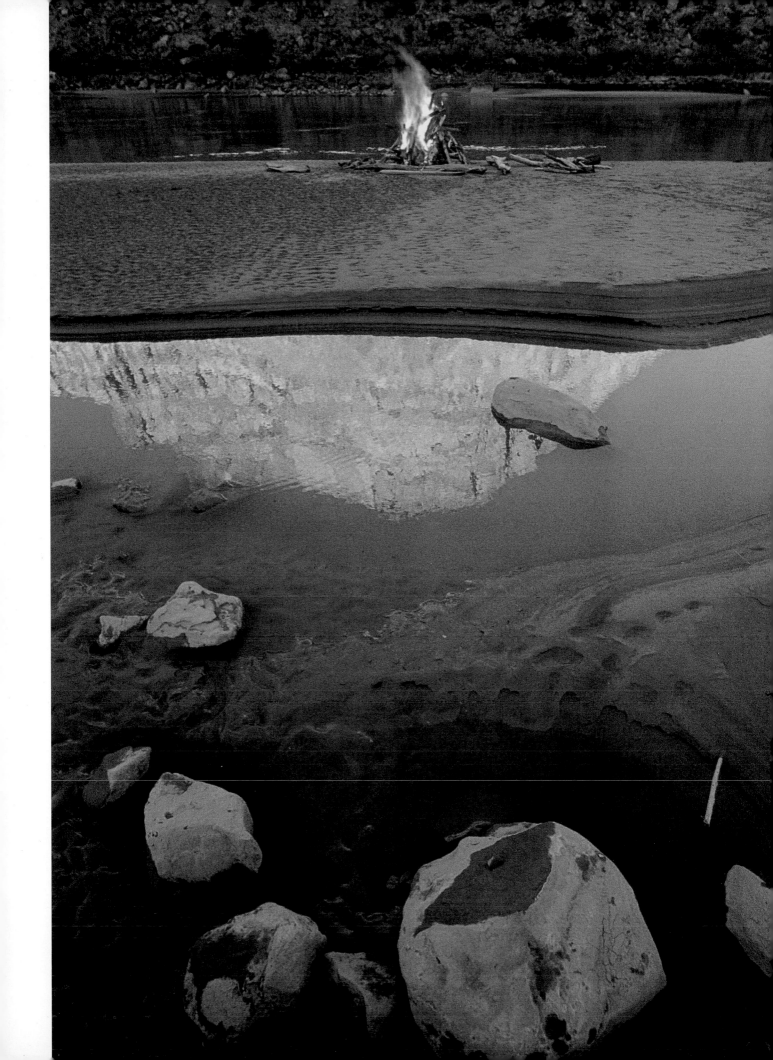

Pictures with Pattern

Patterns are probably the most ubiquitous type of natural subject matter. Many subjects have similarly shaped elements that form patterns. While patterns are easy enough to find, they are often overlooked. I'm not sure why, but I suspect it is because photographers concentrate on taking more conventional pictures. Their seeing is anesthetized by preconceptions of what a picture is supposed to be. Usually the preconception is of a full landscape overview with a conventional center of interest and a three-dimensional look.

When can pattern and pattern alone carry an entire image?—more often than you might expect. Pure pattern pictures are always abstractions, and they are usually ambiguous at first glance. Even if the patterned subject is identifiable, sometimes it takes a few seconds for the viewer to recognize it.

Very minor differences in shape, tone, or color will stand out strongly by breaking the pattern and thereby making a focal point. Any deviation draws the eye, even the most minor. Most of my pictures include pattern as one of several subject elements rather than relying on it exclusively.

This picture on the right of a rippled sand dune and a weed on a bank of the Green River is a good example of my frequent use of patterns. The weed is different in color and shape from the sand ripples, so the weed becomes the picture's focal point. I like this picture when I cover the top and reduce the subject to the weed and the rippled sand, but I like it even better with the distant bush, cliffs, and the small slice of sky.

I noticed this handsome reflection of ten foot tall grass pictured below in a roadside canal in southern Florida. I considered including part of the canal bank in the picture, then decided against it. The water's edge was cluttered with dead and fallen vegetation, and it looked very messy. The reflection alone was more powerful and clean, and I am still content with it many years later.

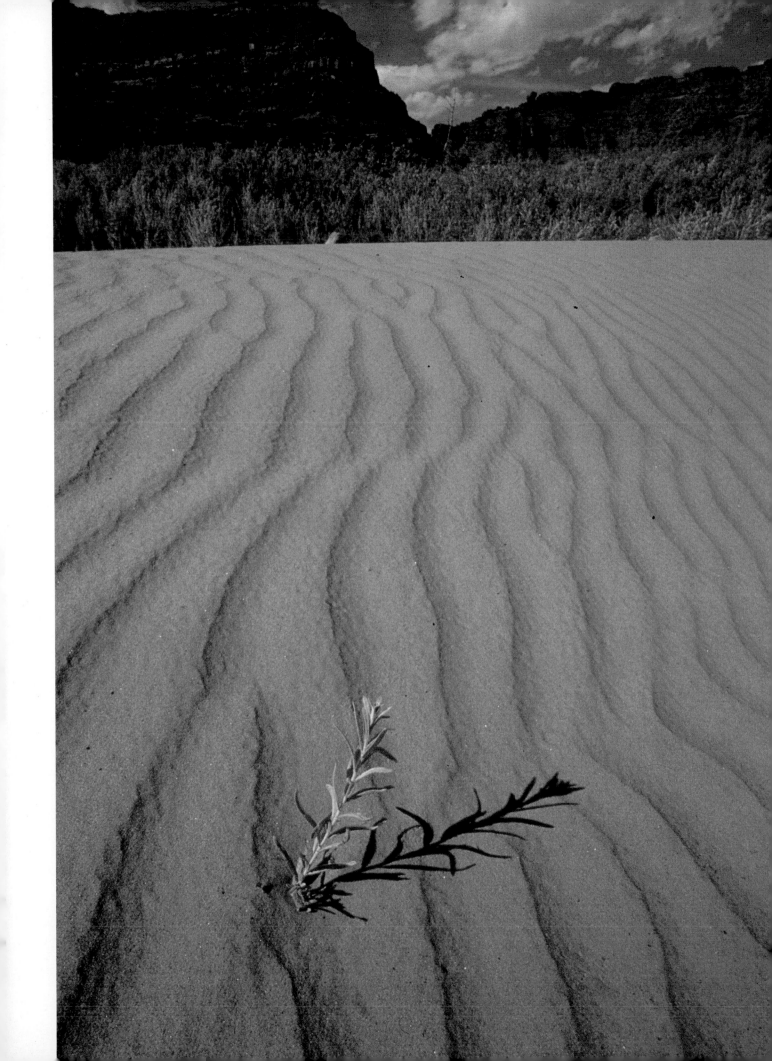

Finding Focal Points

Focal points are areas in the picture that compel your eye to look at them first, usually because they contrast in tone or in color with the rest of the picture. We'll consider the placement of focal points and centers of interest in the frame in the next chapter on composition. But since finding and using them is so very important, I want to show you two very different landscape situations first as an example of how to find various uses for the same focal point. The more thought you give to how you use focal points in your pictures, the better your pictures will be.

There is no one type of lighting or one compositional trick that produces good landscapes. Visually, the two subjects on page 61 and page 62 are very different and so are the colors, the angles, and the lenses used. The prairie's impact comes from the great tension between the foreground and the background, and between the illusion of depth obviously present in the original scene and the eyes being snapped back to the plane of the picture surface at the top and the bottom of the photograph. The swamp appears quite three dimensional with the white blossom floating before a frieze of cypress trees and Spanish moss which are all echoed in the black water's reflection.

These pictures do have one obvious and important common denominator—both are representational. On looking at them you know the size of the scene, and you would know it no matter how large or small the pictures were printed. Even if you removed the flower, there would be no ambiguity about the prairie scenic. The swamp scenic is ambiguous at first glance, but once you realize it is a water lily floating there before you, exactly what you're looking at becomes clear in your mind's eye. You feel oriented and comfortable. The presence of the flower, which is an object of known size, puts everything else into perspective.

Photography at its best is a process of discovery. When working well, photographers can see even the most common subjects clearly and afresh. Such seeing, backed by good technique, presents subjects in new ways to photographers and viewers alike. Edward Weston said composition was the strongest way of seeing, and I concur. And the way a photographer sees will influence the way he or she composes photographs.

It was only by chance that I happened to be in exactly the right place at the right time to capture these pictures, taken as part of an assignment to photograph an overall view of the midwestern tall-grass prarie. On June 21, the shortest night of the year, I stayed at Chase Lake in North Dakota to celebrate the solstice by spending it in the open. At 9:00 PM the sky was still bright, and I noticed a storm in the distance.

Black clouds brewed along the horizon, and rain fell, but other parts of the scene were still brightly illuminated by the setting sun. I recognized the photogenic potential of the scene building before me—this kind of light is among the best I know for making scenic photographs. Taking a camera, several extra lenses, a tripod and film, I started walking, looking for a picture.

The huge tract of Chase Lake Refuge is not natural, unplowed prairie land—it was artificially seeded, and lacked a natural diversity of species that would have included countless blooming flowers intermixed with different grasses. I wasn't satisfied with a composition of uninterrupted green leading up to a dramatic sky. I wanted something in the foreground—a flower if I could find one.

First, I went down into the swale. But as I descended, I discovered I was losing the long, deep sweep of the landscape, the very quality I wanted to depict. I angled back up the hill, hundreds of yards away.

In the distance I saw a spot of yellow. As I walked toward it the clouds cleared away from the sun. Up close, I saw several small blossoms that were perfect for my purpose.

I rotated the camera for verticals, and I came in closer, putting a flower in the bottom of the frame. A strong image began to form, but I didn't like what I saw through the 55mm lens. The flower had to be larger, so I changed to a 35mm lens. Moving closer, I raised the camera height and angled the camera down while looking through it for the same small slice of sky, then relocked the tripod head. To keep the foreground and the background sharp, I stopped the lens down to f/16 and used the depth-of-field scale on the lens to set my focus.

What makes this vertical picture exciting is its extreme depth, the visual tension between the foreground and the background. Cover the blossom with your hand—you can immediately see that its contribution can't be overestimated. This picture has two strong focal points, the flower, and the sky and trees. A tense composition of an apparently gentle landform, this treatment belies the idea that we can only take strong landscape pictures in wild, rugged, faraway locations.

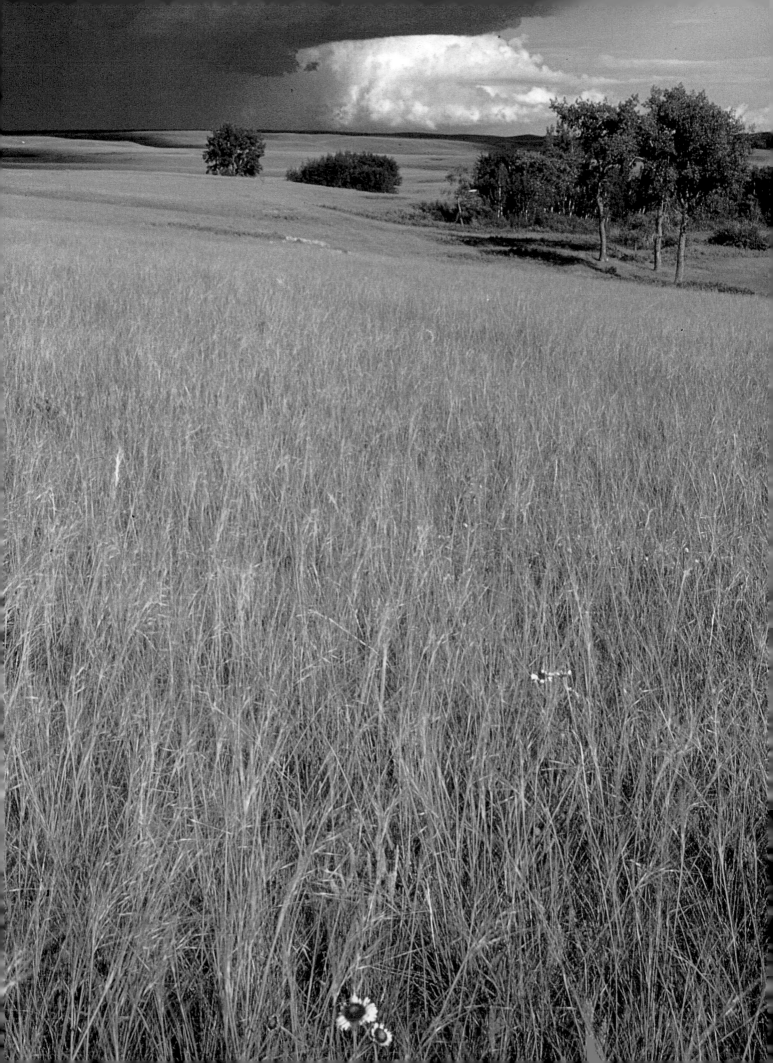

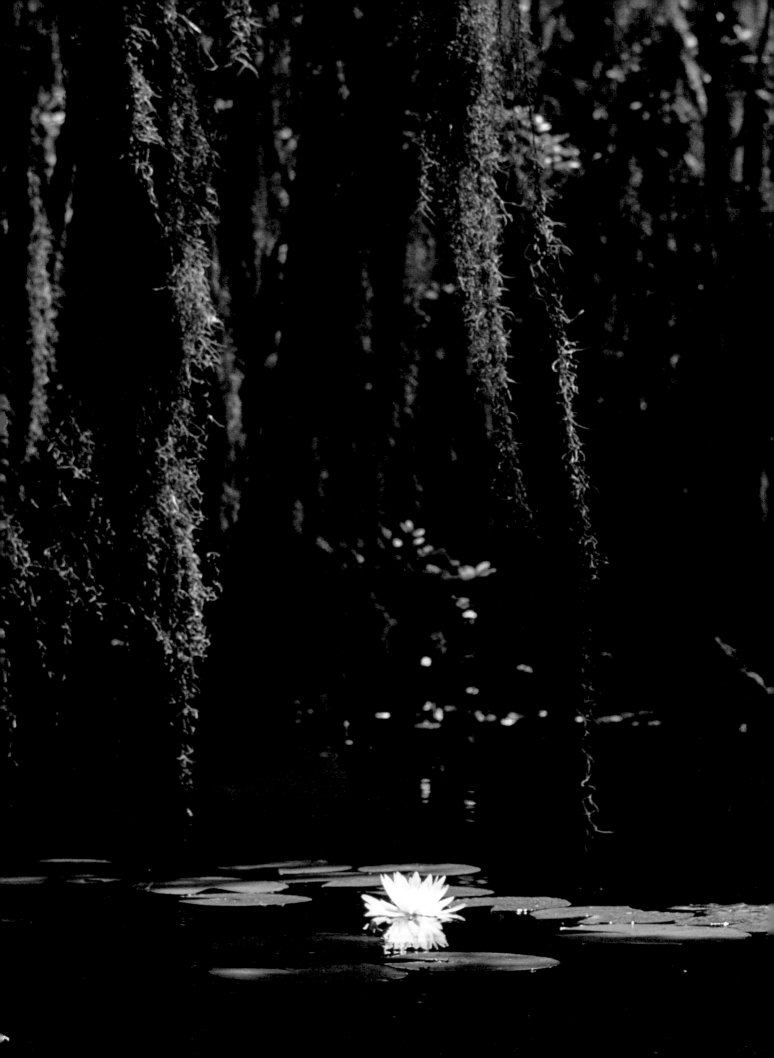

A waterlily is the center of interest and the focal point of these landscape pictures taken in Georgia's Okefenokee Swamp. The lily stands out so brightly that you might think finding and photographing it was quick and easy. It was not. I was in a small motorized boat with a guide, and we had been working in the boat or on foot for several weeks. We had passed this scene about six hours before I made these photographs. The light then had been dull and dreary from an overcast sky. Nothing looked good. The water lilies were not open. (These flowers close up each night and are late bloomers even when the sun is out. Usually it is about 10:00 AM before they can be fully seen.) In addition, this blossom was in a cul-de-sac screened by trees.

Six hours later, the sun was bright and stayed on my flower long enough for me to make a number of pictures from different distances and angles. This vertical was one of the first shots, and it became the cover of the book I was working on. After taking it and several other shots from a distance of about thirty-feet, my guide poled the boat closer to the lily and steadied it by sinking the pole in Okefenokee's famous peat bed while I made different exposures. I don't like to take pictures from boats because they are unsteady, I can't move around as I would like, I can't get up higher if I want to, and I can't get down as low as I want. Boats sometimes drift in the wrong direction and sometimes tip over. Whenever possible, I get out of boats and stand on the bottom. I couldn't do that here because the water was too deep.

The lily is the center of interest in each picture. Otherwise, the pictures are quite dissimilar. The most evident difference is where the lily is placed in the frame. In the first picture the flower is centered horizontally and vertically. This composition is saved from being too static by the branch protruding from the water in the left foreground and by its reflection juxtaposed with the overall reflection of moss-draped trunks and limbs.

To make the vertical picture with the lily at the bottom of the frame, I had to kneel in the boat and lean over the side. My companion leaned in the opposite direction to keep the boat from upsetting. I wanted the Spanish moss to drop straight and vertical; hence the low camera angle. I stood up in the boat, again inviting a spill, to make the horizontal picture showing the lily pads as well as the blossom. Placing the center of interest about two-thirds of the way down the frame makes this the most conventional of the swamp pictures.

Most people think that abstract photographs are harder to find and take than good overall landscapes. I can't speak for other photographers, but for me this just isn't true. I usually amass dozens of fine abstractions of a subject before I make an overview that sums it all up. I am often in the field for weeks or months before I find a smashingly successful overview. Frequently—and this was the case for the vertical prairie picture and swamp picture—I'm not specifically looking for a great landscape when I find it.

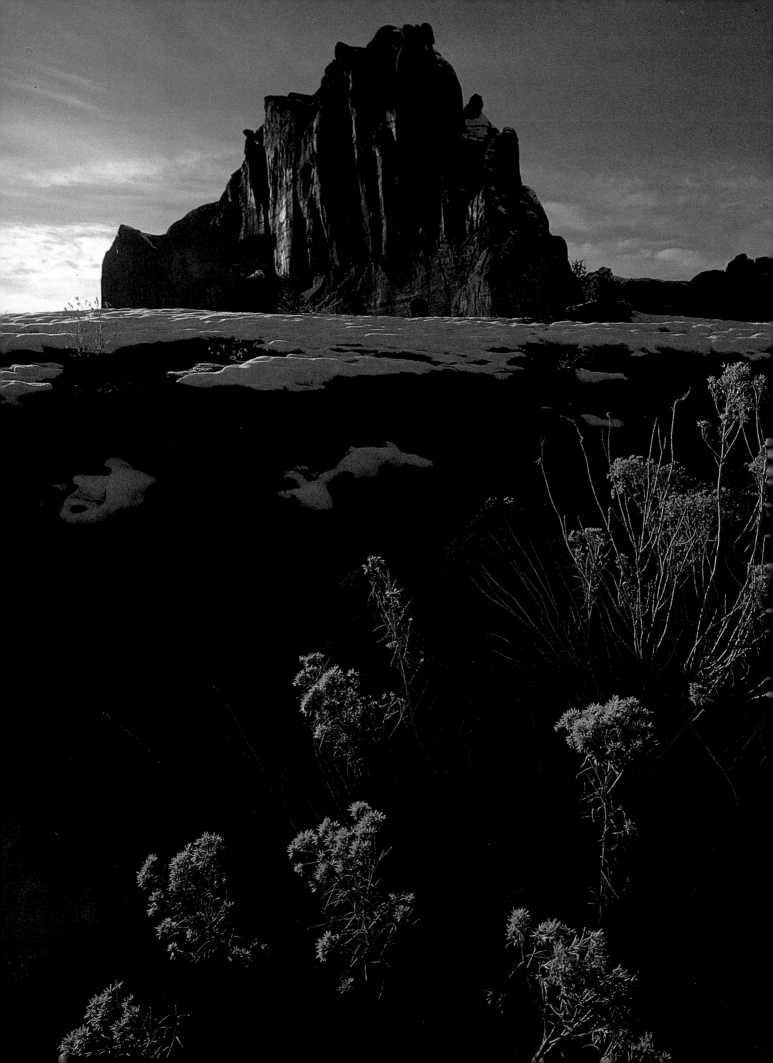

Chapter Four

COMPOSITION

Depth-of-field control is one of the most important tools in your stylistic arsenal. Learning to use it in the field is relatively simple, since the distance scales you need are already incorporated in your lens and in most camera bodies. The other aid to getting the depth of field you want is the depth-of-field preview button that may be on your camera body. Depressing this button stops the lens down to the aperture you will use to shoot, enabling you to check on that aperture's effect and the focused distance on the camera's ground glass. This scenic, taken in Arches National Park, was made with a 20mm lens stopped down as far as possible to f/32. The camera was on a tripod, and the exposure was 1/4 sec. on Kodachrome 64.

Composing photographs is quite different from analyzing scenes for visual elements. Composition is very personal. In this chapter I'll describe how I arrived at certain photographic compositions, which doesn't mean you would or should have taken the same or even similar pictures had you been in the same places at the same time. So far I have purposely avoided talking about rules of composition or suggesting that if you didn't apply them, your pictures would be failures. I believe there are many ways to compose pictures, and that one way isn't necessarily better than another. Still, most successful pictures are well composed in some way. The beginner should consciously consider how to compose a photograph as carefully as he or she analyzes the subjects' shapes, lines, and textures.

There are classic compositional rules for visual organization, and they are covered in this chapter. Knowing them and trying to put them into practice can improve your pictures, as long as you also feel free to break these rules whenever you wish. You should know the rules so you can decide for yourself whether applying one or more of them will render the best interpretation of your subject. To put these rules to their best use, interpret them solely as suggestions, not as boundaries to your imagination.

The Golden Mean and the Rule of Thirds

The classic formula for subject placement, which was practiced by sculptors in ancient Greece and by European painters and architects since the Middle Ages, is called the "golden mean." It says that to produce the most pleasing proportions, a line—or

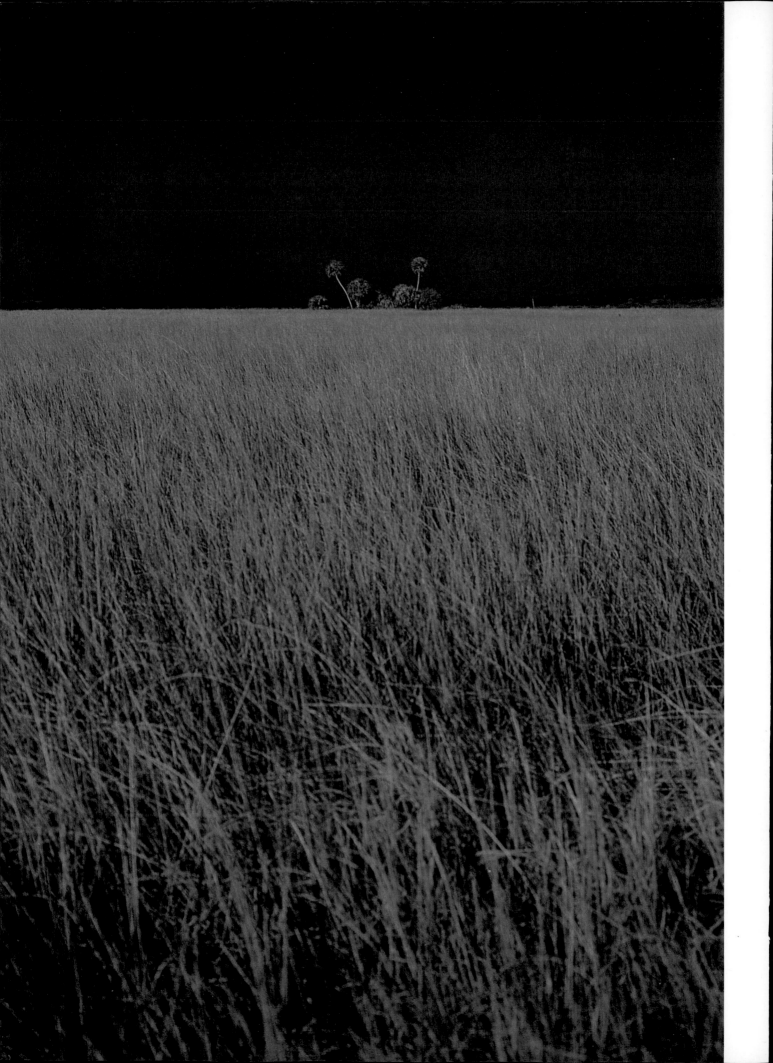

any picture area—should be divided into two parts so that the relationship between the large part and the small part is the same as the relationship between the whole line or area and the large part. When the whole is a 10″ line, the parts are respectively 3.819″ and 6.181″. In other words the 10″ whole is to 6.181″ as 6.181″ is to 3.819″. The same principle can be applied to a two-dimensional picture area.

In practice, a rule called the "rule of thirds" is often substituted for the golden mean, and the resulting proportions are different. The rule of thirds states that the picture should be divided into thirds horizontally and vertically. The center of the picture's interest should be placed at one of the intersections of the vertical and horizontal lines.

I have put grids on several photographs on this page so you can see for yourself how much these photographs comply with the golden mean and the rule of thirds, which are only meant to be general guides to good composition. As stated, the most important parts of these subjects should fall on the lines or intersections of grids imposed on them. Although I haven't consciously tried to take pictures according to these rules, I'm surprised to discover how many of my pictures are in accord with them. As you can see from the small picture grid upon it, the strong and pleasing flower close-up benefits from my unconscious application of the rule of thirds. But you can also see from many of my other pictures that my use of these rules is hardly universal. I think that structuring too many pictures according to any rule would doubtlessly be very boring.

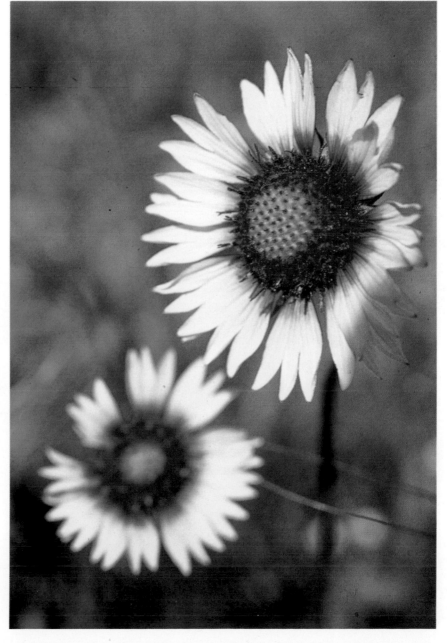

The rule of thirds can be equally effective used on subjects great or small, near or far. The landscape on the opposite page was taken along the Tamiami Trail, which traverses southern Florida, near the intersection of route 29. The dark sky was what attracted me to stop and shoot it. The flowers at the right were at Chase Lake, North Dakota. Both exposures were made on Kodachrome 64 for 1/250 sec. at ƒ/5.6, and both were taken with a 105mm lens.

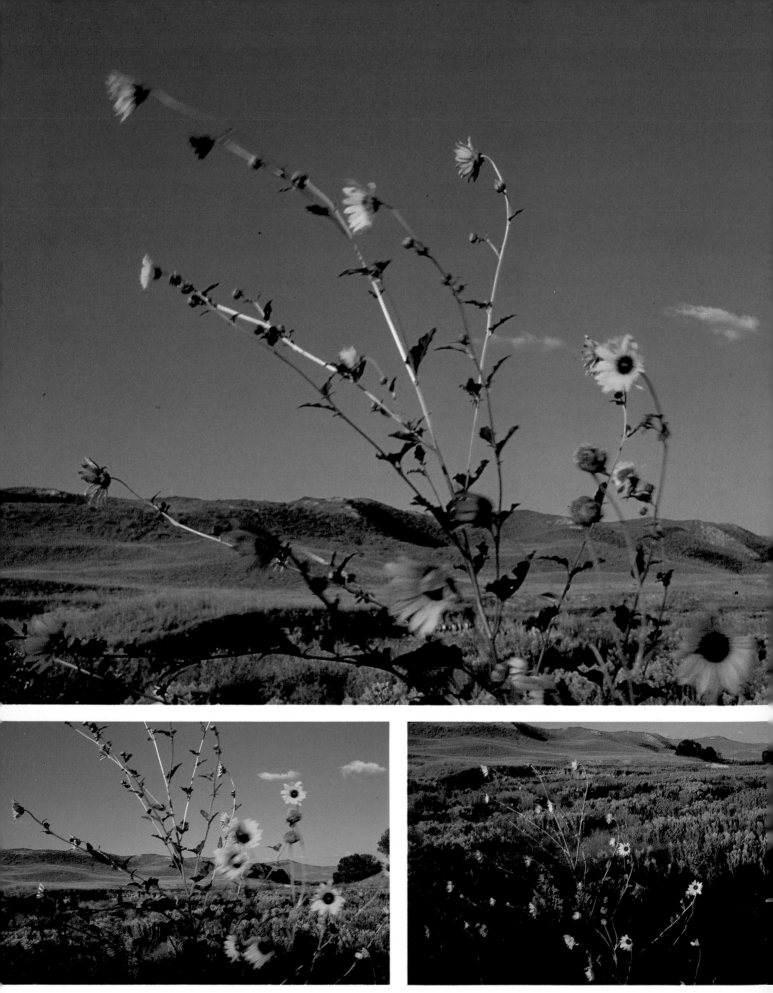

The horizon is usually placed according to the rule of thirds, approximately 1/3 or 2/3 of the way down from the top of the picture, as shown in the top right picture. Splitting the frame in the middle, or placing the horizon so it bisects the frame as in the bottom left picture, is usually less successful. Another possibility is placing the horizon very high so only a small slice of sky appears, which puts the emphasis entirely on the landscape, as in the bottom right picture. I took these three pictures in the Nebraska Sandhills when the wind was blowing hard. They were all exposed for 1/250 sec. at ƒ/8 on Kodachrome 64, using a 20mm lens.

Deciding Where to Put the Horizon

The horizon is such an obvious aspect of any landscape picture, it seems strange that where it appears in the frame is often not well thought out by many otherwise advanced photographers. I suspect this oversight arises when a photographer is so moved by the magnificence of an overview that he or she tries to get it all into one picture.

It is in overall scenics that the difference between our way of seeing and the camera's way is most exaggerated. Our mental mosaic includes everything before us, so our depictions of overall scenics are often disappointing. Usually we try to include both the land and the sky, and because the horizon falls approximately in the middle, this is usually an awkward arrangement, which should be avoided unless it is applied deliberately for effect by an accomplished photographer.

The rule of thirds and the golden mean provide easy answers about where to place the horizon or other subject elements. I recommend, however, that you also experiment with high horizons, low horizons, and horizons close to the middle of the frame. Analyze the horizon placement in a number of the pictures you've already made. The next time you shoot landscapes, frame and shoot various versions of a scene, making them as alike as possible, except for the location of the horizon. In addition to analyzing these pictures yourself, ask others to evaluate them. This is an area where a little thought and experimentation can result in an immediate and startling improvement in your photographs.

If you look at my landscapes, you'll see that I often place horizons very high or low, close to the top or the bottom of a picture. With a few exceptions my scenics are largely of land, sky, or water. Rarely are my picture areas equally divided. I use asymmetrical divisions of space at least as often as I use the harmonious proportions of the golden mean.

Dividing the Picture in Half

Reflections of a subject clearly mirrored in still water often invite an equal division of space in the picture frame. The ambiguity of such scenes—what is up and what is down, which image of the subject is real and which is the reflection—provides visual tension and holds the viewer's interest. Another kind of subject—two real objects so similar in size, color, and shape that you wonder if both are real or if one is a reflection—also asks for 1:1 proportions.

The lake's reflection in the picture to the right shows an equal division of space both vertically and horizontally. The flower picture is an example of another kind of subject that can be well composed in 1:1 proportions.

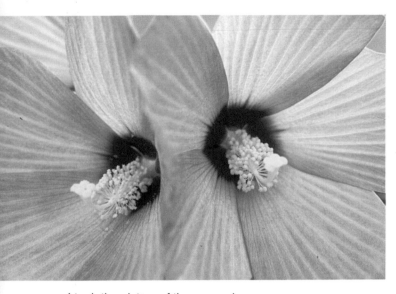

I took the picture of these marsh mallows on a bright overcast day at Brigantine National Wildlife Refuge in New Jersey.. There were lots of the flowers scattered about the marsh, but only one plant was close enough to close in on with a 105mm lens. The exposure was 1/250 sec. at *f*/5.6 on Kodachrome 64.

For a real mirror image you need a still, water surface, the kind found on wind-less days in lakes or ponds. Here, the hills around Lake Mead in Arizona reflect in its calm waters just after sunset. I shot this scenic from an anchored boat using a 200mm lens at an exposure of 1/250 sec. at *f*/4 on ISO 64 film.

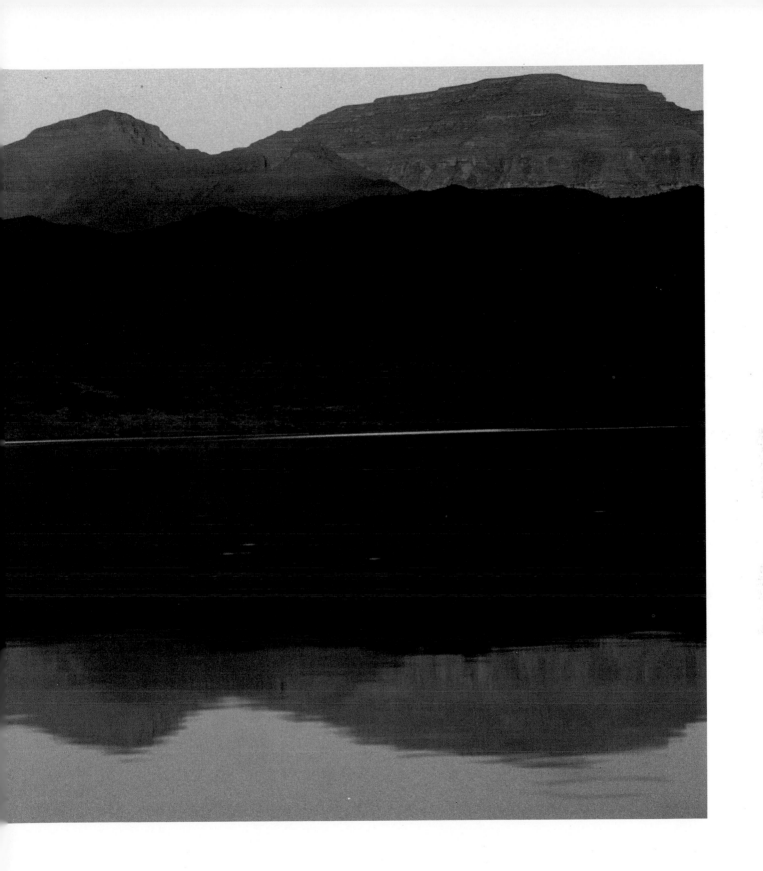

The S Curve

Another classic formula for composition is the "S curve." I have taken a few photographs employing S-shaped compositions, but they have been few and far between, and they are not really good examples of all this convention includes. Obviously, to make S-curve compositions you have to find a subject with an S shape in it. Not every road or river comes with built-in S shapes, and there is nothing you can do about that. I am not personally crazy about S curves; so I don't stress looking for them and thereby running the risk of passing by all sorts of other possibilities that might be more interesting to me.

Rivers and roads are the usual candidates for finding and capturing S curves. Neither of these pictures illustrates the classic pictorialist S-curve composition, which usually includes a foreground, a middle ground and a background united by the S. I found the S-shaped creek in the picture below in a Nebraska meadow, and I photographed it shortly after dawn with a 55mm lens shooting at ƒ/8 for 1/250 sec. on Kodachrome 64. The picture of the S-shaped creek on the opposite page was taken in Arches National Park. The exposure was 1/250 sec. at ƒ/16 on Kodachrome 64, using a 105mm lens.

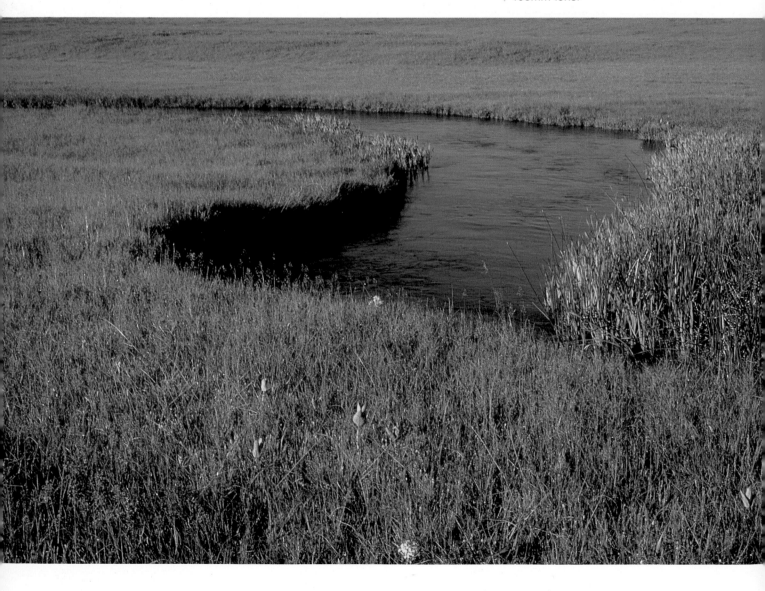

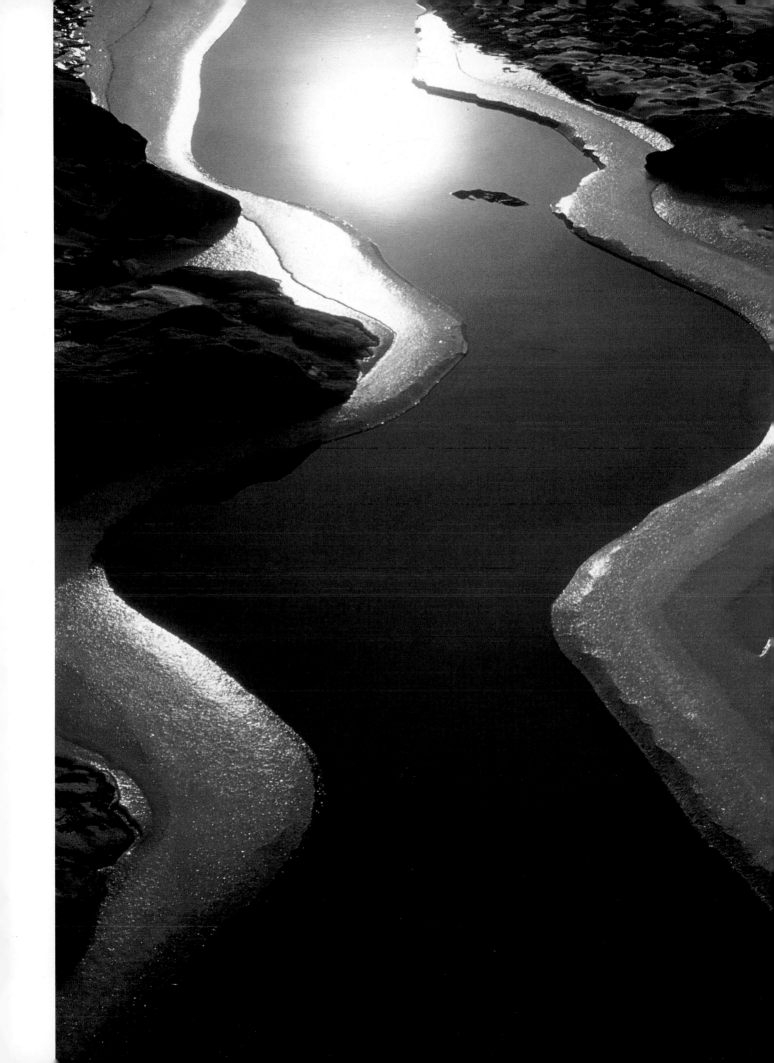

Can Subjects Be Centered?

Of course they can. Some subjects look better when centered than when photographed any other way. To locate them within the picture frame according to the rule of thirds or to use any other rule of composition would be inappropriate, resulting in pictures that were straining for "style." I don't espouse any compositional rule as a sure-fire solution to every picture situation, but I don't dismiss any for being useless, either.

This datura, centered below, bloomed deep in the heart of the Grand Canyon. The simplicity of the composition underscores the symmetrical beauty of the subject. The light source was a clear blue sky and the exposure was 1/15 sec. at f/8 on Kodachrome 64.

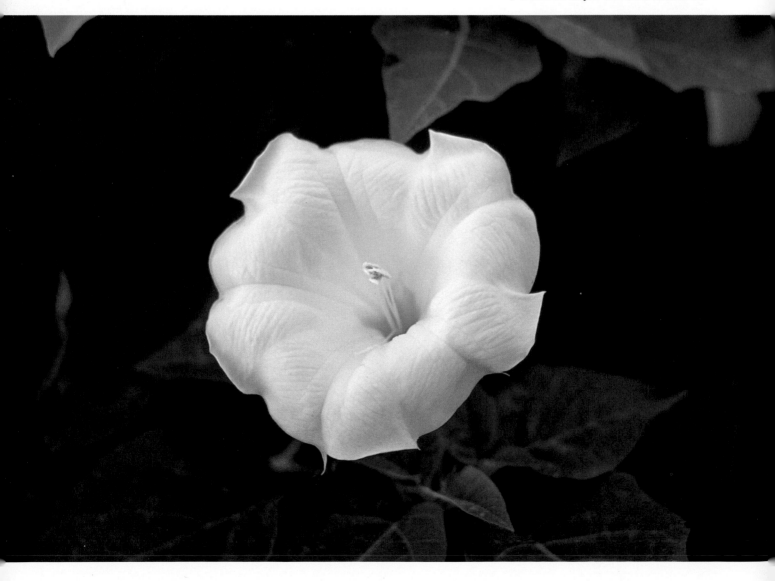

Achieving Balance

That pictures should be balanced is another general compositional rule. Subject elements are weighted and assigned different degrees of importance depending on their size and their tone or color. Large objects have more weight than small ones. Light areas have more weight than dark ones. I make no effort at all to put this rule into practice. Many of the most static and boring photographs I've ever seen were composed beautifully according to this convention. But while I don't consciously strive for it, my pictures usually are balanced.

This rule, by the way, is not in opposition to the rule of thirds. In photographs made according to the rule of thirds, the larger, emptier part of the photograph balances the weight of the main subject. However, the pictures exhibiting weight and balance that I find most interesting break the rule-of-thirds convention. In these pictures of reeds and water I much prefer the version in which the reeds are far to the left of the rule-of-thirds line. What do you think?

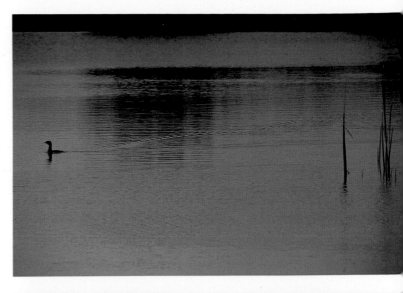

Eco Pond in Everglades National Park is one of the happiest hunting grounds for photographers. I've worked there at every time of day and night and have never failed to find good pictures. The pictures on this page illustrating balance were all exposed for 1/60 sec. at ƒ/11 on Kodachrome 64, using a 70–210mm zoom lens. The bottom picture exhibits the best balance between light and dark areas, and between vertical and horizontal tension.

Verticals Versus Horizontal Formats

If possible, I always take verticals and horizontals of the same scene, changing my angle, vantage point, lens, and/or distance when necessary. As a professional photographer, I'm taking pictures to please editors as well as myself. Taking pictures with both kinds of framing is the way I'm expected to work.

Apart from this professional requirement I let my subject matter dictate horizontal or vertical framing. The right framing is implied by a picture's shape. Our eye is inclined to travel from left to right or right to left with horizontal pictures and from top to bottom or bottom to top with verticals. Horizontal pictures emphasize the horizon or other horizontal lines or shapes. Verticals are more effective than horizontals in showing depth, as you can see from any number of examples in this book.

I spotted the old fence post below on a high pass across a southern Utah mountain range. Parking my car on the road's shoulder, I took many similar pictures from different distances and with slightly different framings. The exposure was 1/30 sec. at f/22 on Kodachrome 64, using a 35mm lens.

I couldn't figure out the source of these strange tracks. I showed the pictures to a game warden who told me they were made by a coyote dragging a rabbit. The vertical picture carries the viewer's eye into the distance, perhaps eliciting curiosity about the animals' mysterious destination, whereas the horizontal picture emphasizes their frozen, inescapable world of snow. The exposure was 1/60 sec. at f/22 on Kodachrome 64, using a 20mm lens.

Framing the Image

In addition to the formal composition principles described above, there are several other important concepts to consider when taking pictures. These include getting close enough to your subject, cropping into it, and examining the frame's edges carefully. After much practice, advanced photographers are no longer conscious of making these choices because they have become part of an automatic process. Beginners can benefit from applying the following principles rigorously. If you are a beginner, I suggest you make a list of all the principles covered in this chapter and carry them with you to check before making exposures.

I have looked at hundreds of thousands of serious amateur pictures in my lifetime, and there is no question that not getting close enough to the subject is the most widespread error in picture taking. With your viewing frame and your camera's viewfinder, start finding out how little you can include in a picture and still make the statement you want. Practice looking at your subjects this way on a regular basis. Is it possible to come in too close? Of course it is. Always ask yourself whether the background and the subject's surroundings add to or detract from the photograph.

Careful framing usually eliminates cluttered frame edges, the second most common picture-taking error. Unnoticed items intruding from outside the frame or extruding from within are almost as common a problem as not getting close enough. Habitually examine your pictures' edges, especially when you are shooting a static subject and have plenty of time.

This seemingly simple picture actually required complex maneuvering to get the exact framing I wanted of the sky and the arch's outline. The exposure was 1/30 sec. at ƒ/22 on Kodachrome 64, using a 20mm lens.

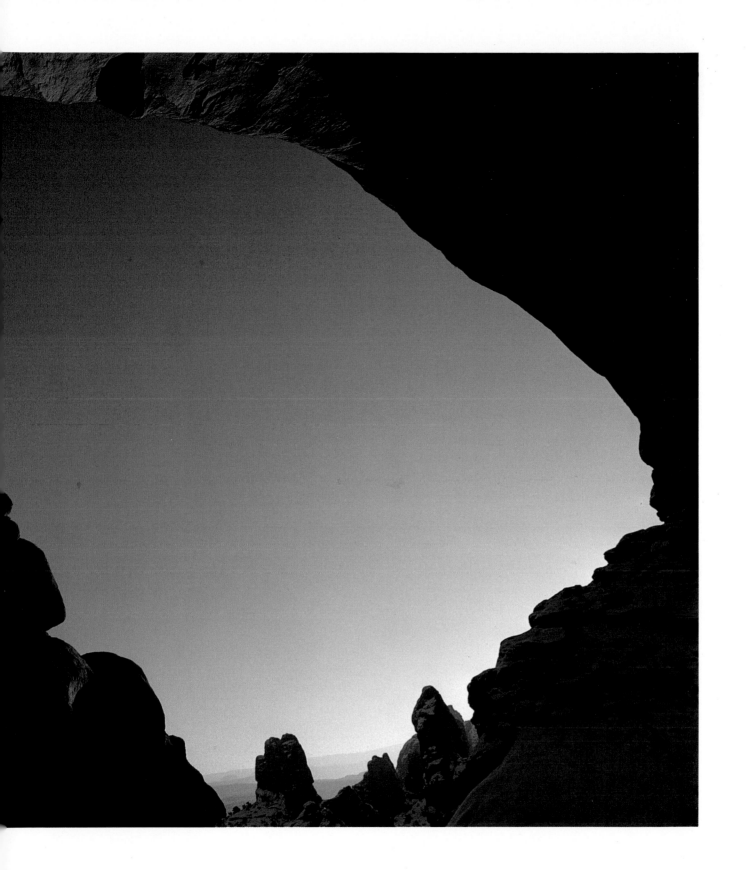

Check the Background

Regarding backgrounds, your camera's viewfinder can mislead you as much as your eyes. As in pictures of people, in nature pictures you want to avoid any juxtapositions of your subject and a background object that makes the latter appear connected to the main subject. Telephone poles growing out of people's heads is the prime example of bad picture taking, but I'm sure you can understand that a pine tree seeming to sprout from a deer's back is no better.

Except when I'm photographing fast action, I use the depth-of-field preview button before making an exposure to see the effect of the aperture I've chosen, paying particular attention to the background's relationship to the main subject. If the juxtaposition is not to my liking, I change it in one of several ways. I may select a wider aperture to render the background more out of focus. I may change my vantage point, coming in closer to my subject to eliminate any background. I may change my vantage point and camera angle to alter the relationship between the subject and the background. I may switch lenses to show more or less of the background. Today I make these major changes much less often than I did as a beginner, because I can anticipate these problems before I set up my camera.

In most pictures, the foreground is the main subject. For the picture of the prairie rose (top, opposite page) I exposed for 1/250 sec. at f/8 on Kodachrome 64 to keep the carefully placed background rose recognizable.

Foregrounds can also be scrims through which you see the main subject, as in the sunrise picture (bottom, opposite page) where foreground bushes create a lacy effect. I took this picture with a 500mm mirror lens with a real f-number of 11, and the exposure was for 1/500 sec. on Kodachrome 64.

Including the dead cottonwood in the background of this picture below made a much stronger image than the field of flowers would have been alone. The exposure was 1/125 sec. at f/11 on Kodachrome 64, using a 70–210 zoom lens.

Foregrounds Are Important, Too

When I stop the lens down to check on the background, I examine the foreground as well. Unnoticed foreground objects or an empty foreground ruin as many pictures as bad backgrounds do.

Filling the foreground is particularly important with wide-angle lens pictures. Many don't make the mark because the foreground is vacant. This seems particularly distressing when a minor change in vantage point or angle could have remedied the composition.

Using a foreground object as a frame in a landscape picture is another pictorialist tactic that I don't admire. I don't believe you can force a satisfactory composition simply by putting a foreground frame around a scene. That is a sure route to constantly making clichés.

I use foregrounds more often as skrims through which you see the main subject in sharp focus than as frames. I very carefully check the effect of my aperture choice on the depth of field when using a foreground skrim in a photograph. Sometimes I change the aperture I'm using, sometimes I change the camera-to-subject distance, and sometimes I change both to render the foreground-to-subject relationship the way I want it.

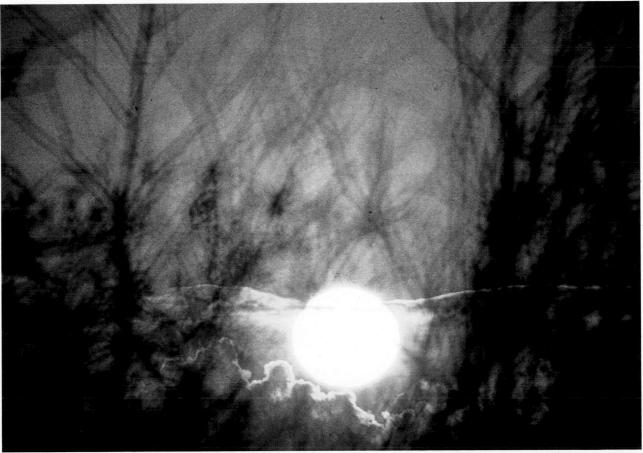

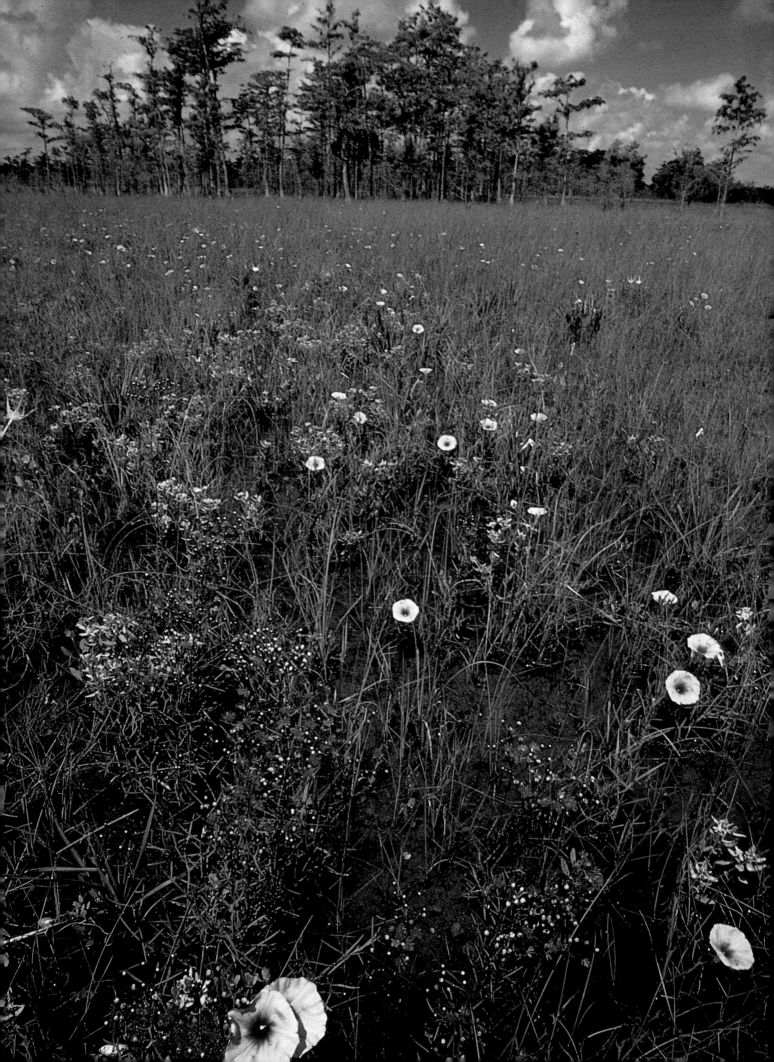

Shooting in the Field

I must have passed this Florida sawgrass prairie a thousand times before I came upon it bursting with bloom and stopped to photograph it. I chose a 35mm lens rather than a shorter focal length to keep the distant cypress trees the size you see them, rather than any smaller. To bring the entire picture into focus, I used the depth-of-field scale on the camera to set my focus, and I used *f*/22, the smallest aperture I had. With the camera on a tripod, I changed position to put the near left blossom almost but not quite at the bottom of the frame. The shutter speed was 1/30 sec. and the film was Kodachrome 64.

In the field—the real world—subject characteristics rarely appear one at a time, as they have in the examples I've chosen for illustration. The techniques photographers use—angle of view, camera-to-subject distance, lens focal length, aperture, shutter speed, and exposure—are used in combination one with another, rather than one at a time.

In this chapter I cover both the nature of the subject and the methods I've used to interpret it. Keep in mind that my way with any one of these subjects is not the only way or even the best way to show them. Another photographer, given the same scene, may make other choices and produce different pictures, not necessarily inferior to mine.

Changing Light

Exceptional natural light is as much responsible for my best pictures as the landforms that I photograph. When I'm on assignment, I scout potential locations in whatever weather is available. I return to the best ones when there is a chance that a dramatic lighting event may occur. On a trip where I don't have the option of returning to a spot, such as on a river trip, I keep alert for changes in the ambient light. I'm always ready to take pictures and am constantly scanning the scene around me for potential subjects.

One important characteristic of natural light, and one which is rarely discussed, is how fast it can change. The peak moment, particularly in storms, may last a fraction of a second. The best light rarely

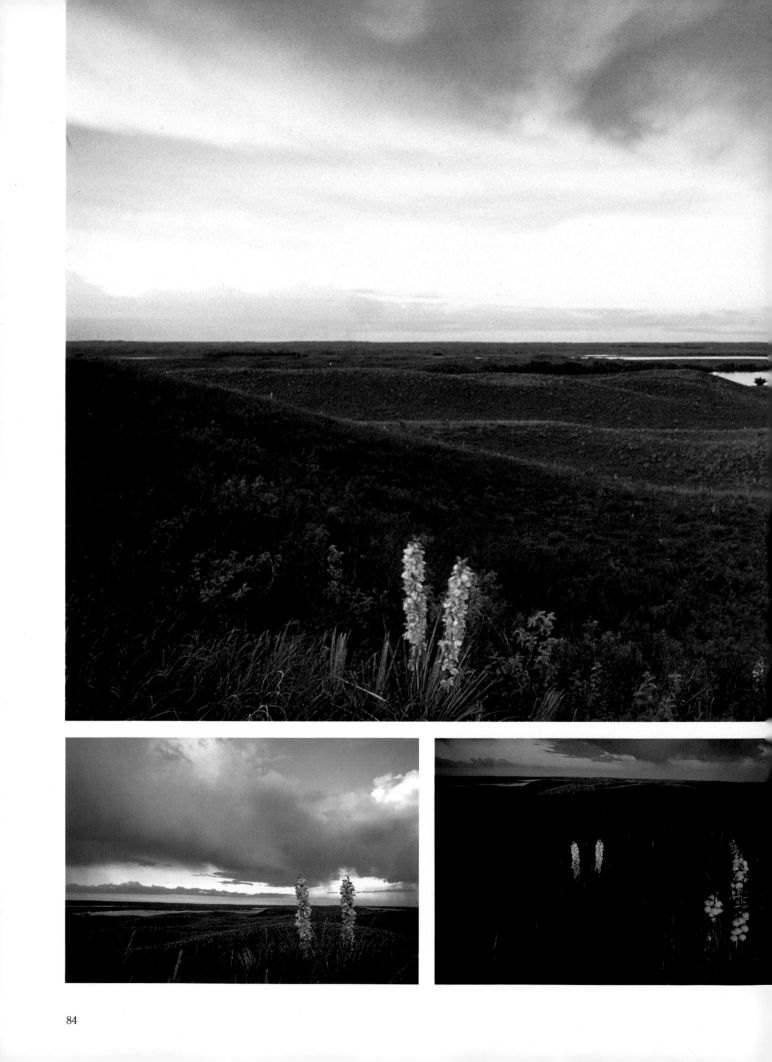

lasts more than a few minutes. Here are some strategies for coping with rapidly changing light. Keep your equipment right by you or in your hand. Keep extra lenses super accessible, and be ready to switch focal lengths in an instant. Always be conscious of the light as well as the subject matter. Look at the light and try to anticipate it. Is a cloud about to pass before the sun and transform the face of a cliff or a field of grass? Is there a storm brewing on the horizon that may create dramatic cloud forms in half an hour? Is it late in the day? Has the changing light altered the look of a landform you had previously dismissed as uninteresting?

As I photographed this sunset in the Nebraska Sandhills, a kaleidoscopic display of different lighting effects occurred in a very short period, and all were excellent.

It had been a long, gray, drizzly day. The light level had fluctuated within a three-stop exposure range, but the light's quality and color remained uninspiring. Suddenly, as the sun was setting, the cloud cover broke up. In the short time before dark I couldn't work fast enough. I made these pictures and several others in about five minutes.

First Light and Last Light

Just before sunrise—that moment between the first imperceptible lightening of the night sky and the appearance of the sun—the moon, stars, and sky are the light sources. Moonlight is reflected sunlight, and its color temperature is about the same as the midday sun, 4800K. Skylight, however, is very blue and cold, no matter what its intensity. As the sky brightens, it supplies proportionately more of the illumination than the moon, and the color of the light on the landscape will be colder. Any colors other than blue that might be visible in white midday light will not be present before sunrise or after sunset because there is no red or green in the blue light from the sky for the subject to reflect. The time you can most fully see and photograph by skylight is shortly before sunrise and shortly after sunset. This is a wonderfully soft, shadowless light; so the subject brightness range is determined by the different subject tones.

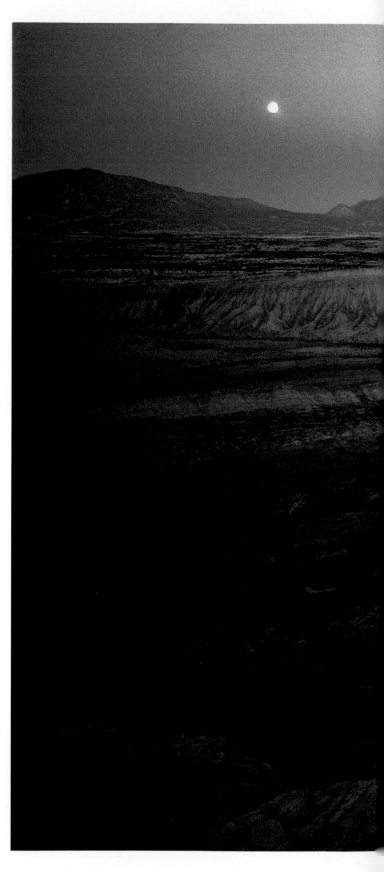

My favorite place in all the world is this lookout in Utah over Capital Reef National Park's Waterpocket Fold. This spot is very difficult to photograph, but I finally got a shot I liked after sunset as the moon rose from behind the Henry Mountains. The change from hard light to a soft and rosy afterglow just after sunset takes a very few seconds and fades rapidly. The camera was on a tripod for this picture, the lens was a 20mm, the exposure was 1/4 sec. at f/8 on Kodachrome 64.

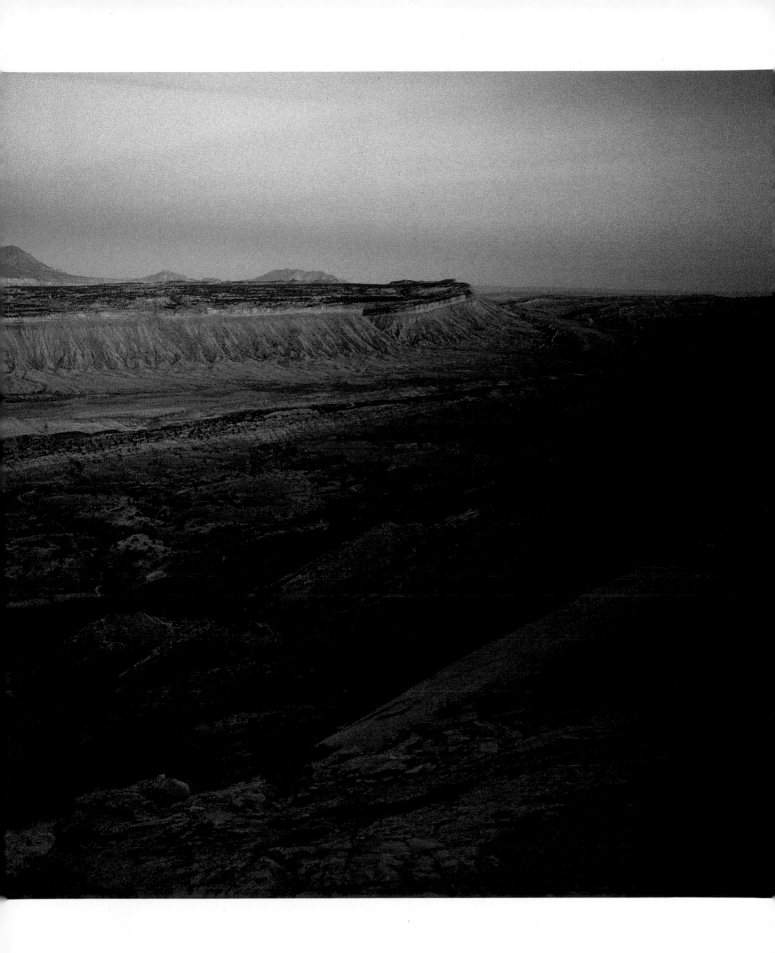

The Color of Sunrise and Sunset

At sunrise and sunset the color of light is usually very red or orange because sunlight passes through much more of the earth's atmosphere when the sun is close to the horizon than when it is overhead. The most intense warm color doesn't last very long, and it varies with the time of year, latitude of your location, and atmospheric conditions.

Measuring straight up from sea level, there are about 50,000 feet of atmosphere above us. Atmospheric particles, such as gas molecules and water droplets, scatter blue light in all directions. It is this scattering and reflection that makes the sky look blue; the longer red rays pass through the atmosphere with relatively little deflection. At sunrise and sunset even more of the blue is scattered away from our line of sight. Shifts in the color of light have to be fairly significant before they are noticeable to the eye; color films are more sensitive and will record changes in how color is illuminated that we may not notice.

Shadows look bluer at sunrise and sunset than at midday due to the great color contrast between the light illuminating them and the direct light from the sun hitting other parts of the scene. Try to observe the light's color carefully early and late in the day. Make notes of what you see and key them to the exact time and the pictures taken. Note how long after sunrise or before sunset you make your observation, and then compare your notes with your processed pictures.

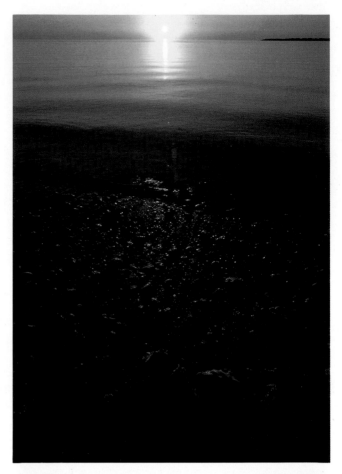

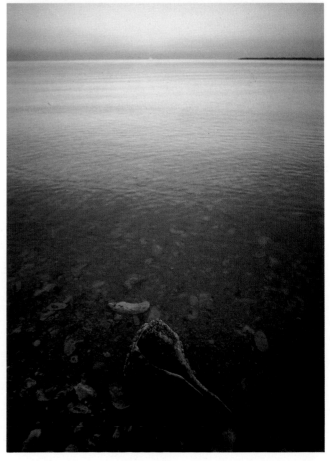

In the top picture including the sun, the shell and the beach edge in the foreground were greatly underexposed. An instant after the sun had set, the second exposure was able to encompass the full range of existing contrasts with no difficulty. This exposure was made at 1/15 sec. at ƒ/5.6 on ISO 64 color film.

Atmospheric conditions refracted the sun image on the opposite page for the sci-fi look of this Cape Cod sunset. The people out on the flats are clam diggers, not invaders from another planet. The exposure was 1/125 sec. at ƒ/8, the film was Kodachrome 64, and the lens was a 70–210mm zoom.

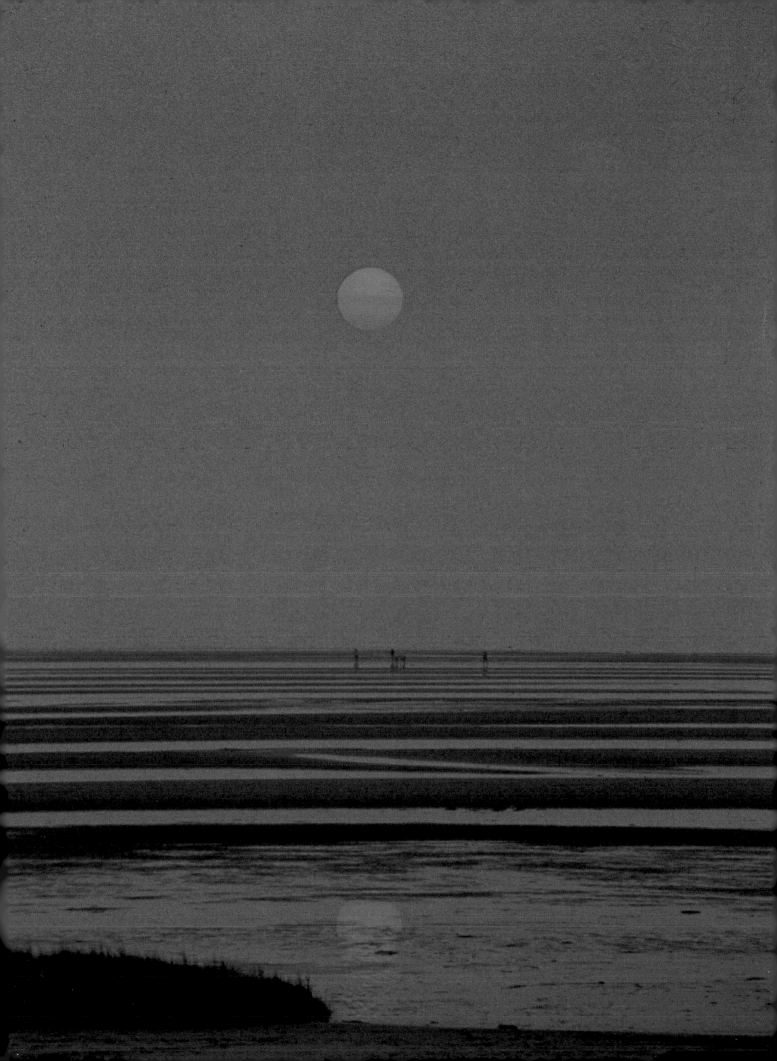

Weather Patterns

Can you anticipate spectacular weather patterns? Weather reports should give a clue, and I do tune them in on the radio or television. Different geographical regions often have their own special predictability (even if it's to expect what's not predicted), and it usually changes with the season. For example, I know that June in the Everglades is often overcast and very rainy. Conversely, in August, mornings are usually clear and sunny, with big clouds and big rains building later in the day. Frequently there is a downpour in the afternoon, but near dark the clouds lift and sunsets are spectacular.

In the American southwest, afternoon storms are frequent in August. In both the southeast and southwest, major weather systems—highs and lows—can prevail in their sunshine or gloom over the usual daily routine.

My experience in the midwest has also taught me that major weather systems will override any noticeable daily pattern. In general, weather reports are more accurate in this area of the country than they seem to be elsewhere, but the timing of the announced predictions still leaves a great deal to be desired.

Some slightly overcast weather conditions have interesting cloud patterns, as in this picture made at St. Joseph's Peninsula in Florida. This is a skyscape. Skies are legitimate nature subjects, too.

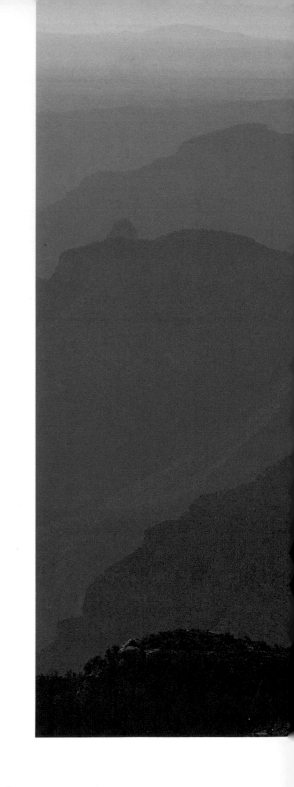

Haze

Photographic film is very sensitive to blue light and invisible-to-the-eye ultraviolet light as well. Because water droplets in the atmosphere reflect blue, your pictures will have a bluer than normal cast. Ultraviolet light is also bounced around by haze and you may find that distant parts of the scene that you could see, even if obscurely, do not appear in your black-and-white or color pictures. You can use filters to cut through haze and record subject features that you can't perceive. (See the filter section in the appendix for more information.) In my work I rarely use filters for this purpose, preferring to include whatever effects are added to the scene by haze.

Haze is particularly well-used with subjects covering a large area distant from the camera. If you include a number of peaks in a mountain range in a picture on a hazy day, you'll see that the different distances are visually suggested by the increasingly greater amount of haze veiling the peaks. The pictures of the Green River and of the Grand Canyon illustrate this use of haze as a distance indicator; without the haze neither would be as dramatic or render the sense of great distance as accurately.

While dissipated water vapor makes scenics bluer than normal, particles from air pollution, forest fires, and dust storms frequently make pictures yellow. The picture at top was made when a forest fire raged near the site I was photographing in the Everglades. The picture at the bottom was taken on a hazy morning. Both pictures were taken with a 70–210mm zoom lens, and for both, the exposure was 1/125 sec. at ƒ/5.6 on Kodachrome 64.

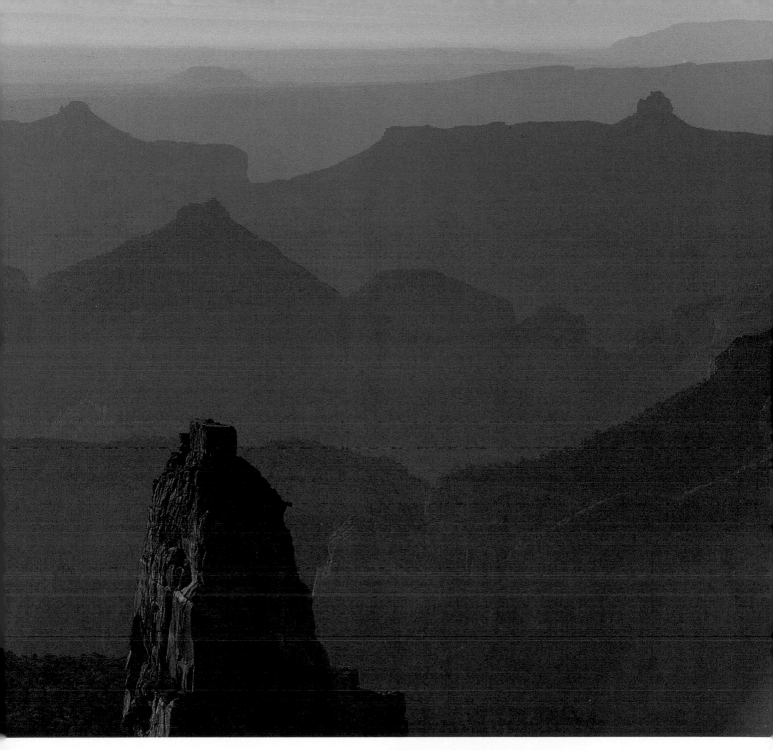

Haze is a great distance indicator, as you can see in this Grand Canyon picture. To make it I stood on a North Rim lookout just after dawn, surveying the extraordinary canyon and its regrettable air pollution. My exposure was 1/125 sec. at ƒ/8 on Kodachrome 64, using a 105mm lens.

Ground fog is never unusual in the Midwest. Generally, it burns off in about ten minutes. I took these pictures at Sheeder Prairie, Iowa, which is a small, state prairie preserve that has never been plowed. I drove out to Sheeder Prairie quite early, starting an hour before sunrise from a nearby town, and was there forty-five minutes before sunrise. The air was perfectly clear as I drove out and when I arrived. At sunrise the water vapor condensed into water droplets—presto, there was fog. I immediately began taking pictures and worked intently while the fog remained. It didn't last for long. Fifteen minutes after sunrise, you wouldn't have believed the day hadn't dawned bright and clear.

Fog

This is one hazy condition I love. I love it when it rolls in, I love it when it lifts, and I even love it when it's so thick I can't see where to put my feet. I like to work in fog so much that I recently found myself disappointed on a trip when the foggy weather I had expected to encounter failed to occur. During my week on the coast of Maine the sun shone bright and clear from the time it rose until sunset. It was ideal tourist weather for everyone but me.

Light and Heavy Overcasts

Under a slightly overcast sky, natural illumination is bluer than it is in bright sun because clouds diminish the amount of direct sunlight more than the amount of skylight. There is less contrast between sunlit areas and shadows in a light haze because the size of the light source is somewhat increased. There are no shadows, except possibly beneath large subjects in heavy overcast weather, because the whole sky becomes the light source.

Heavy, uniformly overcast weather is not my favorite for taking landscape photographs. Usually the light is very soft and seemingly directionless, and unless the subject you photograph has an unusual degree of inherent contrast, the pictures will lack brightness and look muddy or dull.

SHUTTER SPEEDS AND APERTURES FOR DIFFERENT LIGHT/ISO 64 FILM

	brilliant	sunny	hazy	cloudy	dreary
1/60	f/22	f/16	f/11	f/8	f/5.6
2					f/64
1				f/64	f/45
1/2			f/64	f/45	f/32
1/4		f/64	f/45	f/32	f/22
1/8	f/64	f/45	f/32	f/22	f/16
1/15	f/45	f/32	f/22	f/16	f/11
1/30	f/32	f/22	f/16	f/11	f/8
1/60	f/22	f/16	f/11	f/8	f/5.6
1/125	f/16	f/11	f/8	f/5.6	f/4
1/250	f/11	f/8	f/5.6	f/4	f/2.8
1/500	f/8	f/5.6	f/4	f/2.8	f/2
1/1000	f/5.6	f/4	f/2.8	f/2	f/1.4
1/2000	f/4	f/2.8	f/2	f/1.4	f/1
1/4000	f/2.8	f/2	f/1.4	f/1	f/.7

Of all the photographs I have made on heavy overcast days, the one I like best is this one on the right of lilies blooming in a North Dakota field. The simplicity of the scene is matched by the simplicity of the light. I exposed as indicated by my meter's reading of the field, ƒ/4 at 1/30 sec. for ISO 64 film.

The densest, longest fog I have ever experienced lasted for days and occurred on a Salmon river trip in Idaho. Here the fog lifted enough to show the forest carpeting the canyon walls. The exposure was 1/125 sec. at ƒ/11 on Kodachrome film, using a 70–210mm zoom lens.

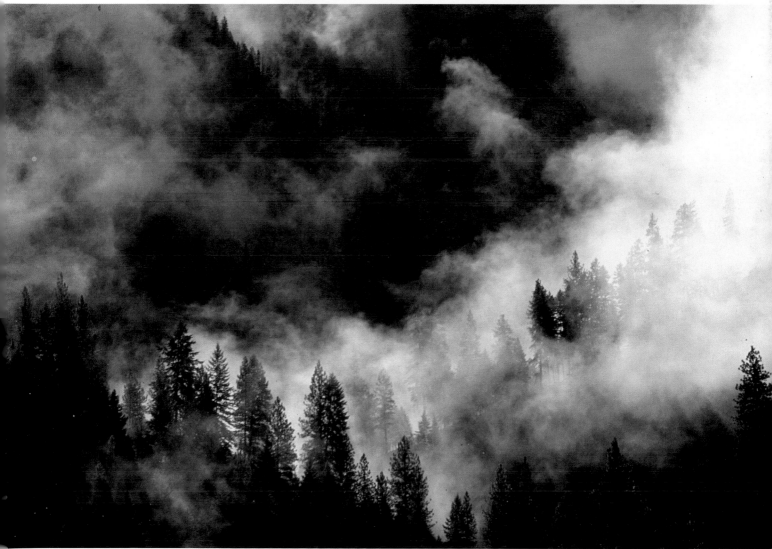

Stormy Weather

Good-looking weather, from a photographic point of view, is the reverse of what most people consider ideal for outdoor activities. Golfers, boaters, bike riders and baseball fans all love clear, sunny skies. If rain is predicted, they reschedule their activities. The same heavy storm clouds propel me in the opposite direction from indoors to outside to try to anticipate the photogenic possibilities of any dramatic weather.

The light from a storm with heavy cloud cover is always much bluer than direct sunlight. Whatever color is overhead is what's reflected, and often it is the color of leaden clouds that prevails.

Lighting contrast is at its greatest when the sun breaks through storm clouds and illuminates part of the subject. The sunlit areas are almost as bright as on a clear sunny day. But cloud covered, the sky is much darker than a clear blue sky. It is the light source for shadow areas in the subject.

Having the ability to recognize the value of special light is part of winning the battle when you're shooting in the field. Equally important is the willingness to drop what you are doing and seize an opportunity. The coincidence of perfect light together with the perfect subject is so rare and usually so short-lived, it's occasionally worth it to me to sacrifice making a connection on a trip or to be late for an appointment in order to make a once-in-a-lifetime photograph.

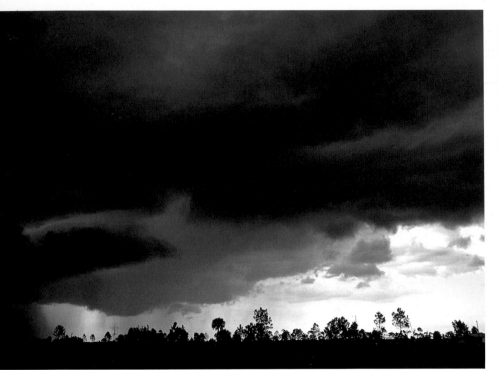

If it weren't for the ominous storm system beginning to move across the landscape above, I wouldn't have bothered to photograph this scene.

It was the bad weather that motivated me to photograph this lake, which I had passed by with hardly a glance several times a day for several weeks. It had never offered any promise of any unusual photographs. Whether smooth and calm or choppy in the wind, the water reflected a postcard-blue sky most of the time, and the few clouds that occasionally obscured the sun never improved the way it looked.

I was in a tearing hurry when I saw the lake's heavy, gray, new look. The clouds overhead were very dark, but much lighter toward the horizon. There is no coming back to photograph such moments. You must photograph them as soon as you see them. The light won't wait and it won't repeat itself.

I backed my car up to a wide space in the dirt road, grabbed my camera case and tripod, and headed for the shore. Stumbling along through the brush, I raced to find a good scene to frame. I found the dead, fallen trees about a hundred yards down the lake shore. With 20mm and 35mm wide-angle lenses, I photographed about ten frames, changing my angle, lens, and framing as I went. In at most five minutes, the light changed. To the west the horizon brightened and the clouds began to break up. The promised storm blew over, taking the dramatic landscape picture possibilities with it.

I walked back to my car, and by the time I reached it, the light was as it had always been—quite unworthy of note. At times like this, I feel I've been given a great gift—seeing, then photographing a quite ordinary scene marvelously transformed by an entirely natural phenomenon.

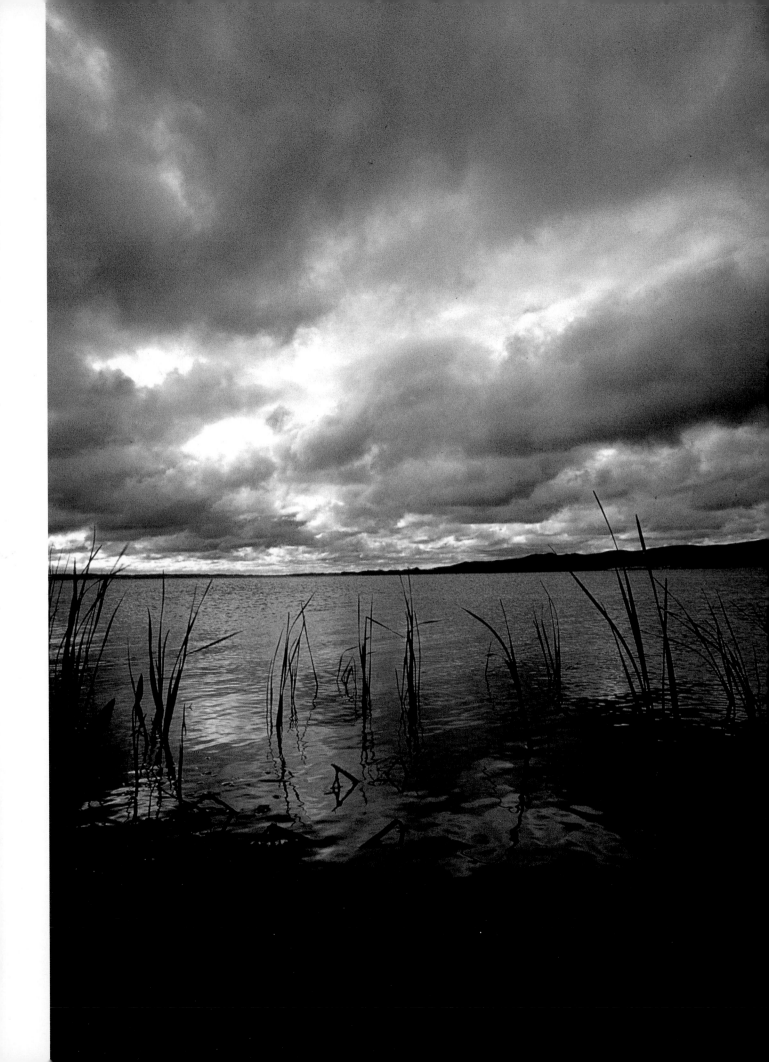

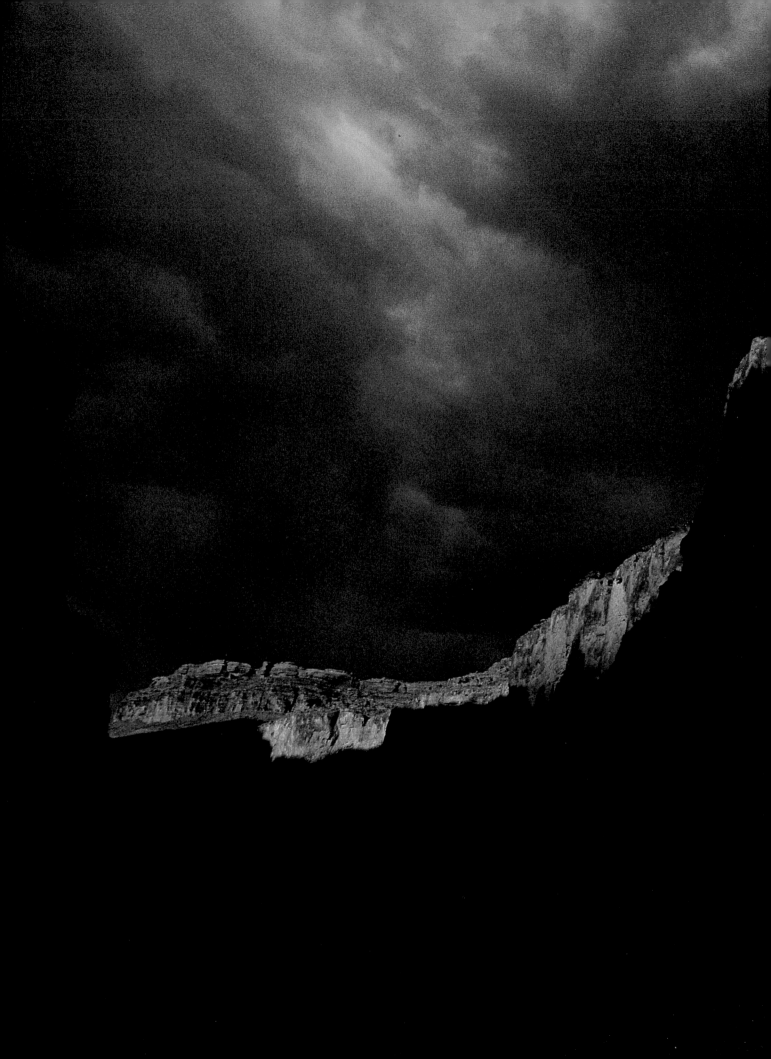

The strong, curved shape of this cliff in the Grand Canyon's inner gorge was obvious when we beached our boats, but it wasn't particularly photogenic in the pervasive gloomy light. When the sun appeared a few minutes after we landed, it was almost ready to set behind the cliff on the opposite bank. The shadow of that cliff confined the warm, direct sunlight to the rim of the cliff you see in this picture.

I couldn't believe it when this extraordinary event went ignored by the other serious photographers on this trip, although it's not surprising. If all photographers found the same things beautiful, they would all take exactly the same pictures, and the variety apparent in the visual world would be less appreciated and pictured.

Pictures in the Snow

I like taking pictures when it is actually snowing much more than I do photographing snow-covered landscapes on overcast days. The falling flakes appear as dots or streaks in the photograph, giving an overall textured look to the scene. Exactly how the flakes are rendered depends on the rate of their fall and the shutter speed you use.

The ambient light is frequently at a very low level during snow storms. If I'm at a photogenic location when a storm hits, I mount my camera on a tripod before leaving shelter. In the field I change film with the camera tripod-mounted. I usually prefer to take several lenses with me, and I carry my camera and tripod under a big poncho. When I stop to take a photograph, I keep the poncho covering me and the camera, extending the poncho to the front of the camera lens to protect the gear from the wet.

I bracket my pictures during a snowfall, making the exposure recommended by my built-in meter and making another exposure one stop more than indicated. The photograph of the tamarisk grove made during a Catskill snowfall was exposed one step more than a meter reading. The apple tree in the field was exposed as recommended by the meter.

My objection to overcast weather and snow-covered landscapes is that the contours of the snow-covered ground aren't visible. To show snow looking bright and sparkling you need the sun, and most often the light should be at a low angle.

I always bracket my exposures during a snowfall, making one based on my TTL meter and another that is one stop more than indicated. This photograph of an apple tree in a field was exposed as recommended by the meter.

Wind

Although flowers and foliage are the prime subjects for showing the wind, water and sand are also ideal for displaying its effects. In fact, you have many possible choices to exercise with any subject in any particular wind or winds. Begin to experiment with shutter speed. You can use a high one to stop the action of the foliage, but wind is better illustrated with a relatively slow speed. What constitutes "slow" in this context? If the wind is a gentle breeze, you may want to shoot at 1/8 or 1/4 sec. If you are out with your camera in a full-force gale, 1/125 or 1/250 sec. may still show action in the leaves or blossoms or stems. Because unwanted motion caused by wind is the biggest problem in flower-and-plant photography, you'll find an in-depth discussion on how to cope with it in the next chapter on flowers and plants. Often the wind is presented as "the enemy." I suggest you cut that attitude out of your photographic thinking and start to regard the wind as a friend.

When I photograph the wind, or rather how the landscape is affected by it, I study the effects of the wind on my subject through the viewfinder before I start to shoot. Frequently there is a pattern to how the wind blows, and a pattern to how foliage, water, or sand react to it. I try to see the pattern and get my timing down for shooting it before I start to work. Even so, I take more pictures than I would of a still subject, and many of them are rejects. If I make ten shots, nine may not be any good. If you decide to tackle moving subject matter, be prepared to throw out more pictures than usual.

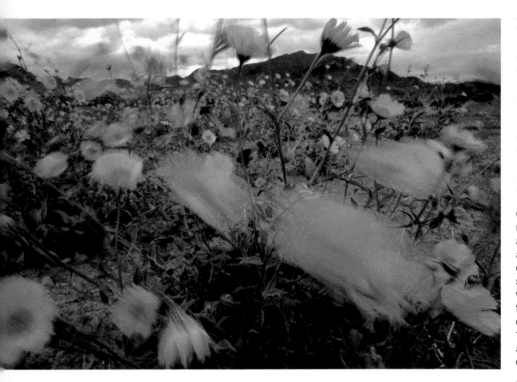

The wind in Death Valley where I photographed the poppies on the left was coming from one direction and was very strong. The exposure was 1/30 sec. at ƒ/11 on ISO 64 film. The great amount of blur creates strong impact in these pictures, resulting from my getting right down with the flowers with a 20mm lens. I used the depth-of-field scale on the lens to set my focus. Notice that the blossoms closest to the camera are considerably more blurred than those at a distance.

Grass blowing in the wind is a ubiquitous and wonderful subject. The amount of blur depends on the amount of movement, the lens, the camera-to-subject distance, and the shutter speed—quite a few factors with which to experiment. I photographed the tall grass on the top right at a distance of about twelve feet with a 105mm lens. It was an overcast day, and my exposure was 1/30 sec. at ƒ/11 on ISO 64 film.

Sand dune ripples are evidence of winds past, but dunes don't really express the ephemera of wind the way photographing wind-blown foliage does. When you focus on sand as a subject, take many shots at different angles, lenses, and camera-to-subject distances. The bottom picture on the right was taken in bright sun at an exposure of ƒ/16 at 1/125 sec. on ISO 64 film.

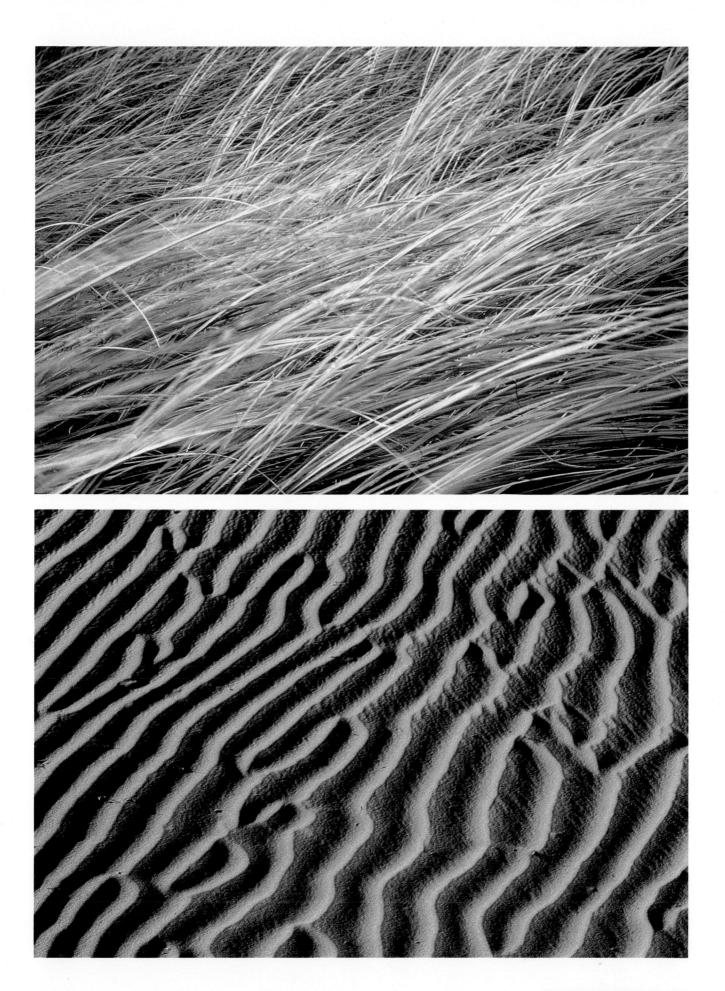

Water

The visual aspects of water are as varied as the techniques you use to photograph them. But in the most important sense, water is just like any other subject, and what you look for in it are the same line, shape, texture, pattern, scale, color, and form that you seek in more solid subject matter. You'll use *f*-number, shutter speed, lens focal length, camera-to-subject distance, angle, and possibly filters to make the best pictures you can of it.

The pictures here display some of the special characteristics of water that you should look for. Water is often moving, and you will want to illustrate this. Should you use a fast shutter speed or a slow one? You don't really have to choose—you can try both, which will give you different pictures. You may find they are both not only interesting but also satisfactory.

Another special quality of water involves its transparency and its different refractive index when viewed from the air. Water of different depths flowing gently over stones distorts the appearance of the underlying material and sometimes makes very interesting images. But don't always expect to see these patterns with your naked eye—your pictures will show you more than you can see. Each frame you shoot, even though your camera is on a tripod and is framing exactly the same area, will be different. Some will be better composed than others but all of them will be interesting—so shoot plenty.

Don't let any of this become a mystery. Just look closely at whatever water you want to shoot and analyze it photographically. These pictures should get you started, then you'll be off making new discoveries on your own.

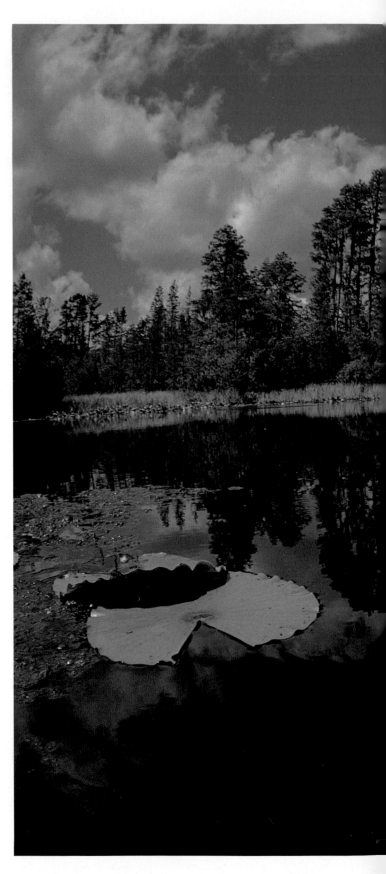

To make this water lily really big in this picture taken in an Okefenokee Swamp lake, I bent way over the side of a boat with a 20mm lens on my camera. I purposely gave my exposure one stop less than indicated by the sunny 16 rule because I wanted the white water lily to have detail and not to burn out, and because I wanted to underexpose the background for a more dramatic rendition of the scene. The exposure was made at 1/60 sec. at *f*/22 on ISO 64 film. I used the smallest aperture for maximum depth of field, and focused by using the depth-of-field scale on the lens.

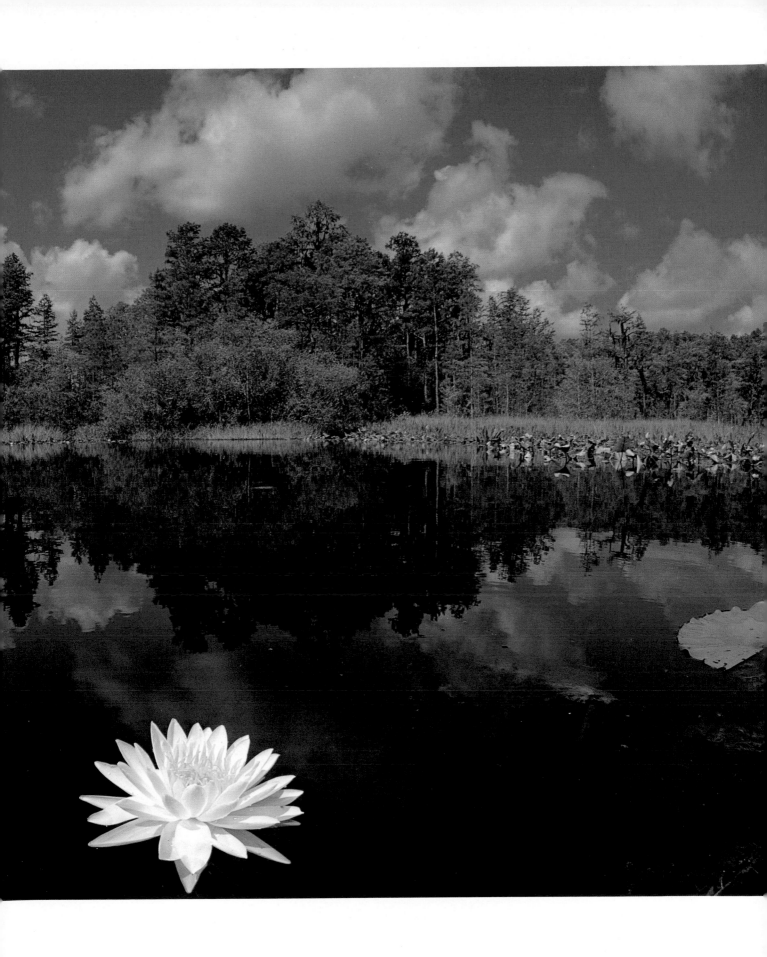

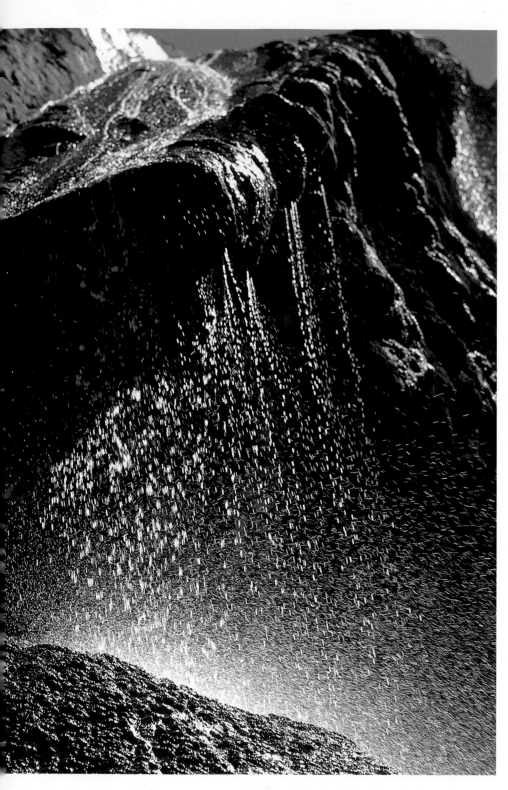

Exactly which speed you'll need to stop or blur the motion of moving water will vary with the speed of its motion, your distance from the subject, and the focal length of the lens you are using. Even a 1/1000 sec. shutter speed did not completely stop the motion of this water going over Travertine Falls in the Grand Canyon, shown on the left. To take this shot I was almost standing in the waterfall, using a waterproof Nikonos camera with a 35mm lens set at f/5.6 and ISO 64 film.

To make the photograph on the right of the waterfall at Elf Creek in the Grand Canyon, I used a speed of 1/2 sec. at an aperture of f/8. In the bottoms of canyons, it is often much darker than it is in normal open shade.

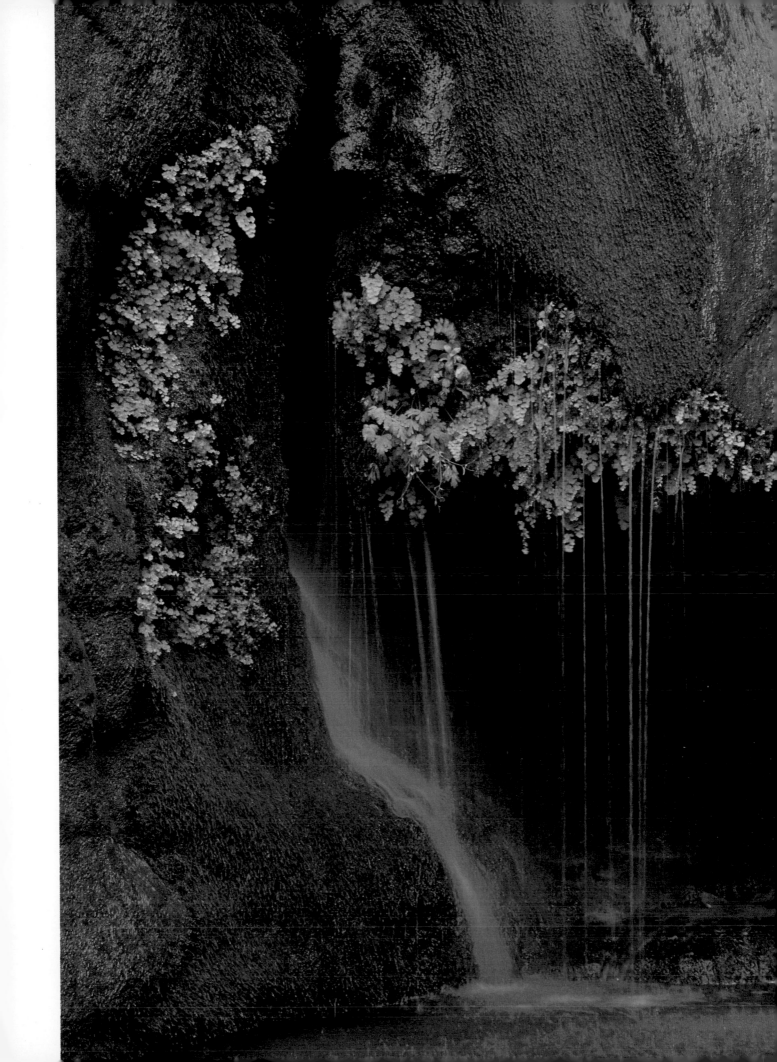

Shells and Stones

Shells and stones are the most architectural of all nature subjects. When you photograph them, your concerns will be like those of the architectural photographer.

The light illuminating the subject is so very important. As wildly arresting as so many rocks are in the Grand Canyon, large and small, most are unnoticeable unless specially illuminated. I know, for I've traveled down the Colorado River through the Grand Canyon three times with my eyes wide open, searching for pictures. I've spent a total of eight weeks down there, and I have found and photographed each rock formation when it was well illuminated only once. Even these most dramatic stone formations need the right light to be worth a shot.

No single kind of light is best for photographing all stones or shells. Bright sun behind the camera works well for fairly flat surfaces. Convoluted surfaces, such as the fluted schist, photograph better in flat light on light-overcast days. In bright sun the shadows cast confuse the image. Dawn and dusk, or overcast days, give good light for photography at shell-strewn beaches. Hard midday light often clutters the image with shadows.

For shooting shells and small rocks, water is your best friend. Photograph shells in surf that tosses them onto the beach, or under clear water in a tidal creek. The same is true for small rocks.

Along a beach where I walked on the Jersey Shore, the shell at the left was the only foam-filled shell I found. Its nacre, although beautiful, was probably the result of pollution rather than a natural phenomena. I took this picture at midday—to disprove the adage that you always get the best pictures before 10 A.M. and after 3 P.M. Using a macro lens let me frame the shell tightly. Note that, although it was midday, the sun was not directly overhead—had it been I would have cast my own shadow on the subject, and there would be no picture. The exposure was 1/60 sec. between f/16 and f/22 on Kodachrome 64, using a 105mm lens.

First light, the very moment after dawn, was the light source that washed over these shells to the right on the beach at St. Joseph's State Park in Florida. A few minutes later this scene was washed out and unphotogenic. The exposure was 1/15 sec. at f/8 on Kodachrome 64, using a 55mm macro lens.

Soft sidelight reveals the form of this fluted schist, one of the oldest rocks in the earth's crust. The fluting comes from the action of water, gravel, and sand cutting the hard surface during the countless spring floods that have carved the Colorado River's inner gorge. I took this picture from a boat slowly drifting past the canyon wall. The oarsman used the oars to steer rather than propel the boat, keeping it as steady as possible for the several photographers in it. The exposure was 1/250 sec. at ƒ/8 on Kodachrome 64, using a 105mm lens.

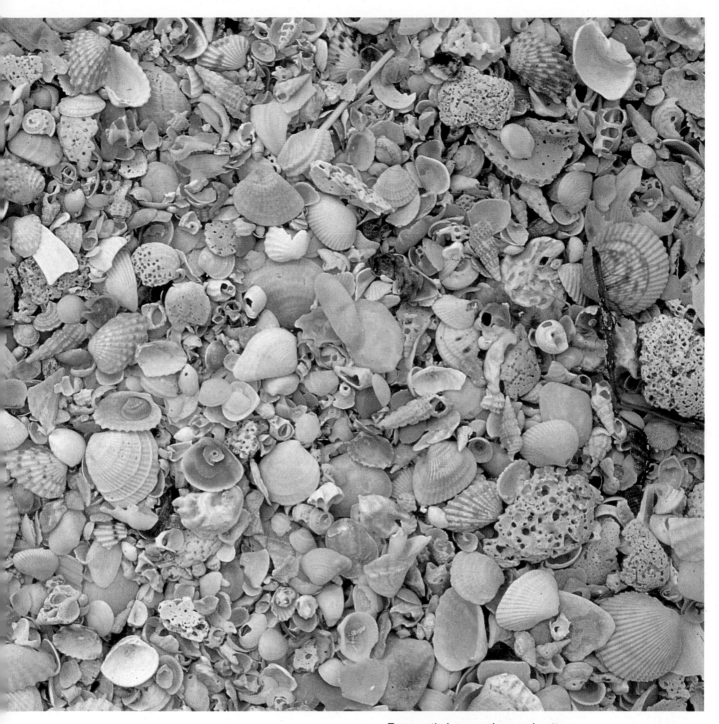

Frequently I can make good pattern pictures in locations that lack a photogenic overview. This jumble of shells on a Florida beach was surrounded by detritus left behind by a falling tide and some scruffy bushes. I decided this scene would be impossible to shoot at any time in any light, but I went ahead and took pictures anyway and was surprised and delighted by the results.

Animals in the Landscape

Pictures including animals are not necessarily animal pictures. Many of these pictures are really scenics that are only given life and interest by including some animate subject matter.

In your mind's eye, remove the fawn from the Florida Everglades landscape below. What's left? Not a good or interesting photograph, that's for sure. It's a lumpy looking, dried grass-colored throw-away. You can't even tell what you are looking at or how large an area it is. Subtract the mammals and birds and reptiles from the other pictures on these pages and what remains is not always so dreadful. But I wasn't tempted to shoot any of these scenes without the animals—in every one they make the picture.

That the light is so awful in some of these shots only testifies to the power animals have to make scenics interesting. I photographed the buffalo, for example, near noon on a midsummer day. The scene certainly wasn't at its best in that flat, overhead light, but the animals make the unattractive lighting—the factor we believe so important to landscape work—unimportant.

Can you approach taking scenics with animals or birds in them exactly as you approach the inanimate landscape? Absolutely not. Most animals will flee at the sight of you. Long lenses, 200mm to 300mm in focal length, are usually the most helpful for wild animals. The adult wild ones don't usually hold still as you approach them—you are lucky to make a shot before they are over the hill and far away.

So even photographing animals from the distances dictated by the long 300mm lens requires patience and some study of animal ways. As far as I'm concerned, the results justify the effort.

The young of some mammal species do not necessarily flee at the sight of humans. Fawns are particularly interesting. The doe instructs them to lie down and freeze in place when she leaves them for any reason, including a person's approach. The fawn to the left stayed immobile while I photographed it from different distances and angles. The picture here was taken from a standing vantage point with a 20mm lens. Bison, pictured at the top right, are too large to fear humans unless hunted. These animals were in a protected refuge, Ft. Niobrara National Wildlife Refuge in Nebraska, and they paid no attention to my car's approach or the car's stopping because I was in a familiar refuge vehicle. The shorebirds in the North Dakota pothole at the near right were very spooky. A few minutes after I took this picture, they flew away, frightened by another person who walked into their line of sight. Animal tracks make good scenics too: at the far right an alligator's footprints and tail print trail across the Everglades mud.

Landscapes From the Air

Expert aerial photographers use special large format aerial cameras mounted on gyroscopes and specialized filters, films, and exposure and development techniques. Uninhibited by the experts' way, I take good aerials using 35mm cameras, lenses, and films. Choosing an airplane from which to work, the time of day, weather conditions, and a few simple shooting techniques are far more important than specialized equipment when it comes to getting good aerial pictures.

I use the same ISO 64 color film for aerials that I use for much of my other picture taking, and the same ISO 125 black-and-white film. I always shoot at the highest shutter speed my cameras permit, 1/1000 sec., along with whatever aperture complements it. If you think about it for a moment, it will be clear why aperture considerations are relatively unimportant in aerial work, even with longer lenses. All parts of any subject you photograph will be hundreds of feet away, so you get sufficient depth of field even at wide apertures. In the bright sun that I prefer for aerial work, the aperture for the ISO 64 color film is $f/4$ and for ISO 125 black-and-white it is $f/5.6$.

I use various lenses, usually from 35mm up to about 200mm. I find telephoto zoom lenses particularly valuable. When making one pass at a subject, I can get a number of different framings in a moment with a zoom. I prefer to use cameras with motor drives or power winders for their superior speed of operation. The only special shooting technique I consider very important is not resting the camera on any part of the plane. This way, your body can absorb some of the plane's vibration.

I prefer flying in fixed-wing aircraft rather than in helicopters for aerial photography. The helicopters I've been in have vibrated much more than fixed-wing planes. And the idea that a helicopter pilot can get you exactly where you want to be for an airborne composition and keep you in that exact position is mythic. Vibration is a problem when flying about in a helicopter, but when a helicopter hovers in place it is even more exaggerated.

I always take the slowest flying plane I can get, and I like one with wings high above the cockpit rather than beneath it, because with the wings above me I can see more of the subject. The struts bracing the wings from below can be worked around—I just choose an angle to frame uninterrupted views.

For aerial photography I insist on shooting through an airplane window that can be fully opened. If there is a door next to me, I have it removed. I won't try to take aerials through glass or plastic unless I am on a reconnaissance-only flight and I am snapshooting.

Choosing a pilot is just as critical as choosing a plane, but it is impossible to know whether a pilot will be good at putting you where you want to be for your pictures without actually working with him. Generally, the more experience the pilot has had with photographers the better. In many of the off-the-beaten-track locations where I've flown I haven't had any choice in pilots. I've winged it out of one-man airports all over the U.S. and luckily have had good results.

With pilots who are inexperienced with aerial photography I explain that it is the angle on the subject from the camera's vantage point that is important; that I will want to take pictures that look toward the subject and anticipate it as well as when we pass by it; and that I will tell him if I want to fly higher or lower.

What you look for when you compose aerial landscapes is naturally exactly the same as what you look for when you have your feet on the ground—lines, shapes, form, color, and textures that will fall into strong compositions. It is harder to compose from the air in many ways (unless you are your own pilot), since you have to direct someone else to bring you into the position you want.

How high should you fly? No higher than 1000 ft. My preferred shooting distance is about 500 feet above the ground for most aerial pictures. Haze in the air gets to be a big problem. Not only is the blue color a problem, the reduction of contrast is a problem. Particulates in the air is one of the reasons you want all the contrast you can get in your subject, and the long shadows of early morning and late afternoon in bright sun are a big help.

I want early-morning or late-afternoon bright sun for most aerial work. The only landforms I have photographed successfully at midday have been islands, where the shape of the dry land has contrasted in color and tone with the surrounding water. Otherwise most landscapes at midday, even those with dramatically tall mountains, tend to flatten out visually.

I took this aerial while on a prairie dog assignment. The white dots you see are prairie dog holes on the flats of Badlands National Park in South Dakota. The herd of pronghorn racing across the plain was an accidental element that actually makes the picture succeed. The exposure was 1/1000 sec. at $f/5.6$ on Kodachrome 64, using a 70–210mm zoom lens.

PHOTOGRAPHING FLOWERS AND PLANTS

Dawn light and dew transform most flowers. My favorite time of day for photography is just before and just after dawn, when plants and many animals are most refreshed. My lens choice contributed to the impact of this photograph. By working very close to this configuration of spider lily blooms with a 20mm lens, I emphasized the round, three-dimensional aspect of the cluster. The exposure was 1/60 sec. at *f*/16 on Kodachrome 64.

Flowers are probably the most popular of all nature subjects. Flowers are colorful, noticeable, easily encountered, and almost universally thought to be beautiful. Spring, summer, and autumn bring different wild plants into bloom. In this way wild flowers aren't much different from garden flowers. Many of the latter have been specially bred and domesticated from wild forebears.

I have photographed wild flowers in many different habitats—deserts, swamps, grasslands, forests, plains, and mountains. At any given locale, the blossoms of one or more species are in their prime for a few days or a few weeks at the most. Even with the bloom at its best, finding a perfect flower to photograph may require a lot of looking. Flaws that seem small and hardly noticeable as you examine a plant will loom large in your transparency or print, especially if you use any of the close-up techniques discussed later in this chapter. And feeding insects can ruin a perfect specimen overnight.

Generally, the best-looking wild flowers can be found along the unplowed railroad right of ways; in open woods; in state, national, and county parks; and in roadside ditches. Ditches along country roads are better for wild flowers now than they were ten or fifteen years ago, when spraying with herbicides was common practice. With less spraying going on, wild flower populations are coming back.

If you miss the best time of year for wild flowers near your home and you live in flatlands in the northern hemisphere, consider making an excursion north. Within fifty to a hundred miles the same

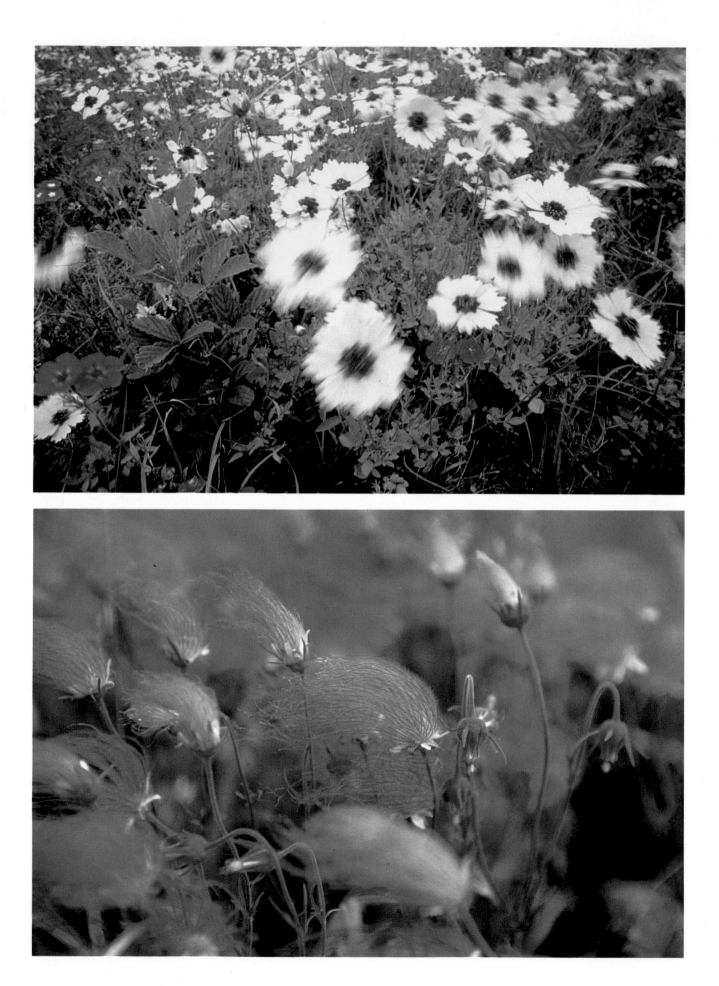

These are wildflowers domesticated by a farmer near Waucoma, Iowa. He transplanted a few specimens of prairie smoke, and they proliferated, transforming the ditch in front of his house to flaming pink every spring. I took this bottom picture in a really high wind that blew without letting up. I made a lot of shots, a whole roll at least, and got only a few I liked. The exposure was 1/500 sec. at ƒ/5.6 on Kodachrome 64.

When I photograph flowers, I may try different vantage points, but I take several shots from each one. The blossoms and grass are blurred differently in each frame. Usually one is notably better than the others. I took this tactic when I photographed the flowers blowing on the top left. The breeze was erratic, and periods of calm alternated with spurts of wind. I made eight exposures from exactly the same vantage point over the course of about five minutes. All the exposures were made when the breeze was moving the blossoms, and I didn't know which exposure would be best until I saw the processed film. Of the eight exposures, the picture you see is the one I find most satisfactory.

plants should begin to flower a week or so after those near your home. Getting a second chance is even easier if your locale is mountainous. The higher the elevation, the later the same plants bloom. I have found the same species blooming in July at 5,000 feet that I had photographed in April at sea level.

Coping with Wind

The main problem in wild flower photography is subject motion due to wind. These delicate subjects often demand close-up techniques, and unusually close working distances magnify such technical shooting problems as subject motion along with the subject. If you have a companion, he or she can position a coat or cardboard as a wind screen. If the breeze is light, you can prop up a wind screen yourself. In the hearty gales I encounter in deserts and on the plains, a wind screen must be tied down to remain standing or be held steady by an assistant. Wind is one of the reasons my picture taking usually starts at dawn—early morning is often the calmest time of day. Winds often increase from late morning through the afternoon.

On gusty days with certain types of flowers, I use a slow shutter speed of 1/30, 1/15, or even 1/8 sec. to blur some of the blooms and the other foliage on film. I can't predict the flowers' motion with complete accuracy, but by watching their movement through the viewfinder for a few minutes I can get a general idea. For such pictures I use the camera on a tripod so that nonmoving elements aren't blurred on film by any camera movement. During the long exposure to blur the flowers I can't see what is happening because the mirror is up; so I make more than one exposure, using exactly the same camera vantage point. I may try different vantage points, but at each one I make from four to ten pictures. The blossoms and grasses blur differently in every frame. Usually one is noticeably better than the others. Because film is cheap compared to my other picture-taking expenses, I don't hesitate to use as much of it as seems necessary.

Tripod versus Hand-held Close-ups

There is a rule of thumb for hand-holding cameras: the slowest speed at which you should hand-hold them is the reciprocal of the focal length of the lens. You should hand-hold a camera with a 55mm lens at speeds no longer than 1/60 sec. You should hand-hold a camera with a 135mm lens at speeds no longer than 1/125 sec. You should hand-hold a camera with a 500mm lens at speeds no longer than 1/500 sec., and so on. For hand-held close-ups I recommend even faster speeds—two or three

stops—if you want to stop the motion of flowers blowing in the wind. Whenever possible, use a tripod. I find tripods as useful on windless days as on windy days.

In the field I carry a small table-top tripod, as well as my regular tripod, to get really low, a few inches from the ground. My regular tripod itself goes very low, about 8″ from ground level. The tripod I currently use is a Gitzo, one of the reporter models having legs that extend straight out and to several intermediate low heights from the standard. You can get a short center post for Gitzo tripods, and I have one for mine. Tripods made by several other manufacturers, such as Bogen and Slik, also have similar extendable legs, and I consider this feature invaluable. If a short center post is not available, cut off the long center post that comes with the tripod. I do not like reversing the center post, as is recommended with many tripods. It is very awkward using the camera upside down.

For long hikes or backpacks, I may leave my normal tripod behind and rely solely on the table-top model. Sometimes I hold it firmly against a tree trunk or place it on a boulder for slightly higher vantage points. You'll want a waist-level or a right-angle viewfinder for your close-up work. Such accessory viewfinders enable you to frame flowers from low angles that would be awkward or impossible with the regular technique. Right-angle attachments are available from Spiratone, a company that manufactures equipment of special interest to nature photographers and photographers in general, as well as from the manufacturers of specific camera systems. Lepp and Associates is another great distributor of special accessories for nature photographers. You can write them and Spiratone at the following addresses:

> Spiratone
> 135-06 Northern Boulevard
> Flushing, NY 11354
>
> Lepp and Associates
> PO Box 6224
> Los Osos, CA 93402

If you are a do-it-yourselfer, you can do your flower pictures a good turn by making a lowpod or a camera stake. A lowpod is a piece of board or plywood, ½–1″ thick and about 4″ wide and 8–10″ long with a ball-and-socket tripod head attached. A camera stake is a metal or wooden stake or spike no longer than 6″ with a ball-and-socket head attached to it. Both devices provide firm support right at ground level or a few inches above it.

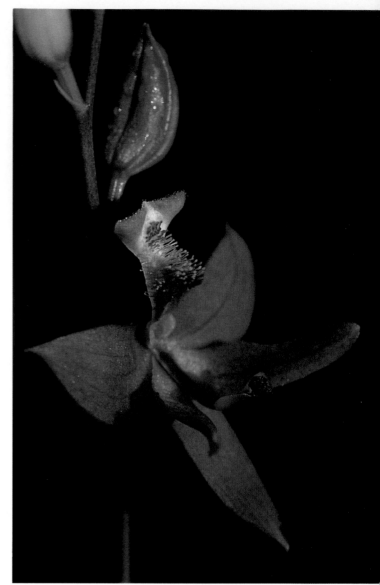

The orchid above grew in a grassy meadow. Even so, I was able to get an angle that isolated it against the deep shade cast by a grove of trees, and I photographed it at daybreak.

The inclination is to photograph a flat blossom, such as this goat's beard opposite, head on. Try to get down, angle up, and include part of the stem for more interesting framing. This exposure was 1/15 sec. at f/11 on Kodachrome 25.

Aperture and Background Considerations

I frequently use a fast shutter speed, such as 1/250 or 1/500 sec., even when there is no wind. This is because I want a large aperture to throw confusing backgrounds out of focus. I use this selective-focus technique most often to subdue backgrounds in an image.

Unlike some photographers, I don't cut wild flowers or transport them to another location for photographing. I prefer to return another day or at a different time of day if I don't like the light as I find it. Wild flowers are protected in many states and it is illegal to cut or transplant them. If you think you must move a wild flower to photograph it well, check with state authorities to be sure it isn't a member of a protected species. You should also be certain that there are many other plants of the same species at the location.

Many plant photographers use artificial backgrounds that they bring with them into the field. They use blue poster board to simulate a sky background, green-and-brown blotchy backgrounds to simulate an out-of-focus wooded background or black to simulate a dark, shaded background.

I have no objection to this practice, but it doesn't seem too practical for the way I usually work. I'm rarely photographing flowers exclusively. I look for scenic pictures, medium-distance pictures, pictures of animals and plants. I carry other equipment in addition to what I plan to use for flower close-ups, and I'm usually by myself. Backgrounds haven't presented enough of a problem for me to carry around large pieces of cardboard in addition to the rest of my gear. To date, I haven't found it impossible to photograph a flower simply because I didn't like the background. I have always managed to locate a specimen of the plant I want to depict that looks good from one angle or another when viewed in its own environment.

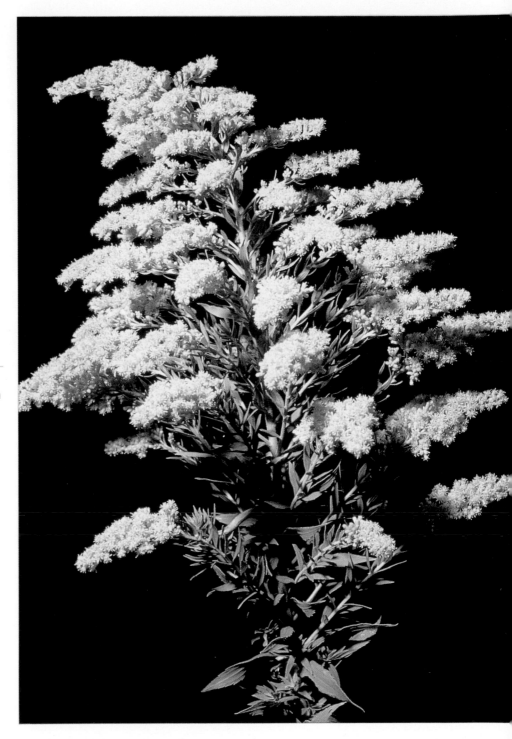

Here's a pair of pictures that shows some of the possibilities of playing with depth of field. In the first photograph I shot wide open at $f/4$, with the focus on the front blossom. For the second picture I stopped the lens down to $f/22$, its smallest aperture, and first focused on the front blossom, noting its distance from the camera as indicated on the lens. Next I checked the distance of the rear flower. Then, using the depth-of-field scale, I determined the aperture necessary to get both acceptably sharp. The lens was a 105mm macro.

You can create black backgrounds for flower subjects by using flash. I made this picture of goldenrod in the shade of a Nebraska barn. I positioned the flash off camera and used an aperture of $f/32$. The shutter speed was 1/60 sec., and this so underexposed the background that it appears black. The lens was a 105mm.

Landscaping

The most I will do to alter a scene I compose is remove objectionable objects with discretion and care. My technique for removing them varies. If background branches or twigs confuse the picture, I bend them and tie them back out of sight. If the objectionable material is dead wood or grass I sometimes, but rarely, break it off and put it to one side. I do this only after carefully considering every possible camera angle in search of one that will permit me to frame my subject without including the distracting items. The small scissors incorporated in my Swiss Army knife help me cleanly clip dead grass close to the root if I need to remove it. And I use one of the knife blades to cut intrusive dead twigs.

I approach my flower subjects with care and try not to step on any blooms, even those I have no intention of photographing. I stay back and slowly consider the field, hillside, or ditch before walking out into it. Why am I so cautious? Because I know that a picture I may later want to take can be destroyed by my footsteps. Another reason is that I have a general respect and regard for my subject matter, which I believe should not be sacrificed because of my interest in it. Unless the picture I am after is the result of some transient miracle of light, in which case I may move fast, I progress unhurriedly, sometimes stopping to consider and reconsider the scene every few paces.

Often flowers will look their best at dawn before the dew evaporates or when the sun breaks through the clouds after a rain. To simulate this effect I sometimes spray a fine mist of water on flowers with a small atomizer. (Some photographers use glycerine because it stays beaded longer than water does.) In a pinch, a spray bottle that originally contained window cleaner will do. Be sure to discard the cleaner first and rinse the bottle thoroughly with water.

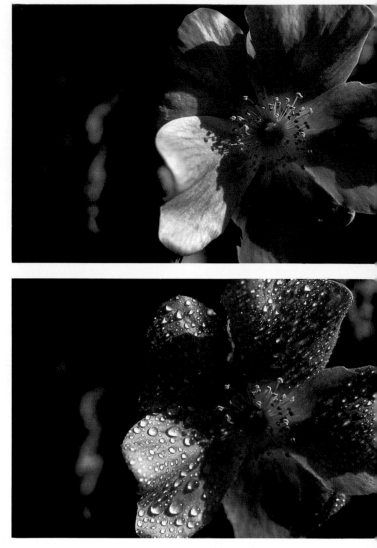

The do-it-yourself dew in the bottom shot came out of an old window spray bottle I carry with me and occasionally use. Any spray device will work—the best is a perfume atomizer that sprays fine droplets. I took this pair of pictures very early in the morning, less than an half hour before sunrise, in a Nebraska meadow. The exposure was 1/60 sec. at *f*/16 on Kodachrome 64, using a 55mm macro lens.

In the opposite picture, flowers and dead foliage were flattened to the ground by winds and rain in the Grand Canyon. I stood directly over them and framed what I saw. The exposure was 1/30 sec. at *f*/8 on Kodachrome 64, using a 55mm macro lens.

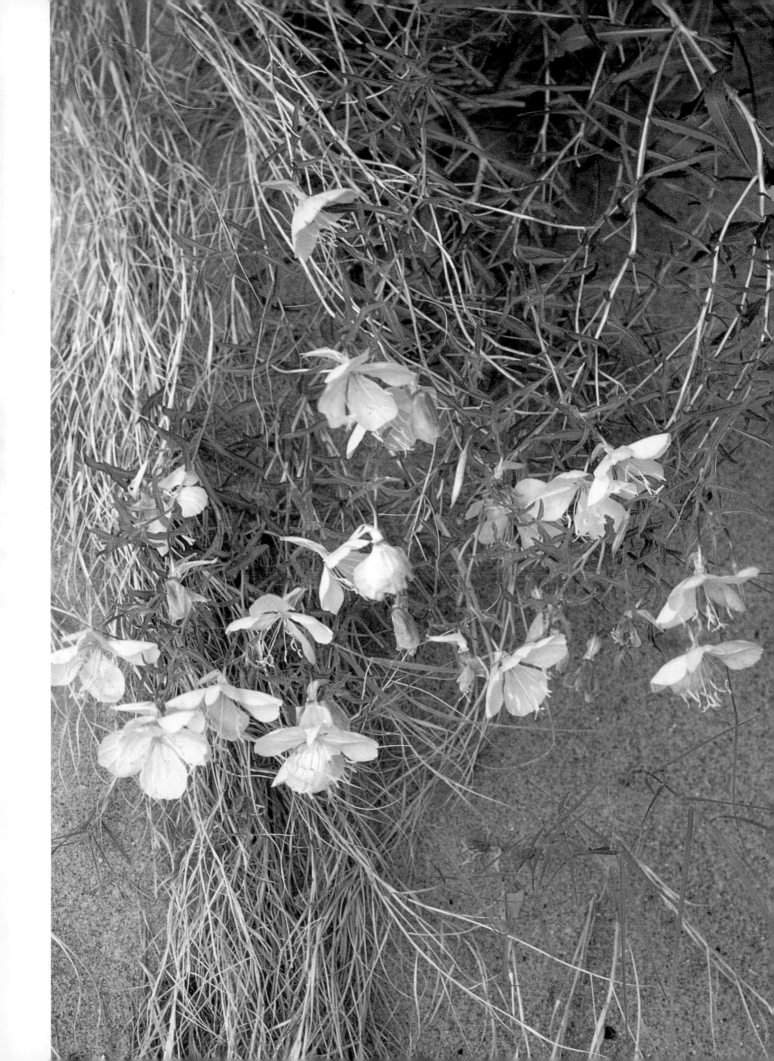

Finding the Best Camera Angle

Two of the most important variables that can be controlled are camera height and angle. Do you want the camera looking down at the flower, framing the blossom without showing the stem like a bird's-eye view? Or should the camera be down at ground level looking up, with the flower isolated against the sky? Sometimes the angle I like best is looking straight at the flower from its own height. I have used tall step ladders for head-on pictures of blossoms on tall trees and I often lie flat on the ground for pictures of short-stemmed flowers.

The quality and direction of the light as well as the flower's shape determine which angle is best. A flower that looks mediocre and uninteresting with the sunlight from above and behind me may be glorious when I change my angle 180° to backlight it.

Background clutter is a big problem in flower photography. One technique that frequently works is using a low angle below the subject height and isolating the blossoms against the sky. I photographed this thistle flower and bud from about two-and-a-half feet above ground level, using a right-angle finder on the camera to make sighting easier. The exposure was 1/15 sec. at ƒ/16 on Kodachrome 64, using a 55mm macro lens.

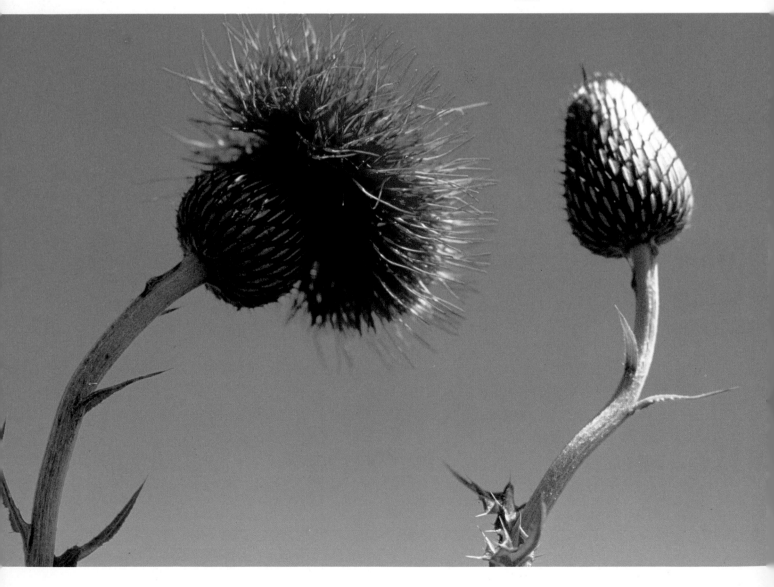

Filters for Flowers

If you are working in black and white, you will need filters for flower photography. Color contrast alone accounts for many flowers' high visibility. When photographed in black and white, red flowers in particular can reproduce in the same gray tone as the green foliage that usually surrounds them. A filter transmits light of its own color. (See the filter section in the appendix.) If you want a red flower surrounded by green foliage to appear light against a dark background in black and white, use a red filter. Use a green filter for a dark flower against a light background.

Filters are useful for color pictures of flowers as well, particularly if accurate color is important. This is especially important if the pictures are to be used for flower identification. Flowers found in a forest, for example, are illuminated by light transmitted through or reflected from green leaves. Because this green "environmental" light may be the only light falling on the subject, there will be an overall green cast to the pictures. You can use a color temperature meter to measure the color temperature of the ambient light and to determine the strength of the proper color-compensating (CC) filter.

An alternate strategy is to take the pictures without correcting filtration, and then decide on the appropriate filter by laying various gelatin CC filters over the transparencies on a light box. You'll want a magenta filter of one density or another to suppress extra green light. To correct the color of the transparencies you have on hand, sandwich an appropriate-sized piece of the gelatin filter together with the transparency in a new mount. To make in-camera corrections of similar situations involving that subject and light in the future, use the same strength magenta filter over the lens when shooting.

Blue flowers sometimes don't appear in the photograph as we see them in the field. There is a difference between our perception of blue and our color films' record of it. Compared with the film, our eyes are relatively insensitive to red and relatively sensitive to blue, but blue flowers often reflect a lot of red that is invisible to us. You can correct this oversight by using a cyan CC filter to suppress the red. In the future, use the same filter when photographing the same species of blue flower.

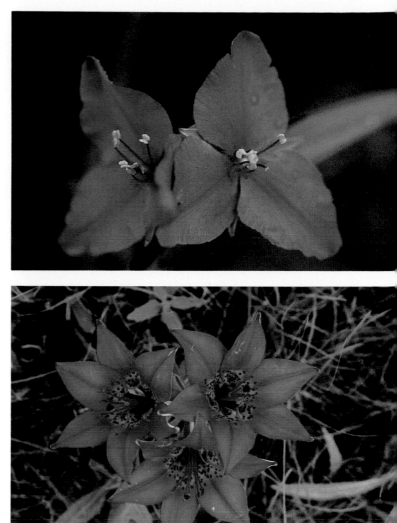

Overcast days are best for most flower photography, regardless of a flower's form or color. The techniques I used to shoot these two prairie flowers were actually identical, even though the blue blossoms grew on a long stem and were several feet from the ground and the red lilies were inches above it. In each case I stood directly above the subject for a head-on view. I was working with a 55mm macro lens, which made it very easy to switch between small and large subjects without undue thought. Both pictures were exposed 1/30 sec. at ƒ/5.6 on Koda-chrome 64.

Long Exposures for Low Light

You'll definitely need long exposure times for some of your flower subjects, particularly those in forest shade. Exposures longer than 1/10 sec. can cause serious problems of which you should be aware.

One is camera movement, which can be more troublesome at long exposure times of relatively short duration, such as 1/8, 1/4, or 1/2 sec., than at extremely long exposures of 1 sec. or more. The mirror flopping up before the shutter opens can cause significant camera vibrations that are detrimental to image sharpness. With exposures of 1 sec. or more, relatively little of the time the shutter is open is marred by the mirror's action, but during shorter exposures the camera may be vibrating most of the time the shutter is open.

There are two ways to work around this, and both ideally require locking the mirror up, which cannot be done with all SLR cameras. With the subject framed the way you want it and the camera on a tripod, lock the mirror up and use a cable release to make the exposure or use the camera's self timer. For exposures of several seconds you can also cover the lens with a piece of cardboard or other opaque object, and open the shutter (which should be set at B) using a cable release. Next, remove the cardboard from the lens and time the exposure by using a watch or by counting seconds. Replace the cardboard when the exposure is over, and then shut the camera's shutter while continuing to hold the cardboard over the lens. Under these conditions, bracket your exposures widely, particularly when making the longer exposures.

Changing the Incident Light

Although I haven't found any illumination impossible for flowers, I prefer light overcast days to bright sun at midday. Glaring sunlight is especially unkind to white or light blossoms. These are often overexposed when the correct exposure is made for keeping detail in the dark foliage. You can diffuse harsh midday light by wrapping several layers of cheese cloth around a hoop or between two stakes that can be stuck in the ground for support. Again, an assistant to hold the diffuser between the sun and the subject comes in handy, but if you don't have an assistant, you can use light stands or extra tripods to hold the diffuser.

I was prowling around a deep, dense, third-growth forest near New Hampton, Iowa with Vince Gebel, Chickasaw County's wonderful superintendent of parks. Vince led me to a perfect stand of trillium, and I managed to make a few shots before we were deluged by a storm. I had my camera on a Leitz table top tripod. The exposure was 1/8 sec. at $f/5.6$ using a 55mm macro lens.

Flash for Flowers

On overcast days or in the shade on sunny days I sometimes use electronic flash for flower close-ups. I position the flash off-camera at a distance that requires the smallest lens aperture for proper exposure of the flower. This way the distant background is so completely underexposed that it appears black in the picture. I find this technique most attractive if not overdone.

Similar scenes occur naturally in the woods when a shaft of sunlight breaks through the leaves to briefly illuminate a flower. The contrast is so great between the parts of the picture lit by the sun and the deeply shaded areas that all the background detail is underexposed on film and reproduces as black.

Shooting Flowers Close-up

Most flowers must be photographed close-up for a detailed blossom portrait. Flowers are not only the most popular nature subject—they are the most popular close-up subject. You don't need to go to extreme magnifications for close-up photography of flowers, and everything you need to know can be easily learned and practiced. You can achieve closer focusing and greater magnification by extending a lens away from the camera. You can use extension tubes or bellows to do this. On a macro lens, the long focusing mount extends the lens outward for the same effect.

I use the simplest techniques I can for close-ups. I have two macro lenses, a 55mm and a 105mm. The 55mm focuses to one-half life-size, and a life-size adapter—actually an extension tube of about 25mm—permits life-size, or 1:1, magnification. My 105mm macro lens focuses to life-size continuously. It has a very long helical focusing mount. It seems as if I must turn the lens endlessly to get from infinity focus to 1:1.

To get from 1:1 to 2:1, where the image on the film is twice the size of the subject, I put a 2X teleconverter between the camera and the lens. The teleconverter I use is a good one, made by the camera manufacturer for use with lenses in the focal length range of my macros.

Often I move in on a subject, exploring it as I go, coming ever closer until I get as close as I want or as close as my equipment permits without adding extension or switching my close-up method. The accompanying pictures of hibiscus illustrate what I mean by exploring a subject like this. Shooting this flower, the closest I got was 1:1—the actual size of the interior of the blossom was recorded on film.

How important is it to have several macro lenses of different focal lengths if they can both be made to give you 1:1 magnification? Well, first of all, macro

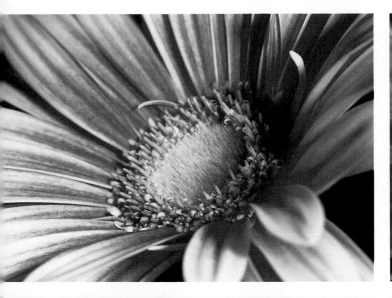

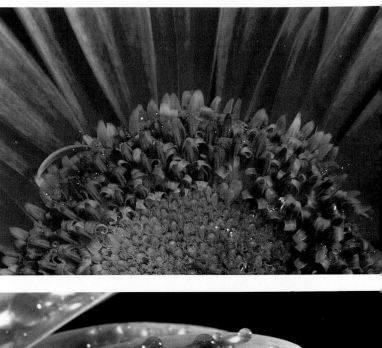

These close, closer, closest pictures of a flower that was in my living room were made with a 105mm macro lens. Using a macro lens is the simplest way to achieve 1:1 reproduction. With cameras that have TTL meters, exposure takes care of itself. With cameras set on manual, or with cameras lacking a TTL-metering system, you must increase exposure by two stops over what it would be with the lens focused at infinity for 1:1 magnification. The light source here was a quartz light.

In a birch grove at Twin Ponds, one of Chickasaw, Iowa's county parks, golden lady slippers bloom every spring. The day I arrived to shoot them clouds marched across the sky, so the flowers shown at the left were alternatively illuminated by hard, bright sunlight and by flat skylight. The differences in lighting account for the differences in these two pictures. I exposed the top picture for 1/60 sec. at f/5.6. The bottom picture was exposed for 1/125 sec. at f/11. Both were made on Kodachrome 64, using a 105mm lens.

lenses of different lengths are really entirely different animals, giving you different camera-to-subject distances, or working distances, for the same distances. They also include different amounts of background. These differences are so important that I want a 200mm macro in addition to the ones I already have. Since I can't justify the expense of buying it for the amount of work I would do with it, I use my 70–210 zoom lens at the 210 focal length with extension tubes or with the two-element close-up lenses made by my camera's manufacturer.

Getting the right exposure for close-ups is no problem at all if you have a TTL meter in your camera. Your meter will give you the right exposure. However, be aware in advance that the exposure for a close-up focus will be much greater than for the same subject at standard focusing distances if your magnification results from extending the lens farther from the film plane. This is true regardless of whether you are adding extension tubes, bellows, or using a macro lens. Two full stops, or 4X, is the actual exposure increase when you work 1:1 or life-size. Close-up lenses that screw into the front of camera lenses and increase their magnification don't require any exposure increase, but I don't recommend using them for magnifications greater than .5, or 1/2 life-size.

Making good close-up pictures isn't really difficult, but you must be very careful focusing since you have such limited depth of field. Standard close-up focusing involves moving the camera back and forth rather than focusing by the usual method. If you mount your camera on a tripod, get a focusing rail. A focusing rail permits you to move the camera back and forth, leaving the tripod in place. Without one you must move the whole tripod, an awkward, even impossible, process if you want to achieve a precise camera-to-subject distance. Focusing rails are made by your camera manufacturer and various independent companies. Remember that the camera must be rock steady. Camera movement becomes a much greater problem with close-ups than when working at more normal distances.

The biggest close-up hurdle for me was learning to think in terms of magnification. At first, I couldn't immediately look at a small subject or a small portion of any subject and decide how big I wanted it to be on film. Deciding on hardware, practicing extra careful focusing, and getting rock-solid camera support were comparatively easy. My approach to understanding magnification evolved by actually taking close-ups. If I had just sat and thought about the theory behind it without shooting, I would still be just thinking.

I settled on the macro-lens method to close-up photography because I didn't want to use a bellows in the field. It is too fragile to haul under barbed wire fences or be slung with a tripod-mounted camera over my shoulder as I go hiking about in wooded areas. I didn't want to use extension tubes on non-macro lenses for two reasons. First, the image quality is not as good as with macro lenses. Second, I hate taking extension tubes on and off when I want to change image size. I want my vision and my photographic thinking to be as uninterrupted as possible. I do like the continuous focusing system offered by a macro lens because I don't always take close-ups according to the system envisioned by the experts, who believe you should decide in advance what magnification you want so you will know exactly what equipment to use, enabling you to preset your focus before you address the subject.

Teleconverters are an alternative. When placed between the lens and the camera body, a teleconverter magnifies an image by a conversion factor. A 300mm lens plus a 1.4X converter has a combined focal length of 420mm. A 300mm lens plus a 2X converter becomes 600mm.

Teleconverters reduce lens speed by the same factor that increases focal length. For example, a 2X teleconverter reduces the speed by 2 f-stops, making an F2.8 lens an F5.6, and an F4 lens an F8. The loss of speed can make focusing and shooting in the field very difficult.

Although teleconverters aren't ideal, their results can be so good that you can't tell that an excellent prime lens wasn't used. When buying a teleconverter, buy the lowest power with the best quality available. Those manufactured for use with specific lenses tend to be especially good.

Plants without Flowers

Although flowers are the most popular nature subject, other types of photogenic plant life are too often overlooked. Many plants lack flowers altogether, yet they make very interesting photographic subjects. Throughout this book there are pictures of nonflowering plants which illustrate some of the camera techniques and different kinds of lighting suitable for photographing them as well as such plant parts as leaves, bark, stems, roots, and fronds.

The most primitive types of plants are algae. Many algae are unicellular, and are fit subjects for photomicrography rather than the general photography techniques we discuss in this book. The life histories of many types of algae are extremely complex and some are not completely understood. If you want to try to capture the life cycle of a species of algae rather than just take occasional pictures of it,

Wonderful plants may grow on the ground in otherwise ugly sites. This incredible grouping of lichen, pine cones, and needles was one among many identical elements on the floor of a central Florida sand-pine scrub habitat. Overall, this plant community is scruffy, not suitable for good photographs. This exposure was 1/30 sec. at f/11 on Kodachrome 64, using a 55mm macro lens.

Cycads are primitive palmlike plants that grow mainly in the tropics and subtropics and are not native to the temperate zone in the United States. I photographed this specimen at Fairchild Tropical Garden in Miami, viewing straight down the leaves toward the center of the plant. This exposure was 1/15 sec. at f/22 on Kodachrome 64, using a 35mm lens.

you may want to work with a marine biologist. After reading all you can find on algae in general and on the specific type that interests you, try to find through a nearby college, university, or marine laboratory a scientist who can help you photograph algae. You should offer the scientist duplicates of the photographs you plan to take for his or her own use in lectures and scientific publications, but reserve the commercial publication rights for yourself.

The nonflowering land plants are mosses, liverworts, hornworts, ferns, and conifers. Most pictures taken to identify these as well as other plants are extraordinarily dull and lacking in pictorial interest. By exercising the controls we discuss in this book, there is no reason why your photographs can't immediately be far better than most of the pictures you see in textbooks and in many magazines. Your careful use of lighting, camera angle, exposure, and other picture-taking techniques will result in your creating superior images. Such simple practices as moving on to find a more ideal plant specimen, one with a background that is shaded rather than illuminated, can vastly improve your take.

All parts of plants are suitable as subject matter. Of particular commercial interest are those aspects of a plant that help differentiate it from other species. For example, the shape and veination of a maple leaf may make a beautiful and saleable stock "pattern" picture. Tree trunks and deciduous trees in winter have beautiful shapes. And some of the best texture and pattern pictures I have ever made are of tree bark. Roots, of course, are the hardest to document, but when you occasionally come across a fallen, uprooted tree, be sure to shoot the naked, exposed root structure.

I've never made a complete set of photographs describing a single species on one field trip by shooting just one plant. My best sets of photographs have been taken at different times and places and have shown different individual specimens or groups of plants.

The top picture is of the bark of a gumbo limbo, a Bahamian hardwood common in the Everglades and Florida keys. I photographed this section from a distance of about two feet with a 55mm macro lens. I took the near right close-up of Spanish moss from a distance of about eight inches with a 55mm macro lens. The pond weeds at the far right grew in Twin Ponds, a Chickasaw County Park in Iowa.

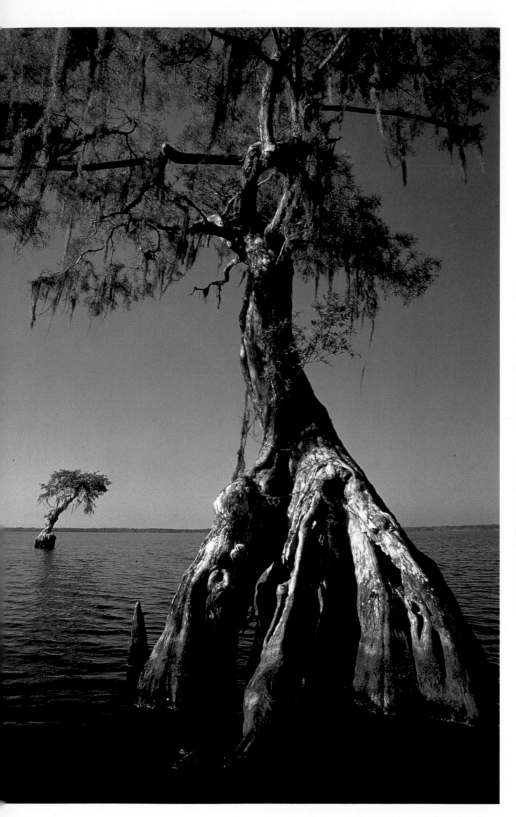

The weirdly shaped cypress trees on the left protrude out of Florida's Lake Diston, an artificial lake that was flooded after the trees were grown. I was shooting with a 20mm lens to get the strangest look possible with these amazing plants. This picture is an excellent example of using depth of field. The exposure was 1/30 sec. at ƒ/22 on Kodachrome 64.

I found the wildly shaped, lightning-struck trees on the right on a bank of the Green River in Utah. What makes this picture is the storm light behind them. A bright sunny day would not have been true to the spirit of the subject. I took about ten pictures of these trees, all with a 35mm lens, making minor changes in my stand-point for slightly different juxtapositions of the branches and the trunks. The exposure, 1/60 sec. at ƒ/11 on Koda-chrome 64, was for the sky.

Identifying Plants

To take the best possible pictures of the plant kingdom you should have some botanical knowledge. The information in a general college-level biology textbook is enough to get you started. Big city and college bookstores often have discontinued textbooks at great discounts. New textbooks usually cost twenty dollars or more; even so, the full price is still worth the information in the book if you can't find a discounted discontinued text. You may also want to buy a more specialized botany text for in-depth information. Field guides are also valuable because they'll enable you to identify your plant subjects whether you are showing slides to friends or trying to break into the professional market.

I have asked botanists at several colleges and other institutions for help in identifying plants in my pictures. The staff at botanical gardens have invariably been helpful. If you find yourself far away from your local natural history museum or college, seek help in identifying plants from local botanists who are familiar with the flora where you are shooting. Plant identification is complicated, often involving plant characteristics not evident from your photographs. If identification of a plant is not absolutely certain, never guess at it. Often it is not possible to identify the exact species, but the genus is known. In that case when you're labeling your pictures, leave the species blank or indicated with a question mark.

Photograph your local plants. I spent years in the southern swamps, and it was only by familiarizing myself with the flora that I became good at finding the best pictures of it. The two spider lilies on the far left were growing in the Everglades. To their right is a picture of a big, carnivorous pitcher plant deep in the Okefenokee swamp, and directly below is a pond apple flower in the Big Cypress swamp, which I photographed head on. I shot the spider lilies and the pitcher plant with a 35mm lens, the pond apple with a 55mm macro lens.

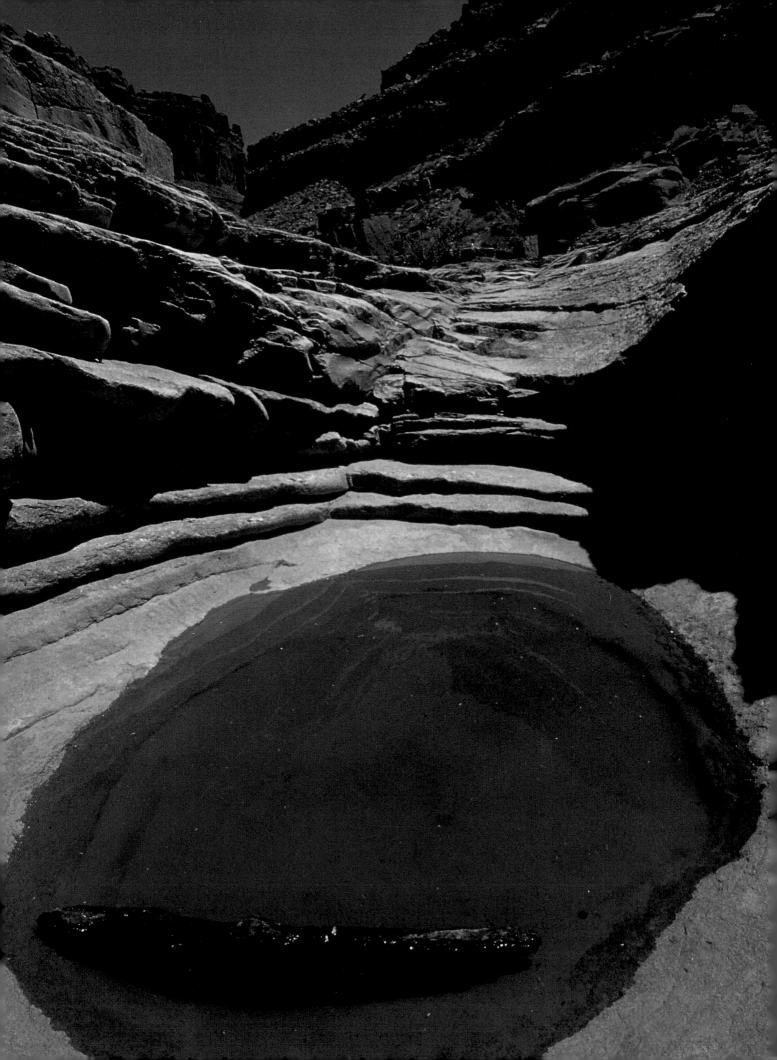

Chapter Seven

ATTITUDES AND APPROACHES

Difficult to approach, the incredible landscape of the San Juan River in New Mexico and Utah is worth the boat trip. My favorite kind of travel in search of unusual landscapes is by boat, either with friends or with an organized group. Boats carry you to unsullied scenes that you can photograph to your heart's content. My favorite scenic shooting has been in the Southwest on the Colorado plateau and along its rivers. I used a 20mm lens to expose this picture, for 1/30 sec. at *f*/22, at high noon in springtime.

Looking—plain, hard looking—will carry you far along your way to making better nature pictures, but there will be times when no amount of looking results in pictures that please you. When you're after a certain shot or a picture of a particular outdoor subject, weeks and even months can pass without your achieving your objective. Your frustration and blood pressure levels will escalate and you'll become easily discouraged with your photography unless you can learn to be flexible and put the fallow time to some other good use.

One of the best alternatives is taking good pictures in addition to those your assignment or aspirations require. This may seem really obvious, but it wasn't always obvious to me and may not be to some of you. Even though you want or need a particular picture, keep your eyes open for others along the way and make them whenever possible.

Most of my best photographs aren't those I sallied forth determined to capture. A lot of those were never taken, at least at the time I went after them directly. But I stumbled across many good ones while I was looking for something else or wasn't diligently looking at all.

I learned this lesson well many years ago when working on an Everglades book for the Sierra Club. I wanted to include a number of difficult-to-locate subjects in this book and one of the most difficult was shore birds. Many species visit Florida in large numbers during their migrations but don't nest there. The few that do aren't easy to find on order.

A friend knew of some mud flats, distant from the nearest land access, where hundreds of shore birds fed regularly. We went by boat, timing our arrival to coincide with the tide that would appropriately expose the mud flats.

After several hours in the boat, we arrived to find plenty of mud but no birds. We stayed for about half an hour, hoping. The wind whipping up, signaling an incoming weather front and a rare winter storm. Turning into the channel, we headed back.

Although I believed the day was lost I kept my equipment out and ready to use. I had two cameras ready for action. One had a 300mm lens on it, the other a 500mm mirror lens. The wind picked up and big clouds gathered while the boat bounced up and down on a choppy sea. Up ahead I saw a giant, dead mangrove tree stark against the sky on the western shore. Earlier in bright sun, it had been unremarkable. As I looked, a big bird descended, gliding silently to the tree. Then another appeared, and another. They were wood storks, rare in south Florida, flocking in to wait out the storm. My friend cut our motor and we drifted past on the swift flood tide.

Why this worked I'll never know. I figured my tripod was useless because the boat was crashing around in the waves. I had to hand-hold those long lenses and shoot at 1/30 and 1/60 sec. because of the gloom. There was some regularity to the lift and fall of the boat after the motor was cut, and I made my exposures at the crest and trough of the waves. The scene was over soon, and we were beyond the tree in a minute or two. We had to hurry away because of the impending storm. Even so, I made several strong pictures of the tree and birds in the shifting light. They were far, far better than the best shots I had hoped for from the shore-bird situation that had been our reason for making the trip.

That kind of flexibility is one of the most helpful characteristics a nature photographer can have, and fortunately, flexibility is learnable. You have relatively little control over your subjects and usually none over your lighting conditions. You have to be prepared to take it as it comes, or else miss out on a lot. There are many once-in-a-lifetime scenic situations, and if you pass them by from sheer photographic inertia or aren't prepared for them by having camera and film ready, you'll be very sorry.

Another important personal attribute for nature photographers is almost the opposite of being flexible. It's perseverance—a kind of bull-dog tenacity that keeps you going no matter what (or at least almost what). Once you know what you want, you should do all you can to achieve it. In fact, I eventually did take the shore bird pictures I needed for my book—I made them elsewhere on another day.

In this case my determination paid off.

Perseverance came more naturally to me than did flexibility, and my earliest experiences in professional photography reinforced this natural inclination. I did most of *Modern Photography*'s in-the-field film testing during my years as an editor there. We checked out new films by using an established, familiar film as a standard. Field testing involved making simultaneous exposures on both films, bracketing in half stops from three *f*-numbers under to three *f*-numbers over the recommended exposures. Every scene actually became twenty-six pictures. Because the aperture settings on both cameras had to be changed manually and checked visually between exposures to be sure there was no error, I needed fifteen to twenty minutes of absolutely consistent light. It sounds much easier than it is. You'd be surprised how many little clouds appear from nowhere on bright sunny days. But I learned to hang in there, a lesson that has paid off since.

All sorts of things go wrong in the field, and they always happen unexpectedly. Once, I made definite plans with a farm family in Alliance, Nebraska to take a photographic walk with them through a fallow meadow. I planned to visit the meadow early before daybreak. It was near the summer solstice, late in the second week of June when the sun sets in Nebraska about 10:00 PM and rises about 5:00 AM.

I was staying about ten miles from the family and their meadow, down a hard-packed dirt road. I figured getting to the farm would take about twenty minutes maximum. I was very organized; I arranged all of my camera equipment the night before. I had my cameras loaded with film and had extra lenses and extra film packed up in gadget bags ready to put in the car with my tripod. I went to bed early, before dark, setting the alarm for 4:00 AM. I rose on time, ate breakfast, and at 4:30 AM got into my car and started down the road.

Unfortunately, I hadn't been able to organize the

A common sight in springtime, in yards and in city botanical gardens, are banks of spring flowers, which are among the most beautiful of all flower subjects. I caught these tulips at their peak in New York's Brooklyn Botanical Garden, and used backlight to trans-illuminate the blooms. The exposure was 1/125 sec. at f/5.6 on Kodachrome 64, using a 105mm lens.

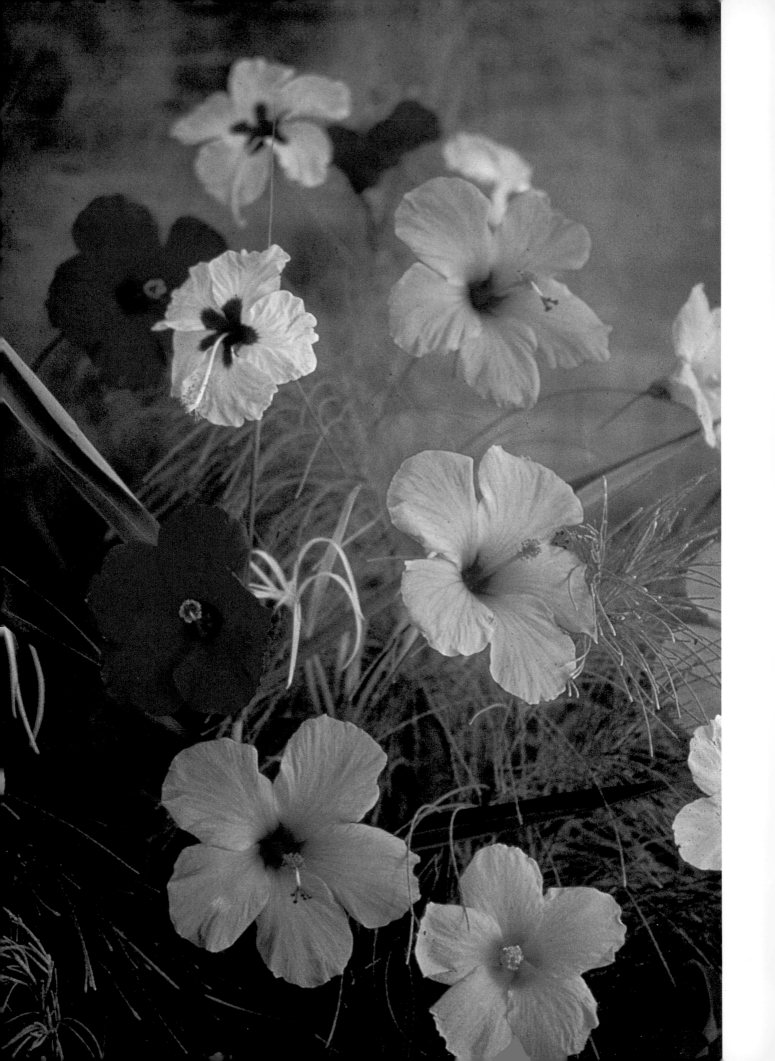

situation enough to prevent rain during the night. In the morning the road was all but impassible, a slippery quagmire. The tire treads got full of gumbo, and I was glad there were no deep ditches for I spent at least part of the trip bouncing off the banks on both sides of the road.

I slid down my farmer's lane about 5:30. The sun was well up, and I was disappointed to have missed its rising and shaken from my trip. It crossed my mind to change our walk to another day, but my hosts were ready to go. They didn't realize how important I considered the sunrise.

In retrospect, I'm awfully glad I went. The meadow was beautiful, and I did make some good pictures. That afternoon the weather took a turn for the worse. It became overcast and rainy and didn't change before I left a week later. That late walk was the only chance I had at the meadow. Perseverance had paid off again.

The small voice from within that suggested I postpone my walk through the meadow is a familiar voice indeed. It can concoct many reasons for not taking pictures. I try to ignore it, and suggest you do, too. Take a picture whenever you see something that interests you. In fact, take several even though in your mind's eye you can see that your circumstances could be better. Your mind's eye may be quite right. However *could* is not the same thing as *will*. You may not have another chance, as my experience with the meadow and many other subjects has taught me.

When I photographed the shell on page 108, I remember wishing that it were later in the day so there would have been more shadows cast; that there would be more upturned, foam-filled shells farther down the beach; that I wanted a different kind of shell; that I should wait until the surf washed over the shell again to photograph it while the bubbles were being deposited on it as well as after the surf had retreated.

As that day turned out there was no "later," at least not for photographs, because the weather turned ugly and I had to leave the beach. When I did go farther down the beach before the storm, there were no more foam-filled shells and there were no different shells. Although I waited after taking several pictures of the shell, the surf didn't wash over it again. The tide was ebbing. So I'm glad I ignored those other thoughts.

Another frequent message from within is that I haven't got time to photograph something at that moment. However, I've learned to discipline myself and take the time, right then, no matter what. I didn't really have time when I stopped to photograph the field of flowers on top of page 118. I was en route elsewhere running late for an appointment when I noticed the field from my car. Nonetheless I stopped, turned around, and was only fifteen minutes later for the appointment that I would otherwise have been. I'd made the right choice because when I went back the next day with further work in mind, the blossoms no longer looked fresh. An insect army had evidently dined on them throughout the night.

Another deterrent to photography which I've encountered is social in nature, although it rarely comes up. I'm usually not in social situations when confronted with nature subjects, and if I am with people, they seldom interfere. I was once strongly moved to take pictures of flowers in a vase during lunch at a fine Caribbean hotel. The dining room, the service, and the other guests were elegant and subdued. About midway through the first course, the ambient illumination changed. The sun, now shining at an angle through the windows, reflected off a polished wood floor. As the light level rose, an arrangement of hibiscus flowers in a vase placed before an antique mirror became irresistible to me.

The flowers looked truly exquisite. I couldn't take my eyes off them. And as my eyes became more engaged, my appetite and my end of the conversation vanished. After a few minutes, I overcame my inhibitions and explained to my companions that I felt impelled to photograph those flowers. I also explained this to the headwaiter, then went to the car for my tripod, mounted a camera on it, took reflected light readings with a hand-held meter and photographed away until I felt satisfied.

Neither my companions nor any of the other diners seemed to object in the least, and ultimately I was more than satisfied by the remuneration I received for this social lapse. A famous artist used one of the pictures, shown at the left, as the basis for a set of paintings and prints. He paid me for the picture's use in his renditions, and selling them netted me several thousand dollars.

One type of social photography situation in which I do frequently find myself is on outdoor trips with groups of people, sometimes with other photographers along and sometimes without. Picture taking on wilderness excursions has never presented me with any problems. Photographers usually make a pact to respect one another's picture-taking aims, being careful to stay out of the area another photographer is framing until he or she is finished. The nonphotographers I have met on trips have always been extremely courteous, letting the photographers lead the way if necessary, and trying to stay out of the pictures being taken.

You may want to join one or more of the environmental or hiking organizations with outings available as part of their programs. Several are described

in the appendix. Be warned, however—by and large I don't find organized hiking ideal for picture taking. The pace is too fast, and you'll often need to linger to take good pictures. But if you are a novice outdoors, the outdoor group experience will help you get started on your own. And even if you are experienced, groups frequently offer the best or the only way into remote areas.

A great help to me in getting with it outdoors has been going on trips down western rivers. On these trips you are outside twenty-four hours a day for the duration of the trip, and there is no substitute for this kind of outdoor experience. Here is a list of the guides and outfitters I have found most helpful:

Fastwater Expeditions
PO Box 365
Boulder City, NV 89005

Grand Canyon Dorries
PO Box 7558
Menlo Park, CA 94026

Grand Canyon Expeditions
PO Box O
Kanab, UT 84741

Wild & Scenic
PO Box 460
Flagstaff, AZ 86002

Another kind of planning ahead is learning as much as possible about an area or a subject before you approach it. I operate on solid information as much as on my feelings when trying to decide whether to tarry longer in a specific location or to travel on fast looking for other good places to photograph. All research pays off. If I am going far afield, I start with the books and magazines in my local library. Probably the single best source of the kind of information I'm looking for is back issues of *National Geographic*. Many professional photographers keep back issues covering several decades on hand. Since virtually all libraries keep them, too, and because they are indexed, you should easily be able to find stories on any area you intend to visit.

Look for articles on nearby places, too, but you can usually obtain the best local information from such local outdoor enthusiasts as boy scouts, scoutmasters, hikers, canoeists, hunters, and bird watchers. When I arrive at new locations, I talk to locals

about what might be photogenic. Naturally I check with the park and forest administrators and with the rangers. I also talk with just about everyone else I run into. I've been directed to wonderful sites I would never have known if a waitress, garage mechanic, or post-office clerk hadn't recommended them.

No amount of research or even first-hand advice is a substitute for scouting. I have found that when I go to any new place, my first pictures are rarely my best ones. I need some time to get with it. So I tour around for an overview before I start to work in earnest. In parks I take guided tours if they are available. I also walk whatever trails are marked, and I make it a point to visit all the more accessible highlights designated by the management. By looking things over myself, I later save much more time than initially invested. After my first tour, I continue to scout actively during the middle of the day because that is my least favorite time for taking pictures. My prime shooting times are usually the three hours after dawn and the three hours before sunset. In spring and in summer there are many hours in between. I've trained myself to project how a subject would look at a different time of day and in different kinds of weather from whatever the present scouting situation offers. If I like what I see in my mind's eye, I return to the location at the right time for them. When I'm scouting, I use a watch to keep a fairly accurate record of my travel time, whether by car, foot, or boat. When taking such pictures as sunrises or sunsets and many others, being there at the exact time is critical. Knowing how long it will take to reach a preselected location is most helpful.

The secret ingredient for successful photography is to love your subject. The best way to take good pictures is to concentrate on subject matter that you really care about and that attracts you. You don't have to photograph mountains, prairies, oceans white with foam, rocks, flowers, and trees: you can concentrate on a single one of them if you want, or on several.

The finest photographers are always specialists. Just because the range presented in this book is so wide doesn't mean you have to do it all. You'll probably take better pictures using a lens with one focal length and working hard on one type of subject that is special to you than you would with a battery of optics spreading yourself too thin.

APPENDIX

EXTREME WEATHER CONDITIONS

Some special precautions are necessary to keep your equipment operating and to ensure good final pictures when you are working in unusually hot, cold, humid or dusty conditions. Here are a few of the techniques I use when working in inhospitable climates.

Heat

The exact precautions I take to cope with heat depend on how I am working. Naturally, I'll follow one set of practices when I am on a long backpack without facilities for artificially cooling my film and camera equipment and another set when I am staying in air-conditioned motels and driving an air-conditioned car.

I can't always avoid locking my film and cameras in a car, and I've found the coolest place in the car is the trunk. Given a choice, I'll drive a light-colored car rather than a dark one—the lighter the better, for light colors reflect heat better and the car remains cooler inside.

When I am driving with the windows open or the air conditioning on, I keep my equipment and film with me in the car, placing them so they aren't directly lit by sunlight coming through the windows. If the car has so much glass that I can't prevent direct sun from shining on my photo gear, I cover the equipment with a space blanket putting the shiny side up to reflect the heat and leaving plenty of room for air circulation beneath it.

If I am in a fairly remote area and am shooting within sight of the car, I leave the car windows open. If I plan to wander farther afield, I lock the car and put my equipment in the trunk inside insulated boxes or bags. I use insulated picnic bags and baby-bottle bags for this purpose, as well as ice chests (with or without ice or other cooling devices, depending on their availability and how hot it is). Camera bags and layers of newspaper wrapped around boxes and then taped, are good insulation. I also pack exposed and unexposed film inside suitcases and surround the film with clothes that function as insulation, too.

If I am using a motel or another facility as a base, I leave most of my film there along with any equipment I know I won't be using. I only carry with me what I need for the period I'll be away, with plenty of film to spare in case an unexpected photogenic situation develops. If possible I leave my exposed and unexposed film in a refrigerator. I mail exposed film for processing as soon as possible using processing mailers. I always mail the film inside the post office rather than using the outdoor drop boxes that heat up in the sun.

In such places as the desert or the tropics, I keep a day's supply of film in an insulated bag or bags. I've found that over-the-shoulder baby-bottle bags are a reasonable size and are well designed for this kind of use. Naturally, any such bag should be light in color. I always use light-colored camera cases, which remain much cooler inside than dark cases if I'm taking pictures in the sun, and I try to shield them from the sun as much as possible. If I'm working in a small area, I try to put my bags down in the shade of a tree or rock, or I drape a piece of cloth over them, leaving room for air circulation.

In very hot weather I open the cases containing my main supply of film only at night, when it is cooler. If I can't mail exposed film for processing, I put it back into insulated cases only at night, too. I prefer to freeze my own coolant, and I use either the commercially available coolant units made for ice chests, canned fruit juice, or water in plastic bottles. Being able to refreeze my coolant nightly requires access to a freezer, and frequently there isn't one available to me. If I'm forced to use ice itself, I carefully package all the film, unexposed and exposed, in water-tight plastic bags. I buy block ice, rather than ice cubes or crushed ice, because it lasts longer.

Humidity

Humidity combined with heat is far more of a problem than heat alone. You need to keep your equipment and film as dry as possible, and this isn't easy in the tropics, not even in the tropical sections of the continental U.S., such as Florida or the Texas Gulf Coast during the summer months. Once again, your tactics must be geared to the way you're traveling. If you can leave most of your equipment and film in an air-conditioned area to which you return nightly, your life will be simpler than if you are constantly on the move.

Heat and humidity combined swiftly deteriorate the quality of the latent image captured on film, and sending film off for processing as

soon as possible after exposure is most important. Until you send it, try to keep exposed film as dry and as cool as possible. In very humid areas I enclose silica gel with the film, and I don't return the film to its individual plastic containers until I am ready to have it processed. I put the silica gel, which is available from chemical supply houses, with the film in airtight plastic bags or in an airtight ammunition case that I open only in the middle of the night to add the day's take. I enclose as little air as possible in the bags. If I am using an ammunition case, I keep my unexposed film in it along with exposed film to keep the case full and exclude air.

Humid conditions present much less of a problem for unexposed film. Films are packaged in conditions of low humidity. Packets of sheet film and roll film are heat sealed and moisture resistant, as are the plastic cans in which 35mm films are supplied. I never open the plastic cans until I am ready to load the film into the camera. Refrigeration is the best protection for unexposed films and papers, but be sure to let the materials reach room temperature before you open their moisture-resistant packaging.

In very humid conditions, such as the rainy season in the tropics, I avoid leaving film in the camera any longer than necessary, and I remove films nightly, even if I haven't finished the roll. In extreme heat and humidity, the film emulsion itself may soften and stick, jamming the camera. I don't use professional films when working in high heat and humidity because these films are meant to be processed right after exposure, and they need to be stored before exposure at cooler temperatures than I can maintain.

If you live in a hot, humid area, you should keep all your camera equipment and materials in air-conditioned quarters if you can, and you may also want to provide drying cabinets for your equipment. Putting a small light bulb inside the cabinet will keep heat and dehumidify it slightly, and there should be airholes for ventilation.

Inspect your equipment for fungus growth, and clean it often. The best protection you can give it is to store it in the driest conditions you can achieve. Desiccants, dehumidifiers, or air conditioning may help, but don't store your equipment in sealed containers unless the interiors are dehumidified. Electronic flash units must be kept dry, too, and they require the same gentle treatments as your camera.

Dust

Dust storms happen in cold, dry climates as well as in hot, dry ones. When working in dusty conditions, I keep all my unused equipment in plastic bags closed with rubber bands, and I always keep plastic bags handy for any equipment I have out even when I'm not actually shooting pictures. I dust off my equipment when I'm back at my motel or campsite, using camels' hair brushes, canned air blowers, and towels. The real point of all this is keeping dust from getting inside of the camera and away from the shutter mechanism, which can be jammed. Another good precaution in dusty areas is to rewind film slowly and carefully because dust can scratch film. If a vacuum cleaner is available, you can use it to help remove dust from your equipment.

Cold

The question to ask yourself here is how cold and how long you plan to work. The main thrust of the following techniques is to keep your cameras and more importantly your batteries from freezing.

Photographers used to send their cameras and lenses off to repairmen to have the regular lubricants in their equipment removed and have cold-tolerant lubricants installed. However, most currently made cameras are lubricated with silicone and molybdenum materials that function well in cold weather. Most new cameras will operate down to −30F.

However, batteries will not. Some manufacturers make external battery packs that can be worn next to the body to keep batteries warm, and if you are going to do prolonged shooting in cold weather, you should check out their availability for use with your equipment. Even if your cold weather sessions can be kept as short as a few hours, always carry extra batteries with you and change them every hour or so. And it is best to forgo using rapid winds and motors, because as their batteries get cold, they will undermine your camera's performance.

Most photographers who specialize in cold-weather work prefer mechanical cameras without any battery-powered automatic exposure or other electric mechanism. Several photographers recommend using rangefinder cameras rather than SLR's, because the latter have automatic-diaphragm lenses that may get sluggish or freeze up.

The metal parts of any cameras, tripods, or other equipment that you may have to touch or that may touch your face when you are shooting should be covered with tape. Wearing gloves or mittens can make photography difficult; so many photographers buy an oversized release button to make exposing the film easier. Wearing silk gloves under heavy mittens is the best hand protection and you can slip off the mittens and work with the silk gloves on when you are actually shooting.

Plastic material cable releases and film can get very brittle and break in cold weather. I suggest you use metal cable releases, and that you wind and rewind your films very slowly and carefully in the cold. In his comprehensive article "Keep on Shooting, Weather or Not" published in *Modern Photography* in February 1982 (and available as a reprint), David Eisendrath recommends rewinding films in a changing bag rather than in the camera when working in extreme cold, and he also suggests shaking the camera and brushing out its interior very carefully in case film chips have broken off inside it.

Moisture will condense when you come into a house or warm car after being out in the cold. You can compensate for this by putting your cameras and film in plastic bags with as little air as possible. As the equipment and film warm up, condensation will occur on the outside of the plastic bags instead of on your gear.

FIELD PACKS

How much equipment I carry with me in the field depends to some extent on how far I have to walk with it and what else I have to carry. If I am traveling by car, I put everything I might need in the car. Then I make up packs as I go, varying my equipment for the kinds of pictures I think I'll want to shoot. If I'll be working within a few hundred yards of the car, I don't carry much; I figure I can go back to the car and get other equipment if I need it. If I have to carry water in dry or dry-and-hot areas, it cuts down on the amount of equipment I can take. For example, in the southwest I have to carry at least two gallons of water per day. Naturally, if I am working near the car, I just leave the water in the car and carry a small canteen.

I don't always use the same bags to carry equipment. I often use a backpack that has precut shapes for holding various lenses, filters, film, and camera bodies. (Unfortunately, this bag is no longer manufactured.) I sometimes put a big Pelecan case inside a backpack, which gives my gear maximum protection. Because the backpack rests on my hips as well as my shoulders, it is also possible to carry more weight this way. The lightest method I've found for carrying equipment is to wrap individual lenses in plastic bubble wrap se-cured with rubber bands, and then put them in a daypack or backpack.

I normally carry a tripod-mounted camera over my shoulder if I am actually in the process of taking pictures. If I'm going to walk miles before I get to where I want to shoot, I carry the camera in a pack. I don't use a regular gadget bag unless I am working near a car or house.

If I'm only traveling a mile or less, I may take quite a lot of equipment with me. A standard lens assortment would include a 20mm, a 55mm, a 105mm, and an 80–200mm zoom lens, along with two camera bodies. Sometimes I add a 300mm lens to this, as well as a teleconverter if there is any possibility of shooting wildlife or birds. If I'm going five miles or more (that is a round trip of at least ten miles), I'll probably only take two zoom lenses, a 28–70mm and an 80–200mm, plus one of the excellent two-element close-up lenses (made by Nikon and Minolta) and a teleconverter.

I never go shooting anywhere with less than ten rolls of film. If I go out for a whole day, I take twenty rolls. I rarely shoot all that film, but once in awhile I'll discover the perfect subjects on the perfect day. There is nothing worse in such ideal circumstances than to run out of film.

Backpacking and camping, I don't take much equipment. I just can't carry a sleeping bag, water, and food if I have too much photographic gear; so I take one camera body and perhaps two lenses. Zooms are much heavier than fixed-focal-length lenses; so I sometimes dispense with the zooms altogether. I don't try to carry more than thirty-five pounds in all, and living necessities usually preclude too much camera gear.

Lured by what I imagine may be just around the bend, over the hill, deeper in the forest, or across the stream or by what goodies I hope later light will bring, I often want to stay longer in the field than I had planned when I started out. Three dilemmas can frustrate that desire: insect bites, thirst, and fear of getting lost. All three are so easily circumvented that I always leave prepared for them. (By the way I'm not including hunger on this list because I can ignore it for several hours, and it is only several hours that I'm discussing here, not staying in the field overnight or for days longer than originally planned.)

Insect repellent comes in tiny containers as well as large spray cans. Cutters and 6-12 are two brands available at most drug stores and supermarkets. Other heavy-duty formulas

are carried by recreation equipment stores and outdoor mail-order houses. When I go out even for a short foray in the field, I carry a small container of insect repellent in my bag or pocket.

I also usually take a small canteen or water bottle, or in a pinch I'll bring along a soft drink. The beverage's volume depends on the location and the time of year. In the temperate zone in a humid climate if temperatures are below 80F, a pint of water is plenty. If the temperature is 90F or higher, I carry a minimum of several quarts. I prefer plastic bottles that clip to my belt or my pack more than over-the-shoulder canteens.

I really detest having to carry more than two quarts of water because it's heavy. But I've been miserably ill from drinking bad water that someone assured me was good; so I won't ingest an untreated drop from the clearest of mountain streams. Subsequent to becoming ill, I've carried water purification tablets in my gadget bag along with my insect repellent. Recently, I added an item called the Super Straw Water Washer, which I obtained from Eastern Mountain Sports. It is supposed to remove chlorine, dirt, agricultural pollutants, rust and sediments from up to ten gallons of water. I expect it will be a long time before I drink ten gallons through it, but then I may never drink through it at all. It is mainly for insurance.

The Super Straw Water Washer doesn't remove bacteria and other parasites. The only way to do that is with iodine or by boiling. Neither chlorine nor halizone kills all aquatic nasties. For the small day or part-day trips I am discussing here, at the present I use tablets containing iodine.

The only place I feel comfortable about treating water in the field isn't supposed to be contaminated anyway, namely running water that is up-stream from any significant source of animal, mining, industrial, or agricultural pollution. Two obscure news stories indicate why. One story was in a small, regional paper in southeastern Utah and warned hunters not to drink any surface water in Utah, Colorado, Nevada or New Mexico because of widespread giarradia, a parasite carried by deer and cattle as well as humans. Giarradia is epidemic in the Adirondack and Catskill Mountains as well. The other story, which I read in a Flagstaff, Arizona paper, concerned an earth dam that gave way dumping two million tons of radioactive uranium tailings from a settling pond into a New Mexico river.

Neither of these stories made the national news. If I hadn't happened to be in these areas, I would have been unaware of both. Add to these stories what I heard from a Geological Survey researcher about back pumping agricultural irrigation water full of pesticides, herbicides, and chemical fertilizer into the once sweet Everglades and you will understand why I prefer to carry as much water as I can manage, why I carry water purification tablets for emergencies, and why I would have to be *in extremis* from dehydration before drinking untreated water.

The third nonphotographic item always kept in my pack is my compass. You don't have to be a real expert with it to work your way back with it to approximately where you started, and that's frequently sufficient. I'm far from expert, although I've advanced considerably from the day I bought my first compass and then got lost practicing with it in my own living room, thanks to the magnetism of a high-fi stereo speaker. Later I learned that high fidelity equipment is not the only undesirable attractant. When I started to use a compass in the field, I discovered I seemed always to be facing south when I took readings. So I turned around 180° in place. According to the compass, I was still facing south. For the second time I declared the compass defective. For the second time, I was wrong. This time my compass had fallen in love with the photoelectric exposure meter I wore around my neck. Now when I take compass readings I put my photographic equipment down and step a few feet away.

I don't go on long solo backpacks. For day trips in unfamiliar wild places, or even in familiar ones, I employ professional guides or join amateur outdoorspeople who know the region. When alone, I stick reasonably close to trails, although not always as close as I recommend. A tenth of a mile can seem as far as ten miles if you sprain an ankle or step in quicksand.

The U.S. Geological Survey produces and publishes excellent topographical maps, and you should carry them with you when hiking in remote areas unless you are led by an expert guide. On topographical maps there are contour lines indicating elevation as well as location. These maps also show the difference between true north and magnetic north, which you must know to work with your compass. It takes practice to work with topographical maps and a compass, and if you are not already an expert, I suggest you join a hiking club and practice on guided outings rather than take off on your own right away.

There are several excellent small books on using maps and compasses as well as on other aspects of getting yourself together for treks in the wilderness. The best sources I know for these books are the outdoor equipment catalogs. Of course, no book can substitute for knowledge and experience.

FILM

The first choice you must make is between using black-and-white or color film. A big factor in making this choice is how you plan to look at the pictures. If you want to project color slides, you'll prefer color transparency films. You can always have prints made from transparencies, and the cost is only slightly greater than for making prints from color-negative materials. If you are exclusively interested in looking at color prints, you should probably specialize in working with color-negative materials. If you want black-and-white prints, you'll naturally use black-and-white films.

Seeing pictures in black and white is somewhat different from seeing them in color. Seeing the former requires more effort, because you must mentally remove the color from the subject and translate it into shades of gray. The contrast in a black-and-white picture is between tonal values, which are the different degrees of gray between the extremes of black and white. Color pictures have tonal contrast, too, and they also have color contrast.

Briefly, what follows are some facts about the way film is made which could influence how you decide to buy film, depending on your shooting conditions and the results you

want. Black-and-white film consists of two layers: an emulsion containing silver halides, and a base to support it. Color films are more complex. They have at least three emulsion layers, one for each of the three primary colors—red, blue, and green. Some color films have as many as six emulsion layers with a high and a low contrast layer for each color. In addition to the color recording layers, some color films also have filter layers that screen one or more of the emulsion layers for better color separation.

The light that passes through the lens when you take a picture makes a latent image on the film. This image becomes visible when the film is developed. Black-and-white development converts silver halides that have been exposed to the image-making light into solid silver. The image areas that have been exposed to the most light are the darkest in the negative.

As you might expect, developing color films is more complicated than developing black-and-white films. The procedure varies depending on the construction of the particular film.

There are many black-and-white and color films on the market. How do you choose between them? The

best way I know is to compare their characteristics, keeping in mind the nature of the subject matter you will most often be shooting. Different films have varying degrees of acutance, or apparent sharpness, which is a function of how much contrast can be established between sharply defined areas of dark and light in the image. If you take pictures of the same subject using the same equipment but with different films, you'll discover that pictures from one roll will exhibit a greater difference in the contrast, or density, in the light and dark areas of the image, than will pictures from the other roll. The film with the greater inherent variations in density will have the greater contrast. The factors that affect contrast also affect graininess and resolution, or a film's ability to record fine detail.

Although there are many films available from different manufacturers, all film types resemble one another in basic construction and share many attributes. Slow films are usually sharper than fast films. Fast films usually have more grain than slow films. Slow black-and-white films are more contrasty than fast black-and-white films. Fast color films are usually more contrasty than slow color films. Both black-and-white and color films can be

"pushed" in processing for higher effective film speeds than their ISO ratings. Such extended processing increases graininess and contrast. Although how you expose and develop a film can temper some of its natural characteristics, following are some other film attributes you should consider when selecting film.

Speed

A film's speed indicates its sensitivity to light and is one of its most important characteristics to a photographer. The faster the film, the higher the number it is assigned and the less light it requires to make an image. The slower the film, the lower the film speed number and the more light it needs for image formation. Film speeds can be measured and are assigned ratings according to test results. For years the ASA rating system was the most widely used in the United States. The German DIN system was more widely used in Europe. In the ASA system, the film speed number doubles when the film becomes twice as light sensitive. The progression is geometric. For example, an ASA 25 film needs twice as much light for the same image density as does an ASA 50 film. ASA 50 film needs twice as much light as ASA 100. With the DIN system the rating increases arithmetically by 3 when the film speed goes up one stop. Currently, most films are marketed with ratings determined by the International Standards Organization, or the ISO, which includes both ASA and DIN rating numbers. The ISO rating for an ASA 25 film, for example, is ISO 25/15. A film's speed is frequently incorporated in the film's name. For instance, Kodachrome 64 has an ISO rating of 64, and Ektachrome 400 has an ISO rating of 400.

The actual film speed you get when you take pictures may vary from the rating indicated for the film you use. Many variables affect the rated speeds. Some of them are variations in the film's manufacture or variations from the ideal in processing. Cameras' actual shutter speeds often deviate from marked speeds, and lenses sometimes don't deliver the amount of light you'd expect from their marked *f*-numbers. Meters may indicate exposures that are higher or lower than correct. Frequently all the small deviations from normal in a picture-making system will cancel one another out, but sometimes they are additive, and should therefore be calculated into the exposure when you take a picture.

That's why I test films with the equipment I'll be using before going on a big assignment. Also, I buy color film in large quantities of the same emulsion number. The quantity may be hundreds of rolls for a big, long, extensive assignment. And I buy at least fifty rolls at a time for my own use. I store the film in a freezer to keep its characteristics stable until and after its expiration date.

Exposure Latitude

A film's exposure latitude refers to the number of different exposures or stops that it permits without significant deterioration of image quality. A film with a wide exposure latitude will produce a usable picture when the same subject is exposed differently. Generally, black-and-white and color-negative materials have a wider latitude than transparency films. For example, Kodacolor film will produce a usable picture of subjects with little contrast when exposed two stops less and three stops more than indicated by a general meter reading. Kodachrome films, on the other hand, have very little latitude. One half-stop differences in exposure can easily be seen, and one or the other will be preferable.

If you can't be sure of the absolutely correct exposure, especially when working in contrasty light situations, you may prefer a film with wider latitude, such as if you were photographing a flower in a forest that is blowing alternately from sunlight into shade.

Special Attributes of Color Films

Color films have several additional characteristics for you to consider. Bear in mind that contrast control with color films is limited or nonexistent, whereas with black-and-white film, contrast can be controlled by adjustments in exposure, developing and printing.

Different light sources have characteristic color balances that are expressed as color temperatures, which was discussed in detail in chapter 4. We compensate for the different colors of light we see, but color films do not. Films are made to produce normal-looking color only when exposed by light from one type of source. The Daylight color films you would use for your outdoor nature work are properly balanced for average midday sunlight, not for indoor tungsten light. Remember that outdoor pictures taken very early or very late in the day usually look orange or reddish, because there is relatively more red in daylight at those times. Different amounts of cloud cover and different types of weather also affect the color balance of daylight.

Color saturation refers to a film's ability to record vivid colors. It is a fixed characteristic of different films. The best way to determine it is to run your own tests, or to rely on the tests the photographic magazines publish periodically.

Defining Your Own Standards

I do most of my work with the same color film and the same black-and-white film. I am a nature generalist, not a specialist, and I often must take photographs of different subjects in a short time using the film that is in my camera. For me to switch between a number of different films while on a shoot is to court disaster. I think of my pictures at the time I take them in terms of the film I am using. If I were to have ISO 25 film in one camera, ISO 64 in another, ISO 100 in a third and ISO 400 in a fourth, I would not be able to function effectively. Most of my nature color pictures are taken on Kodachrome 64, which yields transparencies. Most of my black-and-white pictures are taken on Plus-X, which has an ISO of 125.

Naturally there are times when I use faster films, and I do carry faster films with me in the field. If I want to photograph birds in flight, for example, I may load up with ISO 200 color film. With this film I can use a higher shutter speed than I can with ISO 64 film. I will also use ISO 200 color film if the day is dark and I want to work with long lenses. At dawn or dusk

with moving subjects I may even use ISO 400 color. I've tested these films the same way I've tested my regular materials; so I'm aware of the results I can expect. In a pinch the high speed films can be pushed in processing for even higher effective exposure indexes than their published ISO ratings. The limit is about 2 stops. In other words, the maximum effective exposure index for a film with a speed rating of ISO 400 is 1600. Be aware that such pushing greatly increases a film's graininess and contrast.

I've used the same films for years; I change film only when forced to by film discontinuations or alterations in manufacture. By standardizing my use of film, I've learned what to expect from my films under different lighting conditions; so I can concentrate on finding pictures rather than on an unfamiliar film's way of rendering a subject. I keep an eye on new products, including films, through the camera magazines. If a new film sounds super for my purposes, I buy several rolls and make tests on different subjects. I am very conservative in this area because there is no substitute for the easy familiarity that only comes from working with a product for a long time. Switching from film to film makes it difficult to keep the finer points of a film's characteristics in mind and to integrate the way it renders different subjects with your own seeing.

I don't use color negative films because I don't do my own color printing, and because magazine and book publishers prefer transparencies for reproduction. I have taken some pictures on color negative films and have tested several types, but I have an inherent difficulty with the machine-processed prints I must have made from color negatives in order to assess the image. The printing machines assume that an average-toned subject occupies most of the picture area. Because many of my photographs are very dark or sometimes very light overall, the averaging treatment given my films by machines results in pictures that don't even remotely resemble the picture that I had in mind and that is actually there on the negative. I get the exact picture I intended with color transparency films; so for me there is no choice.

This doesn't mean you should do as I do. Many of the finest color photographers are working happily and wonderfully with negative color films, and negative color may be your medium, too. It is only by exhaustive testing and comparisons that you'll find out.

Film Processing

I don't develop my own black-and-white or color films at the present. I send my black-and-white film to a custom laboratory and have my color film processed by the manufacturer if there is time. If I have a hard deadline on an assignment, I send the color to a custom color lab. The technicians at my black-and-white and color laboratories are tops, their developers are kept at constant strengths, and their methods are consistent. If I test a film or run tests on new equipment, I know the processing I get is absolutely standardized; so the test results are actually significant.

I did my own black-and-white developing and printing for a long time after I started to take pictures, and my picture taking as well as my darkroom techniques benefited from it. By having to look closely at and analyze some sad results I became much more demanding in getting the right exposure and shielding the lens from stray light and much better at choosing camera angles that exclude patches of bright light in the background and other unwanted intrusions. I believe every photographer should learn how to process black and white if he chooses to work largely in it instead of in color. As it is almost impossible to know what quality standards to try to attain when you work alone, take a course or workshop in darkroom techniques. Also, make it your business to see as many photographic exhibitions as possible. The latter will set standards for your own work, and taking a course should teach you how to do it. Developing can't be taught in isolation because the results are dependent on getting the correct exposure in the first place. A good instructor should be able to analyze your successes and errors and otherwise help you overcome any initial difficulties.

Color films are more difficult to process than black-and-white films. There are more steps to doing color, and such variables as time and temperature must be even more carefully controlled. The Kodachrome film I prefer cannot be processed at home or even in a lavishly equipped, professional darkroom. Kodachrome processing requires complex and expensive automated machinery. The temperatures, developers, and dyes used must be so tightly regulated that it isn't possible to do it yourself. Even the big color-picture magazines send their Kodachrome film to Eastman Kodak or to a private lab.

Ektachrome films are simple to process compared to Kodachrome, although they are still more complex than black and white. Many amateurs and professionals process their own Ektachrome without fancy darkrooms. A commandeered kitchen or bathroom that can be made light-tight will do.

I don't consider standard processing of color or of black-and-white films a creative endeavor. Consistency and standardization are the keys to success, not imagination or innovation. Experimental color or black and white is different. If you want to develop color negative film as a positive, you can push films farther than normal for unusual effects or try any of the many other special darkroom practices common for do-it-yourself special effects.

FILTERS

As discussed in chapter 2, each of the different colors we see has a specific wavelength. Our eyes have three sets of color receptors for red, blue, and green, the primary colors. Color films have three emulsion layers sensitive to red, blue and green. All the other colors that we see and that color films reproduce are composed of varying quantities of these primaries.

A filter alters the color of light reaching the film by absorbing some color wavelengths and transmitting others. Most filters transmit light that is the same color as the color of the filter. Filters don't add their color to the picture—they remove other colors. For example, a red filter transmits red and absorbs blue and green; a green filter transmits green and absorbs blue and red; a blue filter transmits blue and absorbs red and green. The amount of color absorbed depends on the density of the filter.

Some filters screw into the filter threads at the front of lens mounts. Others come in different series sizes, and are put in series adapters that mount to the lens. Color-compensating (CC) filters are only available at reasonable cost in gelatin form, which is a kind of acetate film, and these "gels" go in holders that attach to the lens. Some filters are glass, some are gels mounted between two pieces of optical glass, and others are plastic. Relatively new systems such as the Cokin line are squares of plastic that slip into holders that are in turn attached to the filter threads of the lens.

You can get good, sharp results with optical glass, gels mounted in optical glass, or plastic filters, but the very best filters are pure gels. When used singly or in pairs, gels cause no observable optical degradation at all. Gels are fragile, though, and are very easily scratched and otherwise damaged; so you may find using glass or plastic filters more practical.

Calculating Exposure with Filters

The best way to calculate an exposure made with a filter is exactly what you would think: with TTL-meter cameras, take a light reading with the filter in place. When using colored filters, I also suggest you bracket your exposures more than you might for a picture made without a filter, particularly if you are using filters to introduce unusual color to the image. If your camera lacks a built-in TTL meter, calculate your exposure disregarding the filter, then figure in the filter factor, which usually appears on the rim of screw-in filters or somewhere in the packaging of unmounted filters. Be sure to read the instructions with any filter you buy.

Filter factors indicate the amount of extra exposure necessary for getting the right exposure when there is a filter in place over the lens. There are two different systems for indicating filter factors. The older system indicates exposure arithmetically, so that the filter factor tells you how many times the exposure should be increased. For example, a factor of four means you should give four times more exposure, or two stops. The newer system indicates the number of stops by which exposure should be increased. With this system a factor of four means you should give four stops increase, or sixteen times the normal exposure without a filter.

If you are metering through the lens with filters, don't apply the filter factor. Filter factors should be used only if you determine exposure by the sunny f-16 rule, or if you use meters that are separate from the camera-lens system.

The Most Common Filters

Many photographers use skylight or ultraviolet (UV) filters on their camera's lenses all the time. These filters screw into the filter threads on the front of most lenses. Skylight filters

are a very pale pink. UV filters, which are available in several different strengths, are very pale yellow. Skylight and UV filters absorb the invisible ultraviolet light to which photographic films are sensitive. The pale pink skylight filter also absorbs the excessive blue of distant, hazy scenes. Many electronic flash units emit ultraviolet light; so UV filtration is helpful for close-ups taken by electronic flash too.

Another reason photographers keep skylight or UV filters constantly in place is to protect the front element of the lens from dirt and scratches. I think this is a good policy only if you use the very best filters available, and if you get new filters as soon as scratches or abrasion occurs. There is not much point in buying the very finest lenses for your camera and then degrading that optical system by putting a cheap filter in front of it.

Filters for Color Film

There are two basic reasons to use filters with color films in nature photography. The first is to make pictures resemble the scene being photographed as nearly as possible. The second is to make the scene look unusual or change its natural appearance—that is, to use the filters for creative purposes.

Remember that color films are balanced for light of a specific color temperature. Only when your illumination is that specific color will the results look the same as they do to the naked eye. When your film and light aren't exactly balanced, you can filter the color of the light reaching the film to make them match. Color-conversion filters permit you to use a daylight film with tungsten light or a tungsten film with daylight. The exact filter designations for various conversions are in the chart (below).

Color-conversion and light-balancing filters are intended for matching a film's type with the color temperature of the available light for normal-looking results that have clear, untinted whites and pure neutral grays. These filters can also be used to produce unusual color for creative purposes and to simulate the color of light found at a different time of day than the time you are working. For instance, you can use the cooling filters to make pictures look as though they were taken after sunset or at night, or you can use warming filters to mimic the warm hues of sunrise or sunset.

Color-Compensating Filters

Color-conversion and light-balancing filters affect all the colors of visible light relative to one another in order to produce changes in color temperature. Unlike them, color-compensating (CC) filters affect only one primary or one complementary color. (The colors in light were discussed in chapter 2.)

Color-compensating filters come in six colors: the primaries, red, blue, and green; and the complementaries, cyan, yellow, and magenta.

WHAT COLOR CONVERSION
FILTERS DO

The 85 series is amber, and is meant to adapt tungsten type film to daylight.

85	3400 K film to 5500 K light
85B	3200 K film to 5500 K light
85C	3800 K film to 5500 K light

The 80 series is blue, and is meant to adapt daylight type film to tungsten light.

80A	5500 K film to 3200K light
80B	5500 K film to 3400 K light
80C	5500 K film to 3800 K light
80D	5500 K film to 4200 K light

Light balancing filters are warming and cooling filters in 100K increments.

Warming (amber)		Cooling (blue)	
81	+100K	82	−100K
81A	+200K	82A	−200K
81B	+300K	82B	−300K
81C	+400K	82C	−400K
81D	+500K		

The color and the density, or strength, of the color are used to designate specific CC filters. Each color filter comes in densities of .025, .05, .10, .20, .30, .40, and .50.

One of the ways CC filters are used is to correct color when color shifts occur because of reciprocity law failure taking place during very long or very short exposure times. CC filters are also used to balance films for the unusual spectrums produced by fluorescent light sources. You can use CC filters to obtain any color balance you want if you don't like the one produced by your film or processing. The weak density filters will subtly enhance or absorb subject or atmospheric color. Your best guide to using CC filters appropriately will be your own experiments. The two filters I find most helpful are a .10 green, which absorbs excessive blue light (sometimes present in wet, tropical, swamp atmosphere) while transmitting the green; and a .10 magenta for photographing white flowers in swamps or forests where much of the light illuminating the blossom has been filtered through the surrounding green leaves and is distinctly green in color.

Polarizing Filters

Like UV and skylight filters, polarizing filters are used with both black-and-white and color film. Polarizers darken skies and remove light reflections from foliage. You can also use polarizers to eliminate reflections on water surfaces. If the water is shallow, eliminating reflections lets you see and photograph the details on the bottom of a pond or river.

The reason for using a polarizing filter is that light in the sky at a 90° angle to the sun is polarized, which means it vibrates in one plane. Nonmetal reflections, such as those from leaves or water, are also polarized. A polarizer cuts reflections and shows color with increased saturation when the subject is illuminated with front light. However, the polarizer is most effective with sidelit subjects; for example, using a polarizer on skies that are 90° from the sun will render them with maximum darkness.

To use a polarizer, you view through the filter and rotate it. With

an SLR, you do this while the filter is mounted on the lens. You are getting the polarizing effect you want when the image is darkest. The filter factor for polarizers ranges from about 1.5 to 2.5X, depending on the degree that the filter is rotated on the lens. Naturally a TTL meter takes care of the factor as it reads through the filter on the lens.

There are two types of polarizers: linear and circular. Most camera models use linear polarizers, which are less expensive, but some cameras that incorporate beam splitters or half-silvered mirrors in their TTL metering systems need circular polarizers. If your system requires a circular polarizer, it will be noted in your camera's instruction book.

Filters for Black and White

Filters for black and white function the same way they do with color— they absorb the wavelengths of color that are different from their own hues. One reason for using filters in black and white is to translate color contrast into tonal contrast. The impact of many color pictures comes from the contrast between different subject colors, not from differences in tone. Another reason to use colored filters with black and white is to darken skies. Black-and-white films are more sensitive to blue and ultraviolet wavelengths than to others, so a yellow filter that absorbs blue makes skies look more natural and closer to what we see than photographing the same sky without a filter. An orange filter will darken blue

THE RELATIONSHIP BETWEEN FILTER FACTORS AND F/NUMBER INCREASE	
Filter Factor	*F/number Increase*
1	0
2	1
4	2
8	3
16	4
32	5
64	6
128	7
256	8

skies even more, really making clouds stand out.

A red filter makes skies very dark and dramatic. Coupled with a polarizer, a red filter will make skies almost black. You can't see or focus clearly through a dark-red filter, and viewing through a red filter combined with a polarizer is impossible; and a lot of extra exposure is required when you combine two filters; so you should always use a tripod when you use these filters together, even with fast black-and-white film. Frame your subject with two clear or almost clear filters in place, and focus the image. Remove the filters, and put the polarizer on. Rotate it for maximum effect. Last of all, put the red filter in place. Bracket your exposures extensively, from two stops under to one-and-a-half stops over the recommended exposure.

Remember that using colored filters for black-and-white work affects all the colors in a scene, not just the blue in the sky, and that you can also use the same filters to reduce haze. The yellow, orange, and red filters and the polarizers cut with increasing magnitude through haze made up of water vapor. However, these filters don't work with polluted air or smoke. To exaggerate haze, use one of the blue filters in the light-balancing and color-conversion sequences. The denser the blue color of the filter, the hazier the skies will look.

Special-Effects Filters

Many special lenses that produce unusual optical effects are available. They look like regular filters and they attach to the camera lens the same way, but they are really optical attachments that make changes in the image by bending light rays or otherwise altering the appearance of the picture.

Some of the many optical attachments available include fog filters, diffraction gratings, soft-focus attachments, cross-screen attachments that make four, six, or eight-pointed stars of highlights, and split-field attachments that are actually half a close-up lens mounted on a filter ring.

I rarely use optical attachments in my own picture taking, which doesn't mean you shouldn't experiment with them and incorporate them regularly in your own work. I admire the photographs of many people who use filters a lot, and think you should consider for yourself whether or not they can contribute to your own style of seeing and photographing.

ORGANIZATIONS OF INTEREST

Adirondack Mountain Club (ADK)
174 Glen Street
Glens Falls, NY 12801
A nonprofit group with chapters throughout the northeastern states, ADK is devoted to the protection of the Adirondack and Catskill Mountains and publishes the *Adirondac* magazine ten times yearly. ADK sponsors many hikes and workshops on all aspects of outdoor life, including photography.

American Museum of Natural History
Central Park West at 79th Street
New York, NY 10024
Even if you aren't living in or near New York, membership is worthwhile so you can receive the *Natural History Magazine*. The articles are interesting, and the photographs are excellent.

American Wilderness Alliance
4260 E. Evans, Suite 8
Denver, CO 80222.
This organization sponsors wonderful outdoor trips throughout the US and publishes *Wild America*, and *On the Wild Side*. I highly recommend membership.

Appalachian Mountain Club
5 Joy Street
Boston, MA 02108
Has programs of interest to all residents of the northeastern states as well as to photographers who plan to visit the area.

Appalachian Trail Conference, Inc.
P.O. Box 236
Harpers Ferry, WV 25425
Helps maintain and preserve the Appalachian Trail, and distributes important user information and guide books. Of interest to anyone planning Appalachian Trail hikes and photography.

Federation of Western Outdoor Clubs
512 Boylston Avenue E #106
Seattle, WA 98102
The Editor of their publication *Outdoors West* is Hazel Wolf. This is a federation of 47 outdoor clubs, of interest to outdoor photographers in the west.

Friends of the Earth
1045 Sansome Street
San Francisco, CA 94111
FOE is an enormously active and effective organization of interest to photographers who want to take an active part in the conservation movement.

Grassland Heritage Foundation
5450 Buena Vista
Shawnee Mission, KS 66205
The foundation acquires and preserves representative prairie tracts—of particular interest to photographers in the middle west.

International Backpacker's Association, Inc.
P.O. Box 85
Lincoln Center, ME 04458
The IBA is of interest to outdoor photographers.

Isaak Walton League of America, Inc.
1800 North Kent Street, Suite 806
Arlington, VA 22209
This conservation organization has local chapters that meet throughout the country. The League's purpose is educational—of interest to all nature photographers.

National Geographic Society
17th and M Streets, NW
Washington, DC 20036
The *National Geographic Magazine*, certainly the most popular publication I know of, regularly runs articles of great interest to all nature photographers. If I had to limit myself to one publication, this probably would be the one.

The Nature Conservancy
Suite 800
1800 N. Kent Street
Arlington, VA 22209
Their principal activity is protecting natural lands, and they maintain over 700 natural area sanctuaries across the nation.

Sierra Club
530 Bush Street
San Francisco, CA 94108
The Sierra Club publishes books, sponsors wilderness trips, and takes activist positions on conservation questions. There are 50 chapters nationwide that meet frequently and have excellent conservation programs. They also organize frequent local outings.

Smithsonian Institution
1000 Jefferson Drive SW
Washington, DC 20560
This extraordinary institution sponsors many activities, including field investigations, conservation, education, and producing public information on the sciences. The Smithsonian Institution administers the National Zoological Park in Washington, DC. In addition, the institution organizes wonderful guided trips for members, some of which are wilderness trips. Membership includes receiving *Smithsonian Magazine*.

The Wilderness Society
1901 Pennsylvania Avenue NW
Washington, DC 20014
The purpose of the Society is to preserve wilderness and wildlife. The Society sponsors wilderness trips and publishes the magazine *The Living Wilderness*.

INDEX